The Walter O. Evans Collection of African American Art

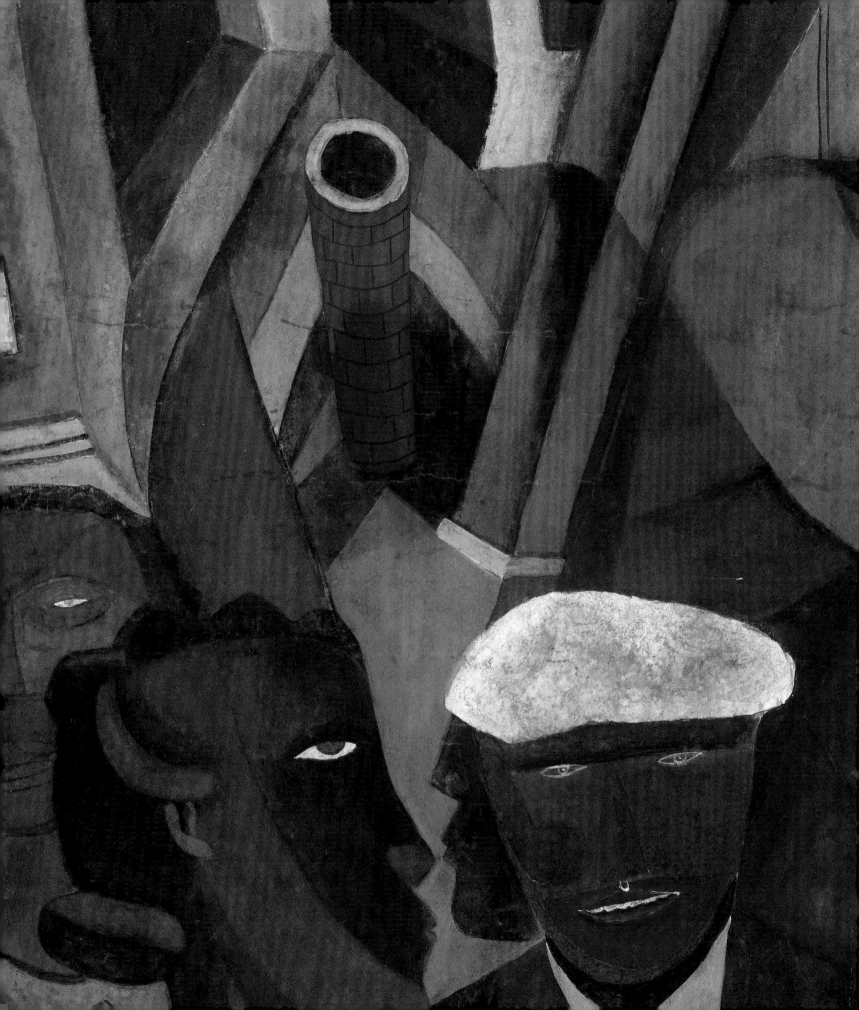

Andrea D. Barnwell

contributions by

Tritobia Hayes Benjamin
Kirsten P. Buick
Walter O. Evans
Amy M. Mooney

**The Walter O. Evans Foundation
for Art and Literature**

in association with

**University of Washington Press
Seattle and London**

The Walter O. Evans Collection
of African American Art

This publication was made possible in part by a generous contribution from the Richard and Jane Manoogian Foundation.

Library of Congress Catalog Card Number: 99-72909
ISBN: 0-295-97920-8 (cloth)
ISBN: 0-295-97922-4 (paper)

Distributed by
University of Washington Press
P.O. Box 50096
Seattle, WA 98145

Edited by Patricia Draher
Designed by Susan E. Kelly
Produced by Marquand Books, Inc., Seattle
Printed by CS Graphics Pte., Ltd., Singapore

Front cover: Jacob Lawrence, *Genesis Creation Sermon VI: And God Created All the Beasts of the Earth* (pl. 56)
Back cover: Robert Scott Duncanson, *Man Fishing* (pl. 30)
Frontispiece: Romare Bearden, *The Black Man in the Making of America* (pl. 10)
Page 6: Charles Ethan Porter, *Lilacs* (pl. 69)

To my wife, Linda, with immeasurable love and appreciation

—WALTER O. EVANS

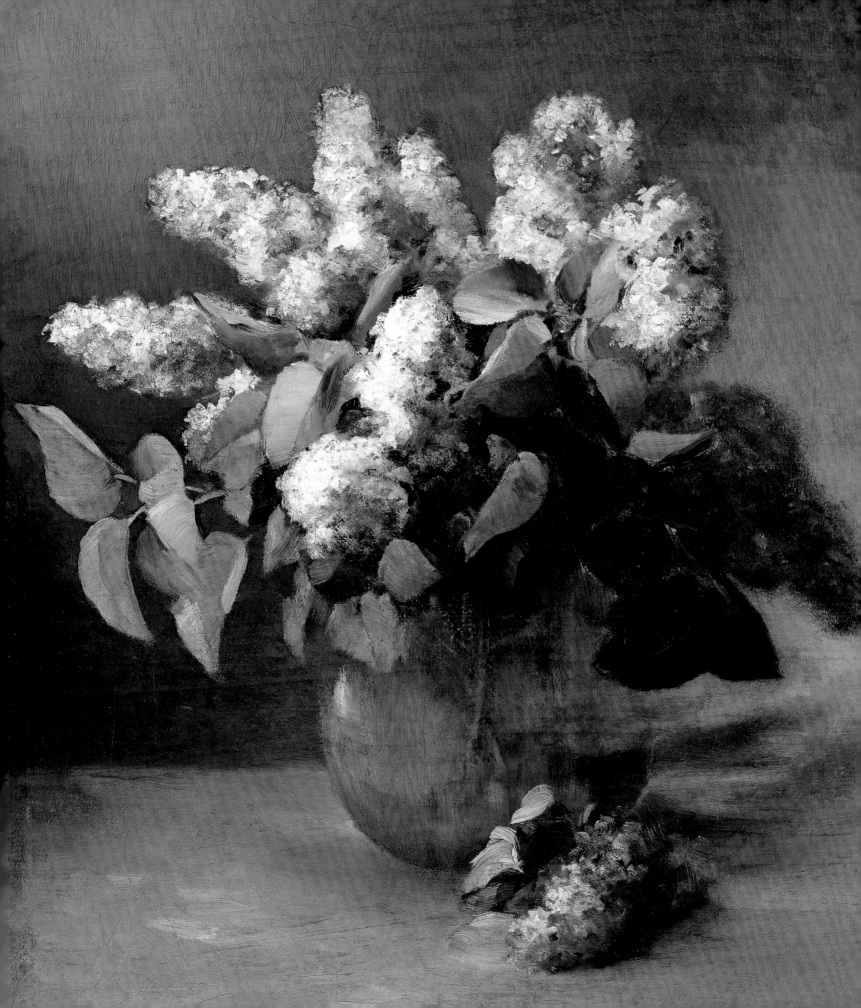

Contents

Foreword

Andrea D. Barnwell

The Walter O. Evans Collection of African American Art, an impressive accumulation of paintings, photographs, sculpture, and works on paper, includes more than two hundred works by acclaimed artists such as Romare Bearden, Elizabeth Catlett, Aaron Douglas, Robert Scott Duncanson, Richard Hunt, Mary Edmonia Lewis, Jacob Lawrence, and Charles White. For nearly a decade Linda Evans, Dr. Evans's wife, has coordinated a traveling exhibition that currently features more than seventy works from the Evans Collection. Dr. and Mrs. Evans's dedication to sharing works from their private collection with the public for such an extended period of time is profound and unprecedented.

The Evans Collection comprises an array of works spanning from 1848 to 1997, from landscapes to modern paintings and sculptures. It is beneficial to discuss this significant corpus of works as a chronological survey of African American fine art traditions. This collection catalogue, however, focuses on the art historical significance of many individual objects. Works such as *Florida* (pl. 72), *#2 Mask* (pl. 43), *Homage to Black Women Poets* (pl. 21), and *Etude in Blue* (pl. 73) by Henry Ossawa Tanner, Sargent Claude Johnson, Elizabeth Catlett, and Alma Thomas, respectively, have extensive exhibition histories and were included in traveling retrospective shows organized by various institutions. Others were featured in important early African American exhibitions. *The Plotters* (pl. 65), by Archibald J. Motley, Jr., for example, was included in *Exhibition of the Work of 37 Negro Artists* in Fort Huachuca, Arizona, in 1943; *Staircase* (pl. 36) by William A. Harper was included in *Exhibition of the Art of the American Negro in*

Chicago in 1940. Other works, however, have never received critical attention. To help remedy this lapse, the essays that follow focus on several objects not previously discussed in detail. I hope these essays, which examine works purchased within the last five years, will ignite further scholarly research on this substantial collection.

The objects selected for this publication represent a significant cross section of the Evans Collection. Most of the works in the traveling exhibition are included, as are several others not currently touring, such as *The Block II* (pl. 11) by Romare Bearden, *Seated Figure* (pl. 1) by Charles Alston, and *Ices II* (pl. 48) by Jacob Lawrence. The book also highlights works the Evanses generously lend to the Art in Embassies Programs of the United States Department of State and those housed in the mayor's mansion in Detroit, Michigan; examples are *Lament for a Bullfighter (Inspired by Garcia Lorca)* (pl. 8) by Bearden and *Cupid Caught* (pl. 63) by Mary Edmonia Lewis. By exhibiting selected works and publishing catalogues on their collection, Dr. and Mrs. Evans demonstrate their commitment to ensuring that many people in the United States and abroad have access to African American art and culture.

Throughout the writing of this catalogue, several supportive individuals have kindly offered their assistance. First I thank my parents, Col. (Ret.) and Mrs. Isaiah E. Barnwell, Jr., my brother Isaiah E. Barnwell III, and my sister Jennifer E. Barnwell, who continually act as sounding boards. I also thank my colleagues in the Department of Twentieth-Century Painting and Sculpture at the Art Institute of Chicago, especially Stephanie D'Alessandro,

Okwui Enwezor, Daniel Schulman, and Stephanie Skestos for their critical insights and expertise. My gratitude goes to Susan Rossen, Director of Publications at the Art Institute of Chicago, for her advice and interest. I am also grateful to Tyronne Baines, Debbie Copeland, Lynn B. Evans, Gretchen Givens Generett, Kelly Gray, Deidre Hall, John Owusu, Richard J. Powell, Maranda Randolph, Howard W. Sterling, C. T. Woods-Powell, and Anne M. Young, whose advice I have appreciated from the initial stages of the project. I would also like to thank the editor, Patricia Draher, and Susan Kelly, Ed Marquand, and Marie Weiler of Marquand Books for their assistance, time, and professionalism.

I am especially fortunate to have worked with stellar colleagues on this publication. I thank Tritobia Hayes Benjamin, Associate Dean and Director of the Howard University Gallery of Art, Washington, D.C., for her insightful introductory essay that profiles the scope and historical significance of the Evans Collection. From the beginning I have appreciated her enthusiasm and interest in exploring aspects of the collection with me; her time and scholarship have been invaluable. It has been gratifying to work closely with Kirsten P. Buick. Discussing her research on works by Mary Edmonia Lewis and Nelson A. Primus has been a high point of the project. Amy M. Mooney has written an engaging and praiseworthy essay on paintings by Aaron Douglas and Jacob Lawrence. Her discussion of the roles of written and visual narratives contributes greatly to art historical investigation of the relationship between modernism, narrative series, and folk culture.

My final and most sincere thanks go to Dr. and Mrs. Evans. In 1991 while I was a student at Spelman College, I first viewed the Walter O. Evans Collection of African American Art at the Hammonds House Galleries in Atlanta, Georgia. I eventually had the opportunity to meet Dr. and Mrs. Evans in 1994, when their collection was exhibited at the Ackland Art Museum, University of North Carolina at Chapel Hill. As a graduate student in the Department of Art and Art History at nearby Duke University, I was invited to present a gallery talk on women artists represented in their collection. In preparation, I traveled to Michigan to interview them on the specific subject and ended up spending the day discussing, among many other topics, recent acquisitions, their collection of first-edition books, and their relationships with many African American artists.

Over the last several years, I have been astounded by the Evanses' unyielding dedication to featuring their collection in university museums and galleries. Such a commitment continually encourages the general public, and especially students, to use it as an educational tool and enables educators to integrate African American art and culture into their curricula in meaningful ways. In his statement in this publication, Dr. Evans explains how he became a collector, speaks of his relationships with many artists, and describes the personal satisfaction he gains from collecting African American art and rare books. His words make clear the benefits and significance of investing in culture.

It has been a pleasure to revisit the Evanses' phenomenal collection, and an honor to take such an active role in shaping this collection catalogue, which accompanies their traveling exhibition. During the last few years I have been able to observe how their collection continually evolves. I have seen how, for Dr. and Mrs. Evans, collecting is an integral aspect of building, sharing, and leaving a legacy that is creative, historically significant, visually appealing, and distinctly African American.

Introduction

Investing in the Vitality of American Art

Tritobia Hayes Benjamin

*I get a joy out of tracking the items down, the rarity of it.
I want to own it. That may be selfish, but that's what makes
me a collector—not an investor. . . . I want to invest in my
culture. . . . Culture defines a people and art is a significant
part of that definition, like music and literature.*

—WALTER O. EVANS, 1991

An important collector of African American art, Walter O. Evans has systematically amassed a sizable representation of paintings, sculptures, and other media reflecting himself, and hence his culture. Journeying through the aesthetic complexities of his ancestors, elders, and contemporaries, Evans has embarked on a process of discovery; intellectual curiosity fuels his collecting habits. An eclectic body of work, the collection begins in the mid-nineteenth century with Robert Scott Duncanson's *Man Fishing* of 1848 (pl. 30) and moves through the decades of the twentieth century to Richard Hunt's 1997 work *Instrument of Change (The Diaspora)* (pl. 40). And although there are discernible gaps in representation of individual icons, Evans has approached his collecting with high standards of quality, connoisseurship, and pedigree.

The collection reveals the diverse range and aesthetic progression of artistic voices over the last 150 years, as well as the ideas, stylistic choices, and creative genius of artists of African descent in America. Evans has revealed his preference for a multiplicity of stylistic approaches: figuration, portraiture, studies of domestic and social events, and narrative content central to the lives of black people. Nature is also revered in the traditional landscapes and in meticulous floral arrangements of selected artists.

Beginning his fine art collecting in 1977 or 1978 with the acquisition of Jacob Lawrence's prints of his *John Brown* series, Evans shifted to art of the nineteenth century with the work of Edward Mitchell Bannister, Robert Scott Duncanson, Mary Edmonia Lewis, Charles Ethan Porter, and Henry Ossawa Tanner. His commitment to build an art collection is rooted in his statement above: "I want to invest in my culture." Evans's investment, both financial and personal, is specific to his identity, and is as different from that of other collectors as are fingerprints and personalities. John Elsner and Roger Cardinal noted: "As one becomes conscious of one's self, one becomes a conscious collector of identity, projecting one's being onto the objects one chooses to live with."[1] Selection, then, is a manifestation of self, an expression of one's aesthetic judgment. Regrettably, mainstream Americans have not perceived African Americans as arbiters of culture or the arts. This retarded point of view, fortunately, has been corrected by the multitude of African American collectors who have come to the public's attention over the past few decades. But unbeknownst to this audience, a small coterie of benefactors has supported African American art and artists throughout the greater part of this century.

Historically black colleges and universities (HBCUs) were the primary matrices for the flourishing of black culture, and they played a central role in collecting the works of African American artists. By extension, faculty members on these

campuses supported both established and emerging black artists by purchasing their work. Through soirees, Sunday afternoon forums, exhibitions, lectures, and seminars, they learned of these artists and their careers. By institutional and individual development over the decades, collections quietly began to take shape and, in many instances, formed the foundation of major permanent collections at HBCUs. Other works, exchanged in the venues mentioned above, were given to family members and passed on from one generation to the next.

A network of artist-teachers and artist-administrators supported and critiqued each other. They exchanged paintings, prints, sculptures, and other media, or purchased their respected colleagues' and peers' works directly from them. Although perhaps restricted to immediate circles, this level of collecting and exchange should not be dismissed, for it represents an important cultural network and dedication to establishing and fostering an artistic community. Since the 1920s these individuals amassed significant collections; their activity may not compare with that of some collectors today, but their commitment to black artists confirms their investment in this culture and negates the notion that African Americans are not collectors of fine art. Thus, by building his collection, Walter O. Evans is part of a legacy of African American patrons and collectors who cooperatively invest in our culture.

Born in 1943 in Savannah, Georgia, the youngest of five children of Willie Mae Rakestraw Evans and Fred Benjamin Evans, Walter learned early the importance of acquiring an education and knowledge of his ancestral and cultural heritage. While pursuing his undergraduate education at Howard University and medical studies at Meharry Medical College in Nashville and the University of Michigan, where he graduated in 1972, Evans visited museums and galleries across the United States and eventually abroad. Evans was familiar with art for art's sake, but collecting was not an option for the young physician. This nonchalant position was reversed when a Detroit gallery owner convinced him to purchase the Lawrence prints. Irreversibly proselytized, Evans was now poised to "invest in his culture."

As the eminent black leader W. E. B. Du Bois elegantly opined at the beginning of the twentieth century, the color line is a powerful force in this country, and it permeates every facet of society—including the arts. As Evans frequented galleries and museums of the world, he lamented that he almost never saw any paintings by African Americans; the few that he did come across had no black figures. Driven by this egregious cultural omission, Evans embarked on his mission to champion African American art and artists. Over the last two decades, he has achieved a measure of acclaim as a serious, dedicated devotee of African American art and artists. He has achieved this status by lending works to major exhibitions, organizing traveling exhibitions of the collection, and producing publications for the scholarly community and the general public.

Although not encyclopedic, the Evans Collection offers a unique review of our artistry, documenting the continuity of black visual arts traditions. Let us look more closely at the collection to enjoy the range and scope of its treasures and the keen perception of the collector.

Nineteenth-Century Art and Artists

In antebellum America, society used biblical and scientific justification to preserve the enslavement of blacks and rank them at the lowest level of evolution. Furthermore, white Americans assumed they were unable to produce or appreciate fine art. African Americans who manifested an interest in the fine arts, therefore, found themselves seeking equality on two fronts: as citizens and as artists. In 1853 the famous African American abolitionist Frederick Douglass wrote, "The most telling, the most killing refutation of slavery, is the presentation of an industrious, enterprising, thrifty and intelligent free black population."[2] Art historian and nineteenth-century scholar Juanita Holland surmised that African American artists living in the North shared Douglass's

thought, living their lives and creating their art according to this belief. Holland explained: "Both politically engaged and upwardly mobile, they believed that, 'All eyes are upon us . . . ,' and that the example of their accomplishment would effect 'a sure means of our elevation in society, and to the possession of all our rights as men and citizens.'"[3] Many blacks hoped that Robert Scott Duncanson, Edward Mitchell Bannister, Mary Edmonia Lewis, Charles Ethan Porter, and Henry Ossawa Tanner would, with their art, transcend vicious stereotypes of blacks seen in popular culture—Jim Crow, Zip Coon, mammies, bucks, pickaninnies—and that they would uplift the race, thereby deconstructing these images of black identity. Art historian Sharon F. Patton postulated:

> By mid-century, members of the free African-American middle-class community were also encouraging and promoting the African-American fine artists, who were considered a "credit to the race." Their works were praised in their own time as the very flower of Negro culture. Between 1852 and 1887 the black press and several publications by African-American authors . . . all extolled the achievements of African-American painters, printers, and sculptors as those of exemplary citizens.[4]

Acknowledged by some nineteenth-century critics as the best landscape artist in the West, Robert Scott Duncanson developed an early interest in the fine arts. He was born in 1821 into a family of housepainters, decorators, and carpenters. Both his father and paternal grandfather, a former Virginia slave who learned his skills during bondage, practiced the trades, and the young Duncanson was apprenticed to them. He later taught himself the fine art of painting by studying and copying engravings of European paintings. By 1842 Duncanson had begun to paint abolitionist portraits and landscapes. Then an 1848 commission to depict the first major copper mine in Michigan encouraged his interest in landscape painting. A trip Duncanson took to study the mine initiated a series of summer excursions

from 1848 to 1850 during which he drew the rough terrain and forest of the Upper Peninsula. Among the additional paintings that resulted was *Man Fishing* (pl. 30) with its verdant trees and bright azure skies.[5] The painting features a young man leisurely perched on the riverbank, his left foot teasingly placed in the water and a picnic basket at his side. Large lush trees surround him, and his boat is carefully anchored to his right. This picturesque, idyllic scene forecasts Duncanson's romantic vision of nature.

In the coming years, the artist developed an affinity for the wilderness of America: he created a variety of sublime landscapes and pastoral views that appealed to Americans—white and black. *Flight of the Eagle* (pl. 31), executed in 1856, delivers a narrative in this genre. Against a yellow-streaked, anemic-blue sky, Duncanson placed a single eagle soaring into the distance. The wild, untouched landscape is the dominant theme, and its parts conform to a formula —patchy mountain cliff on the right and deciduous, spiny trees on the left, with mountainous peaks stretching into the distance. But is the titular reference in this wilderness landscape a metaphor for a personal or literary journey? The iconography in *Flight of the Eagle* requires further probing.

A contemporary of Duncanson, Edward Mitchell Bannister, shared his interest in and reverence for the landscape. A moderately successful portrait painter, he received support from middle-class black abolitionists in Boston and Providence, Rhode Island, where he settled in 1869. Welcomed by the growing art community, Bannister also enjoyed the patronage of wealthy white art connoisseurs in the 1870s. He became the first African American artist to receive national recognition by winning an award at the Philadelphia Centennial Exposition of 1876 for his landscape painting *Under the Oaks* (whereabouts unknown). Bannister served as an original board member of the newly formed Rhode Island School of Design. In addition, he was a founder of the Providence Art Club, an organization that grew to include some of the city's most prominent social and business leaders.

Pastoral Landscape, The Old Homestead (pl. 4), and *Landscape* (pl. 5) are characteristic of his work and attest to the range of his skills in interpreting nature. Sharon Patton stated that Bannister's landscapes "depict the supremacy of nature—a kind of universal spiritual harmony in which humankind is unobtrusive and unimportant."[6] Thus, the lush vegetation and pregnant clouds hung in a misty sky are the formal aesthetic issues addressed by Bannister, while the houses and animals that punctuate *The Old Homestead* and *Landscape* are mere footnotes to the splendor of nature.

Mary Edmonia Lewis, the first African American sculptor, male or female, to achieve national and international critical recognition, had a studio two doors away from Bannister's when she resided in Boston between 1863 and 1865. Despite the caliber of her sculpture and the critical acclaim that Lewis received, financial success was not within her reach, and she suffered severe hardships toward the end of her life. Drawing upon the dual heritage she claimed, most of her subjects were American Indians and African Americans. *Cupid Caught* (pl. 63) is an exception. (Although there was an American market for such mythological compositions, she produced only a limited number.) As a neoclassical conceit, Cupid is often represented as a happy child, but Lewis's contorted Cupid departs from the playfulness associated with the subject.

Lewis's pride in her Indian heritage projected her mother's ethnic group, the Chippewa, with dignity. Based on Henry Wadsworth Longfellow's popular narrative poem *The Song of Hiawatha*, the sculptures *The Wooing of Hiawatha* and *The Marriage of Hiawatha* (pls. 61, 62) are at the core of a scholarly debate. *The Wooing of Hiawatha* is of particular art historical significance. In a scintillating essay in this book, "A Way Out of No Way: African American Artists in the Nineteenth Century," art historian and Lewis scholar Kirsten P. Buick discusses her groundbreaking discoveries regarding the identity of the sculpture.

Connecticut painter Charles Ethan Porter has not received the critical attention given to Duncanson, Bannister, and Lewis. Yet his observation of nature, particularly in the form of still life painting, is comparable to their understanding of nature as revealed in landscape painting or images of the human figure. His relative obscurity until recent years, due in part to the obvious factor of racism, perhaps also owes to the fact that his work received little exposure outside the Hartford, Springfield, and Rockville communities, where he lived during the productive years of his life. His *Autumn Landscape* (pl. 68), one of the few compositions in this genre, is similar to the rustic, bucolic, atmospheric rendering of Bannister. On the other hand, *Lilacs* (pl. 69), among numerous still lifes, the genre for which Porter is known, reveals his lively passion for clarity of form and demonstrates his skill in the arrangement of flowers and fruits. These compositions set him apart as an artist of fine sensibilities.

Henry Ossawa Tanner received enthusiastic recognition at home and abroad for his biblical characters and themes infused with spirituality and mysticism. The first African American elected to full membership in the National Academy of Design (New York) in 1927, Tanner offered in his early work a sobering counterbalance to negative images of black Americans. The son of Reverend Benjamin Tucker Tanner, bishop of the African Methodist Episcopal (A.M.E.) Church, the artist conducted church business while attending the A.M.E. conference in Tallahassee, Florida, in February 1894.[7] With its Impressionist tonalities, broadly brushed strokes, and the orange grove seen in sunlight diffused through clouds, *Florida* (pl. 72) clearly reveals Tanner's brief time in Paris; he had studied there from 1891 to 1893 before returning home to recuperate from typhoid fever in the summer of that year. During his travels, the artist found time to paint several landscapes, and in April 1894 he exhibited in Philadelphia works completed in France and the United States.

A student of Tanner, William A. Harper came under the influence of the Barbizon School of landscape painting while in France. *Staircase* (pl. 36) deftly

illustrates the palette and compositional structure of those French artists and the early work of Tanner.

As many of the works in the Evans Collection suggest, African American artists in the nineteenth century viewed their art as a means of achieving social legitimacy and acceptance in American society. They were motivated by a desire to disprove the notion that black artists were culturally bereft. More-over, they strove to be among the best American artists, proving their mastery while simultaneously achieving universal appeal. The Evans Collection reflects this pride and the coming changes in society.

Twentieth Century: The Era of the New

Thousands of African Americans migrated to the North between 1900 and 1920 to escape economic hardship and racism, and to search for human dignity and financial opportunity. The veterans of World War I who had fought "to make the world safe for democracy" were determined to make democracy work at home. From this mass migration, urbanization, and military participation, a dynamic artistic community evolved in which music, litera-ture, theater, dance, and the visual arts blossomed. The excitement of this phenomenon permeated many communities, but New York's Harlem became the center.

The 1920s were referred to as "the era of the new": women's suffrage had produced a new woman; jazz was the new music; Henry Ford produced a new automobile for the working class; and there was a "New Negro." Eager to structure a distinctively dif-ferent canon, artists of this generation rejected land-scapes and still lifes for the figurative, the ancestral homeland, and vernacular culture. African American culture as expressed in dance and jazz counteracted the technology-driven, spiritually empty postwar society.[8] As Brendan Gill observed:

> Black writers, artists, composers, and theater
> performers were thought to be opening the door
> to a promising future—one that could be shared

with a white majority only just beginning to perceive black culture not as a form of failed white culture but as something that had its own complex nature.[9]

Advocating an identifiable racial art style and aesthetic, Alain Locke, the self-proclaimed "philo-sophical mid-wife" of the New Negro movement, was the leading spokesman. The artist Aaron Douglas, called a "pioneer Africanist" by Locke, temporarily abandoned his realistic style, seen in portraits such as *Boy with Toy Plane* (pl. 28), for the quasi–Art Deco style of the 1920s and 1930s. *The Creation, Go Down Death—A Funeral Sermon,* and *The Judgment Day* (pls. 25–27), all done in 1927, display the schematic patterns and flat shapes of this style. In her essay below, "Illustrating the Word: Paintings by Aaron Douglas and Jacob Lawrence," Amy M. Mooney discusses the role of the preacher in the black church, the cultural sig-nificance of religious images inspired by everyday people, and the impact of Douglas's and Lawrence's modern stylized paintings.

Two of Douglas's contemporaries, Richmond Barthé and Sargent Claude Johnson, both sculptors, expressed an interest in African, Caribbean, and African American subjects that reflected the dignified characteristics of their race. Barthé's fascination with dance and the theater is underscored by many com-positions he created during this period. As demon-strated in *Head of a Dancer* (pl. 7), his peers often served as models for portrait busts and freestand-ing figures that embrace a naturalistic stylization. Johnson, in contrast, seeking a racial archetype in his treatment of African American portraits, drew in-spiration from the African sculptural idiom. *#2 Mask* (pl. 43) differs from Barthé's "mask" in that it is a composite of modernist ideas and forms: the face is dissected and reorganized based on geometric planes and shapes. It represents a heightened emphasis on the black vernacular in the arts, which in the works of some artists continued after the demise of the New Negro Movement.

The impact of the stock market crash of 1929

and the subsequent economic crisis marked a major turning point in the development of African American artists. Through the creation of the Works Progress (later Projects) Administration (WPA), President Franklin Delano Roosevelt allowed all artists, black and white, to be employed by the government during this national state of emergency. Although American themes were recommended as a focal point, artists could create images without literal directives as to content.[10] Many of the artists in the Evans Collection were hired by the WPA or had some affiliation with a workshop or recreation center sponsored by the agency. These centers, located in New York, Chicago, Philadelphia, and Cleveland, to cite a few cities, were organized into easel, mural, sculpture, and graphic arts divisions.

The Evans Collection provides a view of these WPA artists and the narratives they created. Chicago was a fertile environment for Charles White, Archibald J. Motley, Jr., Eldzier Cortor, Charles Sebree, and Margaret Burroughs—all represented in the collection. Employed by the Illinois mural division, White drew upon the Mexican muralists for inspiration, reference, and technique in creating *Five Great American Negroes*, 1939–40 (also known as *Progress of the American Negro*), in the collection of the Howard University Gallery of Art.[11] White's drawings in the Evans Collection entitled *Frederick Douglass* and *Sojourner Truth* (pls. 78, 79) are cartoons for the nearly 5-by-13-foot mural. In the finished painting, Douglass as an orator and Truth as a leader of the masses (as well as educators Booker T. Washington and George Washington Carver and opera singer Marian Anderson) are represented on a heroic scale with the fervor and monumentality associated with White's figurative style. As Andrea D. Barnwell explains below in her reinterpretation of the historic mural, "Sojourner Truth or Harriet Tubman? Charles White's Depiction of an American Heroine," the drawings in the Evans Collection are significant works in the artist's oeuvre.

Through the Federal Art Project, under the WPA, printmaking as a medium in American art was elevated to a new importance. The Federal Art Project's graphics division led to the establishment of printmaking workshops across the country. Artists such as James Lesesne Wells and Dox Thrash refined their techniques in lithography, serigraphy, and etching. Thrash, who served as head of the graphics division in Philadelphia, invented the Carborundum printmaking technique, as seen in *Miss X* (pl. 75).

A young teenager during the years of the WPA, Jacob Lawrence was one of the more promising students at the Harlem Art Workshop and the Harlem Community Art Center. In the company of mature artists such as Charles Alston, Augusta Savage, and Henry Bannarn, Lawrence developed a reductive signature style that combined elements of folk and naive painting.[12] Using brilliant primary colors, simple shapes, and expressive figures, Lawrence over the decades has created important historical and episodic compositions that document African American life, history, and culture. Well represented in the Evans Collection, Lawrence's artistic narrative series range from *John Brown* and the *Genesis Creation Sermon* (pls. 51–58) to single compositions such as *The Card Game* (pl. 47), *Ices II* (pl. 48), *Wounded Man* (pl. 49), and, more recently, *Library Series: The Schomburg* (pl. 50).

As Evans continued to collect, he became acquainted with the artists themselves. In 1978 he met Romare Bearden at an art reception and acquired *The Magic Garden* (pl. 12) from the artist. Later, Evans introduced Bearden to Detroit art circles; they remained friends throughout the artist's life. As Evans acquired paintings, watercolors, and collages executed between the 1940s and 1980s by Bearden, he learned invaluable lessons from the artist about color and the figure, and about the intrinsic value of art.

Evans recalls getting to know other artists:

> After meeting Bearden, I went headstrong. I met Elizabeth Catlett and gave a reception for her the very next year. I bought a couple of her works. Shortly thereafter, I telephoned Jacob Lawrence and wrote him letters. He had been very friendly. So I took my daughters to Seattle to meet Jacob Lawrence.[13]

Lawrence's and Bearden's works enrich the collection exponentially. Elizabeth Catlett's *Pensive* and *Homage to Black Women Poets* (pls. 20, 21) articulate the status of women in society, a subject that dominates the discourse and concerns of her oeuvre.

Evans found that Richard Hunt, the world-renowned Chicago sculptor, was just as accessible as Bearden, Lawrence, and Catlett. *Model for Middle Passage Monument* (pl. 39), commissioned in 1985 to commemorate the millions of lives lost in the trans-Atlantic slave-trade crossings, brought Evans and Hunt closer as they discussed issues surrounding the project: Hunt relayed that they "embarked on some kind of voyage [themselves]."[14] This work and *Wall Piece with Hanging Form* (pl. 37) are poignant reminders of African Americans' social and political history in America.

In its scope and depth, the Walter O. Evans Collection of African American Art is at once daunting and inspirational. It inspires those of us in the African American community to continue our collecting efforts, however small or ambitious. The works in this collection reaffirm the cultural contributions of African Americans to American art history and culture, and, as Evans remarked, "show that black people were and are very skilled artists, comparable to the best of the best."[15]

NOTES

1. John Elsner and Roger Cardinal, eds., introduction to *The Culture of Collecting* (Cambridge: Harvard University Press, 1994), p. 3.

2. Quoted in Juanita Marie Holland, "To Be Free, Gifted, and Black: African American Artist Edward Mitchell Bannister," *The International Review of African American Art* 12, no. 1 (1995), p. 5.

3. Ibid.

4. Sharon F. Patton, *African-American Art* (New York: Oxford University Press, 1998), p. 71.

5. Joseph Ketner, *The Emergence of the African American Artist, Robert S. Duncanson 1821–1872* (Columbia: University of Missouri Press, 1993), p. 28.

6. Patton, *African-American Art*, p. 89.

7. Darrel Sewell, in Dewey F. Mosby and Darrel Sewell, *Henry Ossawa Tanner* (Philadelphia: Philadelphia Museum of Art, 1991), cat. no. 30, p. 126.

8. Patton, *African-American Art*, p. 111.

9. Brendan Gill, "On Astor Row," *The New Yorker* (Nov. 2, 1992), p. 52; cited in ibid.

10. See Francis V. O'Connor, ed., *Art for the Millions: Essays from the 1930s by Artists and Administrators of the WPA Federal Art Project* (Greenwich, Conn.: New York Graphic Society, 1973), for a collection of essays written by artists and administrators subsidized by the WPA.

11. *Five Great American Negroes* was allocated to the Howard University Gallery of Art in 1947 by the state of Arizona. Because of its size, the work was never displayed or exhibited but remained in storage, rolled on a drum for decades. The mural was briefly exhibited in a class environment at the Maryland Institute, College of Art, Baltimore, from February 1 to March 31, 1995. In 1996, under the auspices of the two-part exhibition project *To Conserve a Legacy: American Art from Historically Black Colleges and Universities*, it was selected by the curatorial team for restoration and exhibition. The mural has been completely restored and placed on a stretcher, and was the focus of an exhibition at the Clark Art Institute, Williamstown, Massachusetts, October 3, 1998, to January 3, 1999.

It began touring in the exhibition *To Conserve a Legacy* in March 1999 at the Studio Museum in Harlem and will travel through July 2001 to Andover, Massachusetts; Washington, D.C.; Chicago, Illinois; Atlanta, Georgia; Durham, North Carolina; Nashville, Tennessee; and Hampton, Virginia. The exhibition includes work from six HBCUs including Howard University, Hampton University, Clark Atlanta University, Fisk University, Tuskegee University, and North Carolina Central University.

12. Samella Lewis and Mary Jane Hewitt, *Jacob Lawrence, Paintings and Drawings* (Claremont, Calif.: Scripps College of The Claremont Colleges, n.d.), pp. 9–10.

13. Walter O. Evans, foreword to *Walter O. Evans Collection of African American Art* (Savannah, Ga.: King-Tisdell Museum, 1991), p. 10.

14. Quoted in Shirley Woodson, "The Middle Passage: Matrix and Memory, the Art of Richard Hunt," in ibid., p. 32.

15. Quoted in Sharon F. Patton, "A History of Collecting African American Art," *Narratives of African American Art and Identity: The David C. Driskell Collection* (College Park, Md.: The Art Gallery and Department of Art History and Archaeology, University of Maryland; San Francisco: Pomegranate Press, 1998), p. 53.

Reflections on Collecting

Walter O. Evans

Growing up in Savannah, Georgia, and Beaufort, South Carolina, did not afford me the opportunity to visit museums and galleries. Blacks simply were not allowed in these so-called public facilities. I did, however, learn about African American writers, educators, and activists in the all-black elementary schools that I attended. I read about Langston Hughes, Paul Laurence Dunbar, Mary McLeod Bethune, Paul Robeson, Frederick Douglass, Booker T. Washington, Henry Ossawa Tanner, and many others. My family also taught me about these historical figures. When I was a teenager, my family moved to Hartford, Connecticut, where all of my teachers and most of my schoolmates were white. People of African descent were not mentioned in history classes. With the exception of a paragraph in the American history textbook, which made the absurd claim that slaves were happy-go-lucky and content, blacks were simply omitted. Although the Wadsworth Atheneum was probably open to blacks, at that time I had no interest in art museums, nor was I encouraged to visit them.

After high school I entered the U.S. Navy. During the latter half of my three-year enlistment, I was stationed at the Naval Hospital in Philadelphia. A friend urged me to visit the many museums of that city, such as the Philadelphia Museum of Art, Pennsylvania Academy of the Arts, and Rodin Museum. My budding interest also compelled me to see collections at major museums in New York and Washington, D.C. During this time I began to read about European and European American artists featured in those museums. However, I never saw art by African Americans in these collections. While I lived in Philadelphia, I discovered my love for books, mainly classics by European and European Americans but also the writing of African Americans such as Richard Wright, Ralph Ellison, and James Baldwin.

In 1964 I entered Howard University in Washington, D.C. While living in the nation's capital, I enhanced my education by visiting the National Gallery of Art and the Phillips Collection. Lectures by black speakers who came to campus, such as Stokely Carmichael, H. "Rap" Brown, Ron Karenga, Amiri Baraka (then known as LeRoi Jones), Martin Luther King, Jr., and Adam Clayton Powell, Jr., further enriched my experiences and cultural awareness. I was mesmerized by the poetry readings of Sterling Brown, then a professor at Howard, though I did not hear him lecture until spring of 1969 when I returned to campus for a black awareness symposium. He would later become a close friend and confidant. While enrolled at Howard, I purchased a portrait of Malcolm X by Jan Horne, an unknown artist. I bought it because Malcolm X was such an important political figure in my life, but at that time I had no thoughts of assembling a collection.

Collecting books and art began quite effortlessly for me. Amy Jacques Garvey, the widow of Marcus Garvey, the Jamaican leader of the Universal Negro Improvement Association, gave me an autographed first edition of her book *Garvey and Garveyism*. Having just completed my medical studies, I was enrolled in a clerkship program at the medical school of the University of the West Indies in Kingston, Jamaica, and had to pass Mrs. Garvey's house at

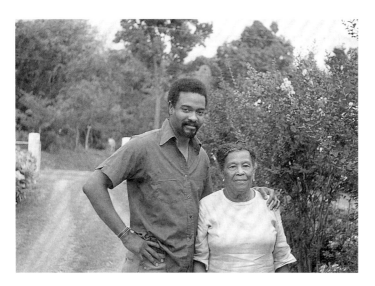

Fig. 1. Walter O. Evans and Amy Jacques Garvey, Kingston, Jamaica, 1972. Photo: John Hall.

12 Mona Road every day on the way to the university. One day she saw me taking pictures of her house and signaled for me to come in. We had an interesting conversation, and after I left Jamaica, we remained in touch until she died a short time later. She was the first of many luminaries I would get to know (fig. 1).

After completing my four-year residency at Wayne State University–affiliated hospitals in Detroit, I met Shirley Woodson Reid, a Detroit artist, educator, and director of the now-closed Pyramid Gallery. Upon her recommendation, in 1977 or 1978 I purchased *The Legend of John Brown*, a portfolio of twenty-two silkscreen prints by Jacob Lawrence based on his *John Brown* series accompanied by a specially commissioned poem by Robert Hayden. Although I had made my first acquisition of fine art, the idea of building a collection still never entered my mind.

Shortly after that purchase, I met Romare Bearden at the home of a colleague, Dr. Beny J. Primm, in New York. Primm was hosting a benefit party for the dance company of Nanette Bearden, the artist's wife. There I purchased the painting *The Magic Garden* (pl. 12). At the same time, through June Kelly, Bearden's agent, I made arrangements to host a similar benefit at my home in Detroit in December 1979. The event was a huge success, and I bought two

more of Bearden's works: *Sunrise* and *Reclining Nude* (pls. 13, 14). Shortly thereafter, I hosted a reception for Elizabeth Catlett in conjunction with her solo exhibition at the Pyramid Gallery, and I acquired her works *Pensive* (pl. 20) and *Head of a Nigerian*.

In June 1981 I consciously began collecting art. I took my twin daughters, Malika and Maisha, to Seattle, Washington, to meet Jacob Lawrence and his wife, artist Gwendolyn Knight Lawrence. About that time I acquired *The Card Game* (pl. 47). Into the late 1980s I collected a succession of paintings, sculptures, works on paper, books, manuscripts, and letters by African Americans. As I became interested in the art and history of Haitian people, I also purchased several works by artists from Haiti.

Some may contend that I made these acquisitions too quickly. I now recognize that in the early stages I bought works by lesser-known artists as well as several works with questionable provenances. A painful topic to discuss at first, I learned from Richard Manoogian, one of America's foremost collectors, that encountering fraudulent art is a common occurrence for avid collectors. The experience can be beneficial, albeit expensive, if we learn from it. For example, I recently agreed to purchase two works by Horace Pippin from a very reputable New York art dealer. After looking at the paintings, however, I instinctively realized that something was not quite right with one. I sent a transparency of the painting in question to my good friend Selden Rodman, an expert on Pippin. He immediately contacted me and cited numerous reasons why he thought the painting was not authentic. Earlier in my collecting career, I would not have gone to such lengths and would most likely have purchased the work based solely on the reputation of the dealer. As a result of my persistence, the dealer eventually withdrew the painting from the market. Early lessons inform my current approach to collecting. In light of the present competitive market, I am now pleased to have acquired a substantial number of works when I did.

No one person taught me how to collect art, although attending David C. Driskell's lectures was a

major influence on my collecting. I learned strategies from some dealers, most notably June Kelly, but proceeded primarily by trial and error and "on-the-job training." I did not always listen when I was advised to buy a significant work of art. For example, after visiting a gallery in New York, Shirley Woodson Reid suggested I purchase a painting by Joshua Johnson, a free black artist who worked from the late eighteenth to the early nineteenth century. In the first stage of my collecting, in the late 1970s and early 1980s, I would consider only works with black subjects. My tastes therefore precluded me from buying pieces by pre-twentieth-century African American artists, as they painted primarily landscapes and portraits of wealthy or middle-class whites. A few years later, when I wanted to acquire Johnson's paintings, they were priced far above my budget. Now they are out of my range, as are many works by Horace Pippin.

Collectors of African American art starting out today have advantages not readily available to me when I began. There were no models upon which to base my collecting practice. Curators at major museums and gallery owners were largely uninterested in works by African Americans. Scholarly research in the field was in its elementary stages. In addition, very few private collectors cared for the subject, and there were no art fairs and very few symposia. The failure of the news media to hire African American art critics or, at the very least, those knowledgeable about this type of art compounded the problem.

The lack of knowledge about African American art became evident to me when a *Cleveland Plain Dealer* art critic reviewed an exhibition of my collection at the Canton Art Institute in Ohio on January 19, 1994. He stated that "the collection is too small to be considered truly comprehensive." In addition, he erroneously called Jacob Lawrence's gouache painting entitled *Library Series: The Schomburg* (pl. 50) "a hopeful, upbeat color *print* of children in the library of a New York public *school*" (emphasis added). The reviewer claimed that the exhibition "lingers too long" on nineteenth-century "bucolic rural landscapes." He declared it did not include enough modern abstracts,

and that *Florida* by Henry Ossawa Tanner (pl. 72) "is not one of the artist's more significant works."

Aside from the fact that this art critic mistakenly identified a work that was clearly gouache on paper as a print, he also failed to realize that *Florida* is one of Tanner's important paintings. A 1991 *Art in America* article on the nationally touring exhibition *Henry Ossawa Tanner* reproduced the painting and described it as representative of the artist's work. The critic's uninformed response to the Canton exhibition underscored the fact that more critical and inclusive research was necessary in the field of American art.

My introduction to collecting printed works (books, manuscripts, letters, documents) was quite another story. I sought out the several dealers (mostly white) who specialized in black material. McBlain's, formerly in Des Moines, Iowa, but now based in Connecticut, was one of the most prominent. In the beginning, I simply wanted first editions, autographed if possible. I paid little attention to the condition of the book and did not realize the value of having a dust jacket.

These lessons and others came to me quite accidentally. In February 1983 a fellow passenger in the elevator at the Strand Book Shop in New York asked if I had found everything I wanted. The conversation continued, and he invited me to his salon: a shop with some of the world's finest and rarest books. Over the next ten years or so, this gentleman, Glen Horowitz, taught me the fine art of collecting books and printed material. Although he did not specialize in books by African Americans, he knew how to judge high-quality works and taught me to pay attention to the condition of the book and dust jacket. He also advised me to acquire books with great associations. One book I bought early in my collecting career was *A Pictorial History of the Negro in America* inscribed to Duke Ellington by the authors, Langston Hughes and Milton Meltzer. I have since collected hundreds of first editions with wonderfully significant associations. Among the materials in my collection is a large group of books, pamphlets, letters, and other written material relating to the

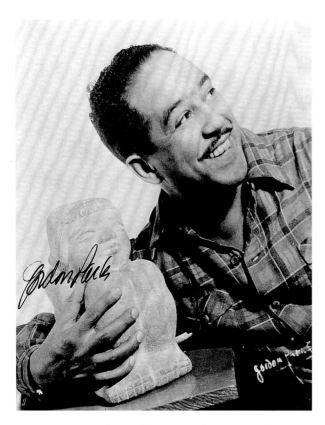

Fig. 2. Langston Hughes with *Figure Sitting*, by Marion Perkins, 1948. Photo: Gordon Parks; Walter O. Evans Collection.

great abolitionist Frederick Douglass. I also own letters written by the Haitian liberator Toussaint L'Ouverture and a valuable letter to L'Ouverture from Napoleon Bonaparte I dated 1801.

Collecting has given me many satisfying moments. I own *The Negro Speaks of Rivers* by Aaron Douglas (pl. 29), a painting Douglas gave to Langston Hughes in 1941 and named for the author's most famous poem. In 1986, a few years after acquiring the painting, I came across a passage in *The Life of Langston Hughes*, by Arnold Rampersad and learned that Hughes had the image reproduced on postcards, which he sent to his friends and acquaintances. I immediately knew I had to have some of these cards. Within a year I located and purchased several.

Another episode was particularly satisfying. When I acquired the Marion Perkins sculpture *Figure Sitting* (pl. 66) from Margaret Burroughs in

the mid-1980s, she told me there was a famous photograph of Langston Hughes cradling it. Years later I bought a collection of publicity photographs of musicians, writers, athletes, and other renowned people from a private owner. Among the shots was the original photograph that Burroughs had mentioned (fig. 2). I was excited to discover it had been taken by Gordon Parks, the acclaimed African American photographer, for the dust jacket of *One Way Ticket*, Hughes's 1936 book of poetry illustrated by Jacob Lawrence. I later showed the photograph to Parks, who obligingly signed it a second time.

Still another collecting experience worth noting began in November 1983. Romy, as Romare Bearden was affectionately known, met me at the Cordier Ekstrom Gallery in New York, where I considered purchasing a large watercolor by him, *The Piano Lesson*. I asked my good friend Les Payne to go see it and give me his valued opinion. He reported back to me: "Don't buy it. It's too flat"—whatever that meant. I took his advice and did not buy the painting. Then in 1990 August Wilson's play *The Piano Lesson* won a Pulitzer Prize. The painting I had once considered buying was reproduced on playbills, posters, and other promotional material for the play. Much later, while visiting New York in 1994, I went to visit Nanette Bearden, the artist's widow. When I told her the story of the missed opportunity, she replied, "Well, you can redeem yourself. I have a very similar collage with the same title, and in my opinion, it's a much better work" (pl. 17 and p. 23). Suffice it to say, I did not let the opportunity elude me a second time.

Collecting has not only been rewarding for the anecdotes and stories affiliated with objects but also for the encounters with people. I have met and become friends with Margaret Walker Alexander, Romare Bearden, Gwendolyn Brooks, Sterling Brown, Elizabeth Catlett, John Henrik Clarke, Leon Forrest, Ollie Harrington, Richard Hunt, Jacob Lawrence, Selden Rodman, and so many others. Believing it important to expose as many people as possible to the legacies of these artists and writers, I invited them to present lectures in Detroit at Wayne State University

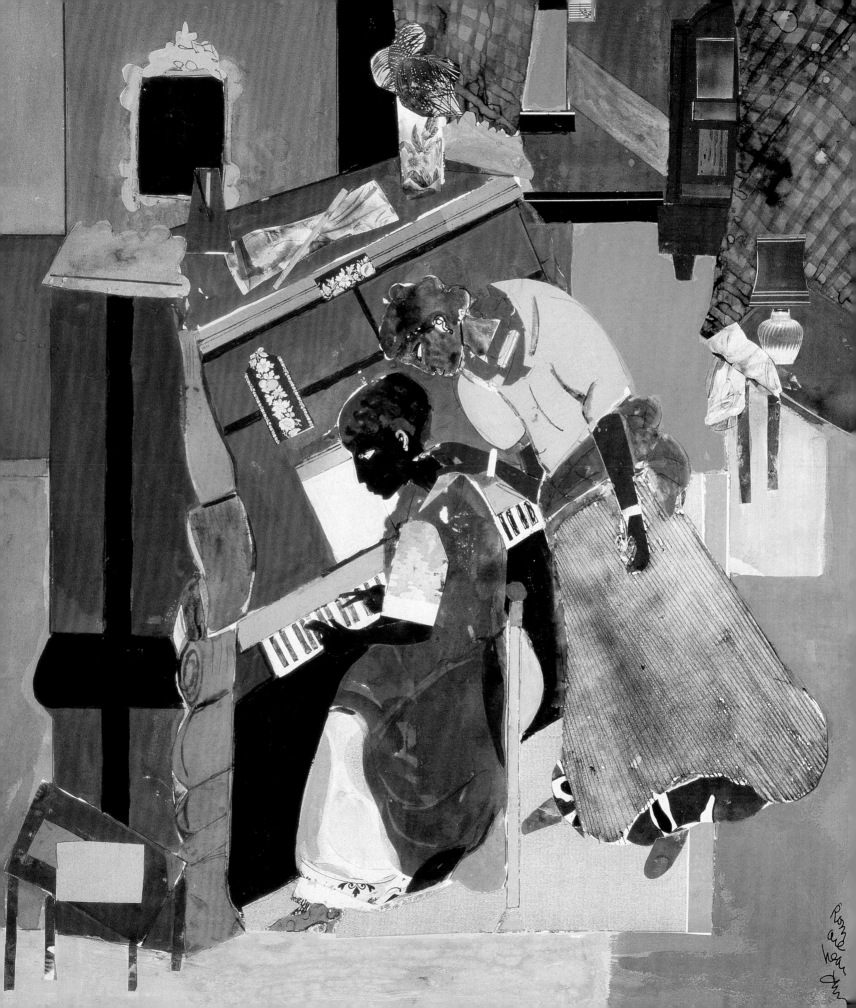

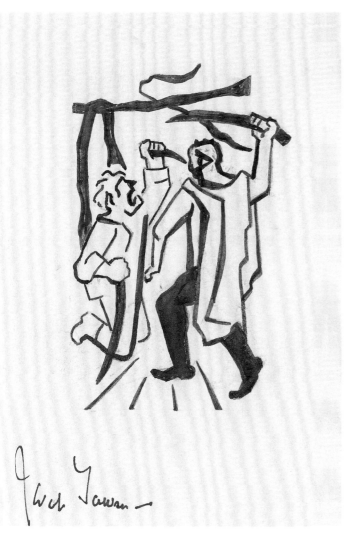

Fig. 3. Jacob Lawrence, *Cinqué Aboard the Amistad,* frontispiece of John Henrik Clarke, "The Middle Passage: Our Holocaust," 1992.

I know of numerous collectors who are reluctant to lend their works of art for fear of damage. I have taken the position that such a possibility is a small price to pay for the joy I obtain from sharing African American art with others. This need to share brought about the traveling exhibition that Linda has coordinated since February 1991. In addition, we lend works to embassies around the world through the Art in Embassies Program of the United States Department of State. We have also shown individual pieces in various exhibitions.

My collections are by no means complete. My wish list includes paintings by William H. Johnson and Joshua Johnson and additional works by Pippin and Tanner. As for books, I am still searching for *Appeal . . . to the Colored Citizens of the World . . .,* by David Walker, and a book of poetry entitled *Les Cenelles,* edited by Armand Lanusse. I would love to own a first edition of *Their Eyes Were Watching God,* by Zora Neale Hurston, inscribed to Langston Hughes. The search for such important examples of written and visual culture by and about African Americans will always be compelling to me.

Of the many pathways collecting has opened up for me, none has been more satisfying than serving on the boards of the Margaret Walker Alexander Research Center, a historical archive at Jackson State University, Mississippi, and the Jacob Lawrence Catalogue Raisonné Project. The catalogue raisonné project was established to document and publish the artist's entire oeuvre in a reference book (print and electronic formats) for scholars and the general public. Allowing my collection to travel to museums and galleries throughout the country for nearly ten years has also been extremely rewarding. In 1991 Mr. W. W. Law, founder of Savannah's Beach Institute, the King-Tisdell Cottage, and the Civil Rights Museum of Savannah, encouraged me to create a traveling exhibition. Because of his initial suggestion, advice, and foresight, I have enjoyed an especially fulfilling pastime and observed and participated as the nation has become increasingly interested in the fascinating, yet underresearched, topic of African American

or the University of Michigan-Dearborn; I published some of their speeches and commissioned artists to illustrate the frontispieces (fig. 3). Over the years I have also enjoyed the acquaintance of curators, dealers, and scholars. Because of our interest in African American art, my wife, Linda, and I were invited to the White House for the unveiling of Henry O. Tanner's *Sand Dunes at Sunset, Atlantic City* in October 1996. We congratulated President and Mrs. Clinton for being the first White House occupants to recognize the value of African American artists by hanging this noteworthy painting on permanent display.

art. My family has been extremely supportive of all aspects of my collecting efforts. I am especially indebted to my brother Louis "Benny" Evans who from the very beginning has been integrally involved in the traveling exhibition.

Collecting is an extremely dynamic process. It has taken on a life of its own as new information and objects are uncovered, discovered, and acquired. My collection looks dramatically different than it did a decade ago. This catalogue reflects the growth, change, and refinement of my acquisitions. I am especially grateful to Andrea D. Barnwell, who has conducted extensive research on my collection and selected a team of scholars who have dedicated a significant amount of their time to the project. I extend my sincere thanks to Tritobia Hayes Benjamin, whose introduction provides a history of the collection. I would also like to thank Kirsten P. Buick and Amy M. Mooney, who discuss the works in the collection with critical insight. As long as I am a collector, I will always have new things to learn; collecting adds a dimension of growth to my life. These four scholars and their knowledge of African American art are significant aspects of this exciting learning process.

I hope that in some small way my collecting will encourage others to do the same, and to recognize the importance of preserving our cultural heritage, providing a legacy for those who come after us. To that end, my wife and I have established the Walter O. Evans Foundation for Art and Literature as a means of keeping the collection intact and ensuring that appreciation for and education about African American art and literature will be perpetuated.

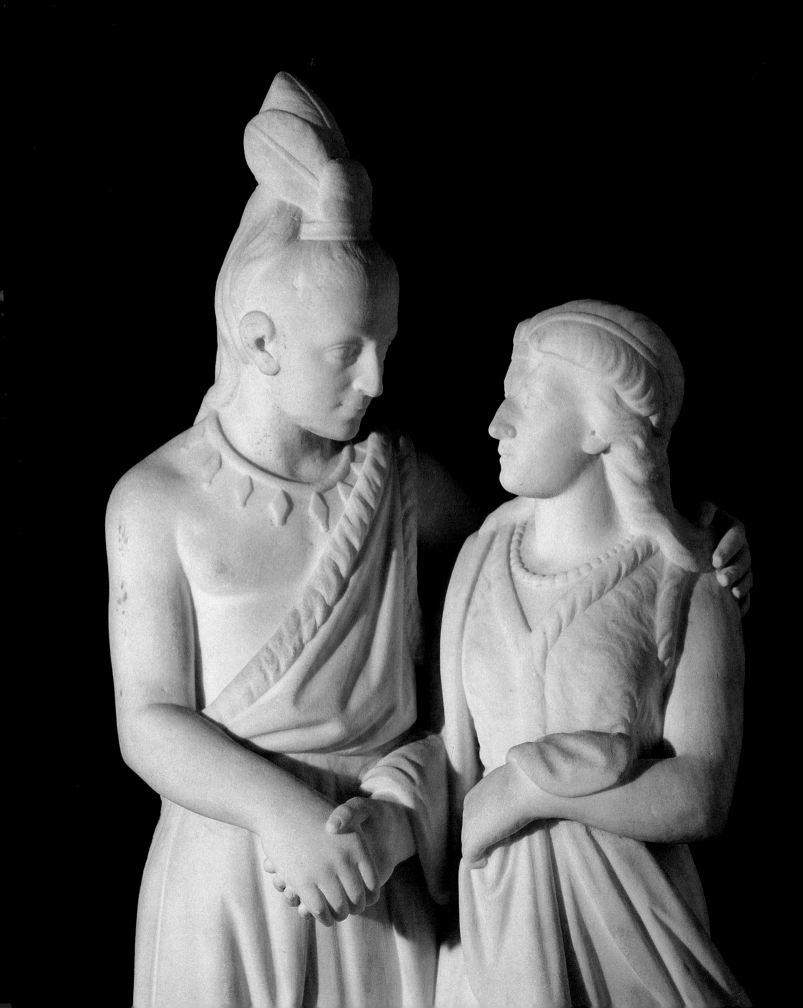

A Way Out of No Way

African American Artists in the Nineteenth Century

Kirsten P. Buick

What we did know was that a rooted forest was the opposite landscape to a place of drifting sand, of exposed rock and red dirt blown by the winds. The Diaspora was sand. So what should Israel be, if not a forest, fixed and tall?

—SIMON SCHAMA

The words of Simon Schama speak not only to the experiences of Jews in the Diaspora, but also to all people seeking a place.[1] In the nineteenth century, African Americans began to search for their own "rooted forest." Slavery stripped Africans of their homelands, and of their memories of home as well. Forced relocation and forced amnesia, inculcated by the system of oppression, necessitated the search to establish themselves as full citizens in their adopted land. Full participation in American life also meant participation in and acknowledgment of their place in the arts. Using the Walter O. Evans Collection of African American Art as an invaluable cross section of African American creativity, in this essay I explore the relationship between artist and region or place. I will examine the landscapes of Robert Scott Duncanson, Edward Mitchell Bannister, and Charles Ethan Porter. Best known for his floral studies, Porter is represented in the collection by a still life and a landscape. Other artists traveled beyond the expected thematic and geographic boundaries. The Evans Collection contains significant paintings by Henry Ossawa Tanner, who visited Florida, and by Nelson A. Primus, who found inspiration in San Francisco's Chinatown. One can also find the roots of modernism represented in the collection in a painting by William A. Harper. Finally, the metaphor of place can be extended to the nineteenth-century

sculptor Mary Edmonia Lewis, who located herself firmly in the popular culture of the nineteenth century. Although they were free, systemic racism and socioeconomic oppression significantly affected these artists. Their art is evidence that they surmounted enormous obstacles. Their creativity reinvigorates the vernacular idiom—the strategy of making a way out of no way.

Etymologically, we trace the English term *landscape* through three words: two are the Old English *landscipe* (region) and the Dutch *landschap* (shaped land), introduced into the English language at the beginning of the seventeenth century as a genre of painting. The third term, connected to the Latin root for *country*, is *(terra) contra*, or land spread out opposite or facing the viewer. "All three ways of shaping the land," according to Elizabeth Helsinger, "assert, though often in order to disavow, an understanding of possession that conveys the right to shape the appearance of the land and control its uses."[2] The artist who selects, frames, and then represents the land owns it. When spectators view the artist's representation, they assume the viewing place of the artist as master of the land, and when the work is purchased, they vicariously own and control the land themselves. The meaning of *landscape*, however, can signify more than a representation or shaping of the outdoors. According to Arnold Alanen, "Perhaps we should not be too concerned when landscape is adopted as metaphor, as long as such usage helps us to comprehend what J. B. Jackson calls 'a concrete, three-dimensional shared reality.'" Writing specifically about immigrants and image makers in the Lake Superior

region between 1865 and 1930, Alanen further noted that "continued attention should be given to the development of a better and more inclusive definition of landscape, one that considers physical settings, social behavior and meaning."[3] As many of the works in the Evans Collection suggest, landscape can also be a state of mind.

Creating a Sense of Place: Robert S. Duncanson, Edward M. Bannister, and Charles E. Porter

When Robert Scott Duncanson and Edward Mitchell Bannister stood as observers of the land, they left a record of their response to the great and small dramas of nature. As artists intimately involved in the process of selection and representation, they shaped the land with their brushes. Like other artists of their time, such as Thomas Cole and Frederic Edwin Church, they beheld the land as Americans. Unlike Cole and Church, however, they were not accepted as full citizens.[4] Landscape is an unusual subject for the disenfranchised. Unable to vote or hold property after marriage, few women painted landscapes in the nineteenth century. Furthermore, no women have achieved sufficient recognition to place them in surveys treating the relation between American landscape and nation. Acquiring land was an overwhelmingly male concern. Controlling the land was an integral part of the formation of a white male identity, which itself became synonymous with America. An identity that would suffer no challenge to its authority, it galvanized the official government policy that called for radical extermination of the original occupants of the land. American art, too, had a crucial role to play. For European Americans the United States lacked the physical evidence of other great (European) civilizations—no ruins, monuments, or cohesive traditions—but it had land in abundance. During the nineteenth century, the land was associated with an intense nationalism, and landscape painting gave Americans a visible sense of place around which to cohere.[5]

African American artists also affirmed their connection to the land by way of representation. In the introduction to *The Iconography of Landscape*, Stephen Daniels and Denis Cosgrove wrote, "A landscape is a cultural image, a pictorial way of representing, structuring or symbolizing surroundings. This is not to say that landscapes are immaterial. . . . A landscape park is more palpable but no more real, nor less imaginary, than a landscape painting or poem."[6] In the process of structuring and symbolizing their landscape surroundings, artists sought to transform the environment into a rational, coherent space while simultaneously situating themselves as the masters of all they beheld.

Duncanson initially intended to make a career of painting portraits and genre (the painting of everyday life), but in 1848 his first important commission was for a landscape. The Reverend Charles Avery, an impassioned abolitionist, commissioned Duncanson to paint a copper mine that had netted the Methodist minister a tidy fortune. The mine was located in the Upper Peninsula in Michigan, not far from Duncanson's studio in Detroit. Between 1848 and 1850, Duncanson made several sketching trips to the Upper Peninsula, finding inspiration in the rugged landscape along Lake Superior. He painted *Man Fishing* (pl. 30) during this time.[7]

The painting marks a transition in Duncanson's career. It represents a bridge between his rather awkward figural paintings and portraits and his landscapes. In this particular composition, Duncanson set for himself several technical problems: the human figure, reflections in a pool of water (and the penetration of a leg and fishing line into it), grass, sky, and the bark of the trees. It appears as if Duncanson, who was most likely in a boat, rowed to his favorite fishing hole, located at a bend in the river. Still flirting with genre, Duncanson incorporated a heavily narrative element with the prominently placed man. He is perched stiffly on the rocks, his foot and fishing line disappearing beneath the still water. In the bark of the tree that looms behind him, an illusion is created: the figure of a woman standing with arms folded seems to scold him. Despite the weaknesses in

modeling, the omission of the figure would have made for an unsatisfying landscape. Furthermore, without the surrounding landscape, the crudely handled figure would have revealed itself more strongly. Each component—landscape and figure—relies on the presence of the other.

When Duncanson traveled south to North Carolina on a sketching trip in 1856, he had already established himself as a landscape artist of some renown. According to art historian Joseph Ketner, one of Duncanson's most productive years was the winter of 1856–57.[8] The breathtaking composition of *Flight of the Eagle* (pl. 31) clearly conveys the merit of his success. Duncanson's point of view seems to be located or suspended in midair. When one finally identifies the eagle in flight, the feeling of soaring is replicated within the viewer. A lone bird, the eagle's mate perhaps, is perched on a branch to the left and stands sentinel as its companion flies away. Duncanson mastered the use of sfumato; the red-tinged sky spreads a haze over the composition that melds foreground with background. This majestic vision weds dangerous mountains and cliffs, rushing water, blasted trees, and tenacious vegetation.

Painted one year before his death, *Lake Maggiori* (pl. 34) represents a memory of Duncanson's first and only time in Italy, almost twenty years earlier. In 1853 and 1854, Duncanson fulfilled the dream of most artists when he took the Grand Tour. In Europe he studied Old and New Masters, artists such as Michelangelo, Leonardo da Vinci, and J. M. W. Turner; his sketches of the land supplied him with material for the rest of his life.[9] *Lake Maggiori* is an intimate work that depicts either the Saint Gotthard Pass or Simplon Pass, passages through the Alps that connect Geneva, Switzerland, to Lake Maggiori in Italy.[10]

Unlike Duncanson, who traveled extensively, Bannister remained in Rhode Island. Finding the national and even the universal in the local, his landscapes were mostly inspired by his home. At home in the spirit, the artist, according to Bannister, "becomes an interpreter of the infinite, subtle qualities of the spiritual idea centreing in all created things." He

explained that the goal of the artist was to expound "for us the laws of beauty, and so far as finite mind and executive ability can, [reveal] to us glimpses of the absolute idea of perfect harmony."[11]

Bannister painted *Streamside* (pl. 2) one year after relocating from Boston to Rhode Island and two years after first advertising himself as a portrait and landscape painter.[12] Art historian Lynda Roscoe Hartigan noted that "Bannister eschewed precise realism yet captured evocative impressions of atmospheric effects and of the Rhode Island landscape. Many of his studies were made while sailing on Narragansett Bay and sketching and painting outdoors around Providence and Newport."[13] The "evocative impressions of atmospheric effects" that Bannister achieved in his work reflect the profound influence of the Barbizon School of French landscape painters.

In the early 1830s, a group of French painters took as their models the Dutch and English landscape traditions, with their emphasis on the ordinary and the empirical. High-flown concepts taken from the Italian landscape tradition, such as the "sublime" and the "picturesque," were abandoned. The first generation of artists, Théodore Rousseau, Narcisse-Virgile Diaz de La Peña, and Camille Corot, found inspiration in the environment surrounding the village of Barbizon in the forest of Fontainebleau.[14] It is probable that Bannister saw the heirs of that tradition exhibited at the Boston Athenaeum in the 1850s and 1860s: artists such as Jean-François Millet, Constant Troyon, and the American artist William Morris Hunt.[15]

In Bannister's choice of subject and handling of paint, *Summer Twilight* (pl. 6) is almost textbook Barbizon. Composed of richly textured bands of paint, the work is constructed in horizontal layers that resolve themselves into stream, green grasses, brown trees, and an overcast white sky that echoes the stream. What captured the artist's imagination? There are no soaring eagles or towering mountain peaks, no rushing water or dramatic sky, as in Duncanson's painting. Gerald Needham's description of

two landscapes by Rousseau and Diaz could easily apply here: "If we were asked to name the subject, we would have a hard job to define it. There are no particular features to identify, and if we had to choose one adjective . . . 'nondescript' might be the most accurate."[16] For Bannister, as for other artists working in the Barbizon tradition, paint itself became the principal expressive vehicle.

From the rigid parallel arrangement of *Summer Twilight*, to the more complexly structured compositions *The Old Homestead* and *Landscape* (pls. 4, 5), Bannister was always sensitive to the eloquence of paint. His soft, feathering brushwork evokes the comfort and ease of an old homestead, replete with lake and livestock in the foreground and warm, weathered buildings nestled among the trees in the middle ground. In terms of technique, *Landscape* is a more difficult composition than *Old Homestead*. In addition to adhering to Barbizon simplicity, the composition has no rivers or streams or any signs of humanity to enliven it. Because the painting includes only the most basic of landscape elements, Bannister's success or failure hinges solely on the application of paint. Rock formations are scattered in the foreground and middle ground, while a fence appears on the right, parallel to the picture plane. The earth, bisected by dark trees, is made up of rich blues, greens, and ochers. A mass of trees looms on the left, rising from a dip in the land, while a group of smaller trees marches low to the ground across the middle of the canvas. Bannister's brushwork endows all the elements in *Landscape* with a palpable texture—especially the sky. The clouds are made up of patches of paint that he created with consummate skill, shading and modeling them to convey to the viewer a sky with a fullness and depth equal to the land below it.

Landscape painting was not only an unusual subject for the disenfranchised but also not always a welcome one. Desiring to be recognized as a painter of landscapes, Charles Ethan Porter was frustrated in his ambition by a public that wanted to purchase primarily still lifes. From 1881 to 1884,

Porter studied in France, where he could visit the forest of Fontainebleau, which inspired a generation of Barbizon artists. Prior to his trip abroad, Porter received a traditional academic education in the arts. In 1869 he attended the National Academy of Design in New York, where he studied painting and learned to model the human figure by drawing from Greek and Roman plaster casts.[17] His experiences at the academy and in France did not necessarily prepare him to paint still lifes, yet his incredible facility for the theme worked to the detriment of his aspiration. When Porter painted *Autumn Landscape* (pl. 68), he had already abandoned a full-time studio in New York. He returned to Connecticut, the state of his birth, and reopened a studio in Hartford. However, he was unable to make a living there, and by 1889 Porter left Hartford permanently for Rockville, Connecticut.[18] He painted *Lilacs* (pl. 69) during this period. Thus, the Evans Collection contains two important works from what scholars have termed Porter's mature period of 1884 to 1890.[19]

A comparison of *Autumn Landscape* to *Lilacs* is enlightening. In *Autumn Landscape* a fence fallen into disrepair is set in a slight diagonal on the picture plane. Wild daisies populate a dark patch of grass in the foreground. The fence reads from left to right, conveying a sense of depth and breadth as it grows larger toward the right and extends beyond both sides of the picture plane. The horizon line meets the fence on the left. Trees and a farmhouse, of which only the roof and smoking chimney are revealed, rise gently along the horizon line as the eye moves to the right. Porter's palette is appropriately autumnal.

At first glance, one might mistake the painting for a landscape by Bannister. *Autumn Landscape* could easily be titled *Old Homestead*. Strongly influenced by the Barbizon tradition, both artists painted deceptively simple subjects (grass, trees, partial views of buildings, and sky). In the true Barbizon sense, "detail" is brushwork. The two artists, however, are distinguished by their contrasting handling of the brush. Unlike Bannister, Porter applied paint using

abrupt transitions in direction and texture. The grasses in the right foreground are painted with vertical strokes, and the tree—placed centrally as a focal point—seems to have been composed with that same excited brush. The sky, however, shows very little variation in color, and the brushwork is almost indiscernible. For the grasses on the left, located toward the middle ground and background, Porter used smooth, horizontal brushwork. Because of the flattened appearance of the sky and sections of grass, the canvas seems curiously empty or underworked.

The bold transitions in Porter's brushwork are much more effective in his still life *Lilacs*. This magical painting fuses three different styles of brushwork within one composition. A light shines down from the left onto a vase of lilacs, the stems of the flowers visible inside the vase. Pierced by the light, the translucent blue-green container seems to dissolve gradually as the eye moves to the right. The smooth brushwork on the body of the vase is similar to that found in the sky and grass in the landscape painting, but the colors are richer and deeper. The background is also treated with smooth strokes whose rich modeling creates the appearance of beaten gold. The light rakes from left to right, and we see that the division between table and wall is an illusion as it, too, disappears on the right, where the two surfaces merge seamlessly. Porter composed the leaves using subtle gradations of color and controlled, parallel lines of paint. The blooms, however, are made up of Impressionistic touches of paint that look as if they were rapidly and spontaneously applied. The colors range from the deepest red-purples of the far right bloom, cast in shadow, to the palest pink and white with blue accents.

It is the *appearance* of rapidity and spontaneity in the application of paint that shows the reasoning mind behind the work. The paradox of controlled bravura is what makes *Lilacs* successful. Reluctantly, Porter became an artist whose explorations of place could be contained by a vase or an artful arrangement of objects. *Autumn Landscape* represents the kind of art for which Porter wanted to be known, while *Lilacs* represents what a public hungry for pretty objects—both real and painted—would accept.[20]

Finding Alternative Frontiers: Henry O. Tanner, Nelson A. Primus, and William A. Harper

Other African American artists of the nineteenth century traveled and worked outside the parameters of home, and beyond the borders of the European Grand Tour. The Evans Collection contains several intriguing examples. Henry Ossawa Tanner, who expatriated to France in 1891, visited Florida for the third time in February 1894. There to attend an African Methodist Episcopal (A.M.E.) Church conference in Tallahassee, he also completed several landscapes.[21] In April, Tanner exhibited *Florida* (pl. 72) together with sixteen other works at Earle's Galleries in Philadelphia. Darrel Sewell has noted that each of Tanner's landscapes of Florida "are about the same size, with paint broadly brushed and rubbed into unprimed, coarsely textured canvas in high-key, Impressionist tonalities, producing glowing colors in the diffused sunlight seen through high clouds in the Florida winter sky."[22] Although Tanner's inscription on the canvas reads "Florida," the gallery's exhibition catalogue referred to the painting as *Orange Grove*. Of the seventeen landscapes and genre paintings included in this exhibition, two are very well known: *The Bagpipe Lesson* (1892–93, Hampton University Museum, Virginia) and *The Thankful Poor* (1894, William H. and Camille O. Cosby).[23] A year earlier at the same gallery, Tanner exhibited *The First Lesson (The Banjo Lesson)* (1893), the painting for which he is perhaps best known, now in the Hampton University Museum, Virginia.

Had Tanner forged a career as a painter of African American genre, Florida would have been a rich source of inspiration. There the history of blacks in the United States is deeply intertwined with the history of the state. The Spanish brought the first African slave in 1528. During the seventeenth and eighteenth centuries, black and Indian slaves escaped from the

Carolinas and Georgia, fleeing to the comparatively less restrictive Spanish colony of Florida. By the early nineteenth century, its young neighbor, the newly formed United States of America, was casting its land-hungry eyes south. On July 10, 1821, the United States officially annexed Florida and raised its flag over the former Spanish colony. Soon, the more brutal policies that governed U.S. slavery extended to the territory. During Reconstruction, African Americans formed a vibrant part of Florida's political and cultural life, holding public office and federal jobs in Tampa, Tallahassee, Jacksonville, and Key West. Florida also contained a strong and influential A.M.E. presence. By the end of the Civil War, the A.M.E. Church had established itself in Jacksonville by founding Mount Zion Church and Edward Waters College. Gradually, however, the Democratic Party successfully eroded African American influence, so that by 1920 only in the city of Ocala did a black man hold an important public office.[24]

Tanner was not the first artist to visit Florida. Throughout the nineteenth century, many artists, such as James Audubon, George Catlin, Winslow Homer, and George Inness, found inspiration there. Providing material for Audubon's plant and animal renderings, Catlin's anthropological studies of Native Americans, Iness's landscapes, and Homer's watercolors, Florida was ideologically a place of exotic splendor. The title of a work by Homer reinforces the sense of the exotic: *Homosassa Jungle in Florida* (1904, Fogg Art Museum, Harvard University). Many artists and scholars who went there treated Florida differently from the South. Although it was firmly allied to the South politically, Florida's climate and location reinforced its association with the tropics. As a result, the state's identity was and is fluid. The titles of two exhibitions that focused on artists who visited Florida are telling, for they highlight the state's real and imagined difference. In 1965 *Artists of the Florida Tropics: Audubon, Catlin, Homer, Inness* was the inaugural exhibition at the University Gallery in Gainesville. The second show, *George Inness in Florida (1890–1894) and in the South (1884–1894)*, held in 1980 at the Cummer Gallery of Art, Jacksonville, explicitly emphasized the division between Florida and the South.

A white artist could visit Florida and experience the tropics, but for Tanner, culturally and socially, Florida was inescapably the South. Tanner arrived in Florida for the first time in 1878, almost immediately after Reconstruction, a tumultuous period for African Americans. He returned twice more, during the winter of 1887–88, and again in 1894.[25] Tanner undoubtedly noticed the negative changes for African Americans. Yet, having established a reputation as a painter of African American genre, why did Tanner produce landscapes during his time in Florida? Tanner's biographer, Marcia Mathews, wrote, "He had been to Florida and experienced the patronizing condescension, more cutting than outright hostility, that prevailed in the southern states."[26] Identity determines the axis of travel: as a white artist traveling to Florida in the nineteenth century, one arrived in the tropics, but as a black artist, one arrived in the South. In other words, who you are when you depart determines where you will arrive. Because of racial intolerance, Tanner decided not to live anywhere in the United States. *Florida*, together with the other works from this time such as *The Bagpipe Lesson* and *The Thankful Poor*, marks a transition in the artist's career.[27] By 1896 he turned from landscape and genre scenes, particularly those having to do with African American life, to subjects inspired almost wholly by the Bible.

Nelson A. Primus also looked for inspiration beyond his home and the itinerary of the Grand Tour. A contemporary of Bannister and Porter, Primus, like Porter, was born in Hartford. He moved to Boston in 1864 to pursue a career as a portraitist and painter of religious subjects. Primus sought aid from the still-struggling Bannister. According to Primus, however, Bannister refused to introduce him to potential patrons and thus thwarted his attempt at a career in Boston.[28] As a result, Primus sent many works back to Connecticut to sell. Finances were so difficult that he was unable to afford a trip to Paris to study. Supplementing his work in portraiture with carriage

painting and bookselling, Primus remained in Boston almost thirty years. Moving to San Francisco in 1895, he partially supported himself by working as a model at the Mark Hopkins Institute of Art.[29] In the earthquake of 1906, he lost many works, and extant paintings number fewer than ten.[30] We know of only two paintings by Primus that were directly inspired by San Francisco's Chinatown: *Fortune Teller* (pl. 70), in the Evans Collection, and *Oriental Child* (1900), in the Oakland Museum.

Primus's depictions of subjects in Chinatown provide the opportunity to form what Alanen defined as a "more inclusive definition of landscape, one that considers physical settings, social behavior and meaning."[31] By the time Primus moved to San Francisco, Chinatown had become home to tens of thousands of Chinese. It comprised ten blocks "of buildings, streets, and narrow alleyways . . . at once a living community and a ghetto prison."[32] In 1906 the earthquake destroyed most of Chinatown; in 1912 the repressive Qing dynasty was overthrown. As a symbol of their solidarity with the people of their ancestral home, the Chinese living in America began cutting their queues and dressing in Western clothes.[33] Therefore, Primus's paintings, which predate these significant historical events, document what he perceived as the essence of Old Chinatown.

Chinese immigrants were first recorded in San Francisco in 1838, ten years before the gold rush. The first Chinese to arrive—middle-class merchants, shopkeepers, and traders—were a crucial link to Chinese laborers, recruited to meet the booming state's chronic labor shortage. Seeking to escape the faltering economy and repression of Qing-dynasty China, the laborers came to work in gold mines or as fishermen and helped to build the first transcontinental railroad.[34] The Chinese population in California increased between 1850 and 1880 from 7,520 to 105,465. According to Ronald Takaki, in 1870 they made up only 8.6 percent of the population but 24 percent of the wage-earning force.[35]

As a result of such high employment rates for Chinese people, working-class whites perceived them as a threat to their jobs, and the backlash was often violent. In 1882 the U.S. government passed the first of a series of laws prohibiting Chinese workers from entering the country. According to John Tchen, the immigration law "betrayed the national consensus that the United States was to be a white nation."[36] The general hysteria over "the yellow peril" was reflected in visual representations of the Chinese. The rhetoric used to stereotype them was the same as that used against African Americans. Takaki, adopting a term from historian Dan Caldwell, described this process as the "negroization" of the Chinese. The *San Francisco Chronicle*, for example, compared the Chinese "coolie" to the black slave, and condemned them both as antagonistic to free labor. Like slaves, Chinese were characterized as "heathen, morally inferior, savage, and childlike . . . lustful and sensual." Even the physical appearance of Chinese was noted for its African-like qualities.[37]

Primus's work in Chinatown thus poses an interesting question: how would a black artist represent a nonwhite subject who was equally disenfranchised? The subjects in *Fortune Teller* and *Oriental Child* are clothed in traditional Qing-dynasty dress. Wearing a deeply brilliant red jacket, blue pants, white stockings, and black shoes, the fortune teller, smoking a long-stemmed pipe and wielding a pen, sits at a folding table covered by a beautiful, brown silk cloth. His business appears to be located in one of the many cramped alleyways typical of Old Chinatown. His sign, written in Chinese, advertises his expertise. The top right character means "capable," signifying his status as an expert in telling fortunes. His particular specialty, the sign intimates, is divination by eight trigrams (*pa kua*). Based on information supplied by the client, such as the date, year, time, and place of birth, the fortune teller can diagram the past, present, and future. Primus has depicted him in the very act of augury. The sign also indicates the fortune teller's ability to count, plan, or scheme one's life or fate (*suan ming*). The metal can on the table is another tool of the fortune teller's trade. Such cans typically contain sticks that the patron shakes

Fig. 1. Hale A. Woodruff, *The History of the Negro in California, Settlement and Development*, 1949, oil on canvas, Golden State Mutual Life Insurance Company, Los Angeles.

and then spills onto a flat surface. The fortune teller divines the client's fate based on the pattern in which they fall. Among the Chinese, the fortune teller is a combination of wise and holy man.[38]

What does an observer see? An outsider would note the dilapidated condition of the man's surroundings, the illegible writing, the strangeness of his clothing, and perhaps the outsider would question the man's self-proclaimed expertise as a diviner of fate. It is most telling that Primus created a genre painting rather than a portrait. Instead of a careful study of an individual, Primus composed a narrative or story about the fortune teller, who, preoccupied with his work, appears unaware of the viewer. The title, *Fortune Teller*, reinforces the perception of the subject as a type rather than an individual. According to Elizabeth Johns, "Such scenes depicted people within a large social fabric who were perceived by viewers

as special in a condescending way—as different, amusing, threatening, or peculiar. As the situations and titles of the works indicate, the subjects of genre painting were not individuals but types or representatives of social orderings."[39] Consequently, the "Chinatown" of Primus's imagination remained untouched by time and events. Rather than depict the Chinese people's contribution to American industry, he focused on their foreignness, on their creation of a little China within America.

Almost fifty years later another African American artist would depict the Chinese in California. In 1948 the Golden State Mutual Life Insurance Company commissioned a two-part mural for the lobby of its building in Los Angeles. A prominent, black-owned business, Golden State hired Charles Alston and Hale A. Woodruff to depict the role of African Americans in the colonization and development of

Detail, fig. 1.

California. According to Gylbert G. Coker, "Unlike conventional visual narratives, the murals have a revolutionary racial significance in that they portray Black people as an integral part of American life, with full justice given to their share and position in history."[40] Alston painted *Exploration and Colonization*, while Woodruff executed *Settlement and Development* (fig. 1). Tucked away in the lower left corner of Woodruff's portrayal of African Americans' rich contribution to California (and by implication to America) is the railroad. As the train tracks arch into the distance, one notices the small figures who lay them. Straw hats and queues, white cotton pants and coats

tell the story of the Chinese building the Union Pacific Railroad. Like the rail ties, they line up beside one of their greatest achievements in the United States, faceless and unindividualized, acknowledged but marginal to the larger narrative of African American accomplishments.

The roots of modernism are represented by works in the Evans Collection. Of the nineteenth-century artists who are included in the collection, only William A. Harper was born after the Civil War. From Canada, his family moved to a small farm in Illinois, and later he studied art at the School of the Art Institute of Chicago, graduating with honors in 1900. In his travels he eventually visited France and studied with Tanner in Paris.[41] There Harper also absorbed the tenets of the Barbizon tradition, "apparent in the intimate setting and the dense impasto of close color values."[42] People had become accustomed to such techniques when seen in landscapes, but Harper's idiosyncratic subject matter coupled with unique vantage points bespeaks a modern sensibility. In *Staircase* (pl. 36) Harper chose an unremarkable subject in keeping with the Barbizon aesthetic sense, but he transferred it to an urban setting. We see a bit of sidewalk, but overall the staircase has no context —no neighborhood, no city.

The challenge Harper undertook was to make the mundane exciting. He surpassed his goal with the radical cropping, visible technique, and the intimation of human presence in the potted plant and statues. Harper further enlivened the work in the articulation of the awning that caps the elegant shallow risers and the exquisite newel post, which accents the banister. In the words of Griselda Pollock:

> Social histories of art have . . . taught us that the *what* of painting, drawn from modern life, was made modern only because of the *how*. . . . Modern art is modern because of a self-conscious manipulation of paint and surface in order to bring out the ambivalence and complexity of the relations between painting as a fabricated representation and its referents in the social world.[43]

Harper's modernity is located within unique perspectives that allowed the tension of the "what" and the "how" to spin out beautifully.

The Sentiments of Home: Mary Edmonia Lewis

Like Henry O. Tanner, Mary Edmonia Lewis lived an expatriate existence but never forgot home. She found inspiration in American popular culture, and she continued to make and sell works for an American audience. Throughout her life Lewis claimed to have been born to a black father and a Chippewa mother; she was orphaned as a child.[44] Her older brother, Samuel, helped to raise her and continued to support her in all her endeavors. With his aid Lewis attended Oberlin College in Ohio from 1859 to 1863, until two controversial incidents closed that chapter of her life. She was accused of poisoning two white housemates in 1862, and one year later she was blamed for stealing art supplies. In both instances her name was cleared, but she was not allowed to register for her final term and thus could not graduate.[45] From Oberlin she moved to Boston, whereupon she decided to become a sculptor. Lewis was supported by the abolitionists of Oberlin and Boston, John Keep, Lydia Maria Child, and William Lloyd Garrison, to name three. They provided her with letters of introduction and monetary help that smoothed her way from Ohio to Massachusetts and finally to Europe. In 1865 Lewis sailed for Rome, where she conducted her career abroad. Gradually the taste for marble sculpture waned, and so, too, did Lewis's career. To date, we don't know when or where she died.[46]

With very few exceptions, her oeuvre was a deeply personal response to the cultural phenomenon of "sentiment" and to sentimental fiction in particular. Shirley Samuels has defined sentimentality as "a set of cultural practices designed to evoke a certain form of emotional response, usually empathy, in the reader or viewer." She further stated that "sentimentality produces or reproduces spectacles that cross race, class and gender boundaries."[47] In many of her

works, such as her most celebrated sculpture, *Forever Free* (1867), Lewis indeed asks viewers to identify with her subjects across boundaries of race, class, and time. Executed four years after the official end of slavery, the male and female figures celebrate the Emancipation Proclamation of January 1, 1863. Lewis conveys the sense of unrestrained joy and thankfulness that has sustained the document's immediacy for more than a century.[48]

Sentimental works did not always address such substantial sociopolitical issues. During her career Lewis created many examples of the "conceit" or "fancy piece," and her sculpture *Cupid Caught* (pl. 63) promulgates the rich diversity of the Evans Collection. William Gerdts pointed out, "One category of ideal sculpture popular with American artists, though less morally or thematically ambitious than the religious or classical works, were the 'conceits' or 'fancy pieces.' These were often in the form of children and made no attempt at monumentality."[49] Lewis's Cupids were among her most popular figures, as evidenced by the number of reproductions made during the nineteenth century. Variously known as "Poor Cupid," "Love in a Trap," and "Cupid Caught," the theme is lighthearted. A rose has been used to bait the trap. As Cupid reaches for the rose, the trap springs and catches his arm.[50] Lewis conveyed his distress through his wrinkled brow and raised hand, which he lifts to his head. For the ancient Romans, the rose was the symbol of victory, pride, and triumphant love; it was also an attribute of Venus, the goddess of love.[51] Cupid would have found the rose irresistible. Instead of achieving victory over love, however, he is snared by it.

In the search for subject matter, Lewis traversed all racial boundaries, only to reconnect to her own heritage: she illustrated Henry Wadsworth Longfellow's sentimental poem *The Song of Hiawatha* (1855). During the nineteenth century, sentimental fiction in America was grounded in contemporary issues and founded on intensive research. Acclaimed examples of sentimental fiction tackled two of the most difficult and pressing concerns of the day: the plight of

Native Americans and that of African Americans.[52] Intending to build a bridge of empathy between white and black women, Harriet Beecher Stowe published *Uncle Tom's Cabin* (1852), the first international "best-seller." It asked middle-class white women to put themselves in the place of black women who were forced to watch their children stolen from them by the brutal masters who enslaved them. Later, her critics compelled Stowe to publish *The Key to Uncle Tom's Cabin*, a book that substantiated with objective facts her heartrending tale of slavery.[53]

Like *Uncle Tom's Cabin*, Longfellow's *The Song of Hiawatha* became one of the most popular literary works of the nineteenth century. Based on the research of the ethnologist Henry Rowe Schoolcraft, it sold more than fifty thousand copies within two years of its publication and was translated into all the major European languages as well as Chinese.[54] The poem tells the story of Hiawatha, the Chippewa (or Ojibwa) brave who won the love of Minnehaha, a beautiful maiden of the rival nation of the Dakota. Ending as it did with the death of Minnehaha, Hiawatha's vision of the arrival of the Europeans, and his subsequent departure, the poem became part of the American mythology—a kind of Genesis for the European American in the New World. Hiawatha's metaphoric absence signaled the European's right to own and inhabit the land.

For ten years after the poem's publication, no artist of note chose to depict scenes from it, according to Cynthia D. Nickerson. However, between 1865 and 1875, five artists began to mine the poem for material: three painters, Albert Bierstadt, Thomas Moran, and Thomas Eakins; and two sculptors, Mary Edmonia Lewis and Augustus Saint-Gaudens.[55] Unlike the other artists, who focused on the despair of Hiawatha, Lewis chose only the happiest moments from the poem. She did not, for example, sculpt the death of Minnehaha or Hiawatha's departure. Instead her sculptures consisted of either busts of Hiawatha and Minnehaha that were sold as a set or works devoted to the courtship and marriage of the couple.

In *The Wooing of Hiawatha* in the Evans Collection (pl. 61), Lewis arranged Minnehaha by the side of her father, the Old Arrow Maker. He makes arrowheads while she plaits "mats of flags and rushes." They appear to have been interrupted in their labors and thoughts—he dreams of the past, and she of the future. Those familiar with the poem would realize that the viewer stands in the place of Hiawatha, whose presence is implied by the small deer resting on the ground in front of Minnehaha and the Old Arrow Maker:

> At the feet of Laughing Water [Minnehaha],
> Hiawatha laid his burden,
> Threw the red deer from his shoulders;
> And the maiden looked up at him,
> Said with gentle look and accent,
> "You are welcome, Hiawatha!"

Lewis continued the narrative in executing *The Marriage of Hiawatha* (pl. 62 and p. 26):

> From the wigwam he departed,
> Leading with him Laughing Water;
> Hand in hand they went together,
> Through the woodland and the meadow,
> Left the old man standing lonely
> At the doorway of his wigwam.[56]

Lewis's gentle and sentimental pieces based on *The Song of Hiawatha* were among her most popular sculptures.

The inscription on the base of *The Wooing of Hiawatha* raises several noteworthy issues. Lewis inscribed the gray marble base "Edmonia Lewis Roma. 1866" on the rear and "The Wooing of Hiawatha" on the front. When Sotheby's auctioned the piece in 1994, the sales catalogue specified that the subject matter did not match the base; the piece was published as *The Old Indian Arrow Maker and His Daughter*. Relying on a description of *The Wooing of Hiawatha* in an 1871 article, Sotheby's had reasoned that the work was erroneously titled.[57] The article described it as representing "Minnehaha seated, making a pair of Moccasins, and Hiawatha by her side with a world of love and longing in his eyes."[58] The writer's mistaken description

Fig. 2. *Hiawatha's Wooing*, 1860, published by Currier & Ives, artist: Louis Maurer, on stone by Hoomer. Museum of the City of New York, The Harry T. Peters Collection, 56.300.76.

was compounded by the fact that Lewis herself retitled the copies she subsequently made, naming them all *The Old Indian Arrow Maker and His Daughter*. Therefore, it has been widely assumed that *The Wooing of Hiawatha* and *The Old Indian Arrow Maker and His Daughter* were in fact two different works. The rather capricious reporting of the nineteenth century has led present-day scholars to presume that all existing versions of *The Wooing of Hiawatha* were lost or destroyed.[59]

I propose, however, that the works were not lost. Rather, they were hiding in plain sight. Popular print media provides evidence to support this assertion. In 1860 Currier & Ives published Louis Maurer's series of lithographs illustrating *The Song of Hiawatha* (fig. 2). It is likely that Lewis saw them. Her statue in terms of pose, relative position of the Old Arrow Maker to Minnehaha, and placement of the deer shows the influence of Maurer's print, *Hiawatha's Wooing*. The main difference is that Lewis, working in marble, did not include Hiawatha. Her depiction of *The Marriage of Hiawatha* is also similar to Maurer's lithograph of the same subject.

The early date on the base of *The Wooing of Hiawatha* provides significant information regarding possible provenance. As the inscription indicates, Lewis created it in 1866, shortly after she arrived in Rome. As such, it represents her first efforts to establish herself as a sculptor and to forge a successful and fulfilling career. The circumstances surrounding the purchase of this sculpture—Lewis's first sale—delineate a poignant moment in her career. On May 1, 1867, the American actress Charlotte Cushman wrote a letter to Moses Pond, president of the Boston Young Men's Christian Association. Accompanying the letter was a sculpture she called *Hiawatha's Wooing*, which she presented to the YMCA as a gift. Cushman solicited and contributed money toward a group purchase, and in her correspondence she stated that the work represented "the first fruits of a talent on the path of development" and proved that "a Race which hitherto in every age and country has been looked upon with disfavor" could produce "work worthy of the admiration of a cultivated people."[60] This was a great burden, perhaps, to place on one work by a twenty-year-old woman.

Questions of authenticity in marble sculpture are not the same as in painting. Normally, sculptors composed their works in clay and used skilled Italian carvers to work the marble. Newspapers, however, do not report Lewis using assistants until 1872, when she began to make multiples of her very popular Hiawatha statues, all dating from 1872 and later.[61] Therefore, Lewis not only modeled *The Wooing of Hiawatha* in the Evans Collection but also worked the actual marble. This sculpture and its history of patronage help late twentieth-century viewers understand the broad scope of Lewis's talent and reconsider how her life and work were shaped by her position as an artist of African and Indian descent living in Rome.

In Italy Lewis discovered that the dynamics of race she had experienced in America did not exist in the same ways. She felt free to create evocative and sentimental works such as the Hiawatha sculptures. In the *New York Times* interview of 1878 titled "Seeking Equality Abroad," Lewis stated: "I was practically driven to Rome in order to obtain the opportunities

for art culture, and to find a social atmosphere where I was not constantly reminded of my color. The land of liberty had no room for a colored sculptor." The columnist ended the interview with a rather ambiguous statement by Lewis about race and her experience in Rome. "Miss Lewis makes no secret of the reason of her return to Rome, which she has adopted as her home. 'They treat me very kindly here,' she said, 'but it is with a kind of reservation. I like to see the opera, and I don't like to be pointed out as a negress.'"[62]

The Evans Collection reflects the earliest efforts of African American artists who began claiming the fine art tradition as their own. The methods and themes that they adopted and adapted to tell their stories were borrowed from a European tradition. Creatures of context, as are we all, they worked within a system that often worked against them. They refused to be marginalized, and when some failed, others were there to step in, continue the struggle, and keep the flame alive for the artists of the twentieth century.

One of the most interesting questions to arise from this exploration of marginalization and place is the cost of taking one's place. Primus's, and later Woodruff's, portrayals of the Chinese force us to ask ourselves if taking one's place must always be at the expense of someone else. Nevertheless, against seemingly insurmountable odds, the aforementioned artists had the drive and talent to claim places for themselves in the rich tapestry of American art and culture. Neither marginal nor Other to themselves, they created works from their own "rooted forest" that were indeed "fixed and tall." They forged a way out of a period in U.S. history that did not accommodate their achievements. The Evans Collection's rich legacy is the preservation of those first efforts. Ultimately, it is a thoughtful and inspiring narrative—an homage to the pioneers of African American creativity.

I would like to thank my "second eyes," Andrea D. Barnwell, for her help and limitless patience in the preparation of this essay. My thanks also go to Clifton Blevins of the Golden State Mutual Life Insurance Company for providing access to and photographs of the company's permanent collection. I dedicate this essay to my father, Eugene Buick.

NOTES

1. Simon Schama, *Landscape and Memory* (New York: Vintage Books, 1995), p. 6.

2. Elizabeth K. Helsinger, "Land and National Representation in Britain," in *Prospects for the Nation: Recent Essays in British Landscape, 1750–1880*, ed. Michael Rosenthal, Christiana Payne, and Scott Wilcox (New Haven, Conn.: Yale University Press, 1997), pp. 15–16.

3. Arnold R. Alanen, "Back to the Land: Immigrants and Image-Makers in the Lake Superior Region, 1865 to 1930," in *Landscape in America*, ed. George F. Thompson (Austin: University of Texas Press, 1995), p. 111.

4. In 1876 Philadelphia hosted the Centennial Exposition to celebrate the first one hundred years of the United States and to showcase the nation's progress in the arts and industry. In the spirit of friendly competition, other countries were invited to exhibit. Bannister submitted a painting (now lost) entitled *Under the Oaks*, which won a first-place bronze medal and certificate. When the officials discovered that he was African American, they were shocked. Later, they attempted to take the honor away, but in vain. Lynda R. Hartigan, *Sharing Traditions: Five Black Artists in Nineteenth-Century America* (Washington, D.C.: Smithsonian Institution Press, 1985), pp. 69–70.

5. David Schuyler, "The Sanctified Landscape: The Hudson River Valley, 1820 to 1850," in *Landscape in America*, p. 97; see also Albert Boime, *The Magisterial Gaze: Manifest Destiny and American Landscape Painting, c. 1830–1865* (Washington, D.C.: Smithsonian Institution Press, 1991).

6. Stephen Daniels and Denis Cosgrove, "Introduction: Iconography and Landscape," in *The Iconography of Landscape: Essays on the Symbolic Representation, Design and Use of Past Environments*, ed. Denis

Cosgrove and Stephen Daniels (Cambridge: Cambridge University Press, 1997), p. 1.

7. Joseph D. Ketner, *The Emergence of the African American Artist: Robert S. Duncanson, 1821–1872* (Columbia: University of Missouri Press, 1993), pp. 25–28.

8. Ibid., p. 85.

9. In 1865 Duncanson also traveled to England and Scotland; ibid., pp. 70–83.

10. For the itinerary of the Grand Tourist that names the Saint Gotthard and Simplon Passes, see Theodore E. Stebbins, *The Lure of Italy: American Artists and the Italian Experience, 1760–1914* (Boston: Museum of Fine Arts, 1992), p. 159; and Ketner, *The Emergence of the African American Artist*, p. 72.

11. Quoted by Hartigan, *Sharing Traditions*, p. 77.

12. I am using the dates found in a most helpful chronology compiled by Juanita M. Holland in *Edward Mitchell Bannister, 1828–1901* (New York: Harry N. Abrams, 1992), pp. 69–70.

13. Hartigan, *Sharing Traditions*, p. 77.

14. Gerald Needham, *19th-Century Realist Art* (New York: Harper and Row, 1988), p. 71.

15. Hartigan, *Sharing Traditions*, p. 74.

16. Needham, *19th-Century Realist Art*, p. 72.

17. Helen K. Fusscas, "The Paintings of Charles Ethan Porter," *Charles Ethan Porter* (Marlborough: The Connecticut Gallery, 1987), pp. 10–11.

18. Hildegard Cummings, "The Hartford Artist," ibid., pp. 68–69.

19. Fusscas, "The Paintings of Charles Ethan Porter," p. 10.

20. For the difficulties Porter faced in winning acceptance for his landscapes, see Cummings, "The Hartford Artist," p. 68.

21. In 1878, after suffering a severe illness while apprenticed to a family friend who ran a flour business, the young Tanner gained permission from his family to pursue his artistic ambitions. To convalesce, he traveled to Rainbow Lake, New York, and also visited Florida for the first time. Tanner went to Florida a second time from November 1887 to February 1888. In November he attended an A.M.E. conference in Jacksonville. In May 1888 his father, Reverend Benjamin Tucker Tanner, was elected the eighteenth bishop of the A.M.E. Church. See Dewey F. Mosby and Darrel Sewell, *Henry Ossawa Tanner* (Philadelphia: Philadelphia Museum of Art, 1991), pp. 35, 36, 38–39.

22. Ibid., cat. no. 30, p. 126.

23. Ibid.

24. Gary W. McDonogh, ed., *The Florida Negro* (Jackson: University Press of Mississippi, 1993), pp. 3–7, 12, 14.

25. Sewell, *Henry Ossawa Tanner*, p. 126.

26. Marcia M. Mathews, *Henry Ossawa Tanner: American Artist* (1969; reprint, Chicago: University of Chicago Press, 1994), p. 34.

27. Ibid., pp. 142–43; and Sewell, *Henry Ossawa Tanner*, p. 126.

28. Samella Lewis, *Art: African American* (New York: Harcourt Brace Jovanovich, 1978), pp. 37–38.

29. Ibid.

30. Edan Milton Hughes, ed., *Artists in California, 1786–1940*, 2d ed. (San Francisco: Hughes Publishing Co., 1989).

31. Alanen, "Back to the Land," p. 111.

32. John Kuo Wei Tchen, "Introduction: Tangrenbu—The Street Life of San Francisco's Chinatown, 1895–1906," *Genthe's Photographs of San Francisco's Old Chinatown* (New York: Dover Publications, 1984), p. 19.

33. Tchen, "Earthquake, Fire, and the New Chinatown," ibid., pp. 122–23.

34. Tchen, "Introduction," pp. 3–4.

35. What is perhaps less known is that Chinese represented 46 percent of the workers in the four key industries of California: boot and shoe, woolens, cigar and tobacco, and sewing. Ronald Takaki, *Iron Cages: Race and Culture in 19th-Century America* (Seattle: University of Washington Press, 1979), pp. 216, 232.

36. The act was amended in 1884, and in 1888 it was renewed as the Scott Act, which excluded all Chinese women except for merchants' wives. The act was extended another ten years in 1892 and extended indefinitely in 1902; Tchen, "Introduction," p. 8.

37. Takaki, *Iron Cages*, pp. 216–17; *San Francisco Chronicle* (March 6, 1879), cited in Elmer C. Sandmeyer, *The Anti-Chinese Movement in California* (Urbana: University of Illinois Press, 1939), p. 26.

38. I would like to express my deep thanks and appreciation for Hsiu-ling Huang's help, not only for translating the written text but also for sharing with me the methods employed by fortune tellers and their significance to the Chinese community.

39. Elizabeth Johns, *American Genre Painting: The Politics of Everyday Life* (New Haven, Conn.: Yale University Press, 1991), p. 2.

40. Gylbert Garvin Coker, *Charles Alston, Artist and Teacher* (New York: Kenkeleba Gallery, 1990), p. 14.

41. Barbara A. Hudson, "The Early Years: Duncanson, Bannister, Porter, Tanner, Harper," *Walter O. Evans Collection of African American Art* (Savannah, Ga.: King-Tisdell Museum, 1991), p. 19.

42. Guy C. McElroy, "The Foundations for Change, 1880–1920," in *African-American Artists, 1880–1987: Selections from the Evans-Tibbs Collection* (Seattle: University of Washington Press, 1989), p. 32.

43. Griselda Pollock, *Mary Cassatt: Painter of Modern Women* (London: Thames and Hudson, 1998), p. 21.

44. There is some question as to Lewis's ethnic background. Her most recent biographers contend that her mother's father and grandfather were African American. Romare Bearden and Harry Henderson, *A History of African-American*

Artists: From 1792 to the Present (New York: Pantheon Books, 1993), pp. 54–63; Rinna Evelyn Wolfe, *Edmonia Lewis: Wildfire in Marble* (Parsipanny, N.J.: Dillon Press, 1998), pp. 12–15.

45. Geoffrey Blodgett, "John Mercer Langston and the Case of Edmonia Lewis: Oberlin, 1862," *The Journal of Negro History* 53, no. 3 (July 1968), pp. 201–18; and John Mercer Langston, *From the Virginia Plantation to the National Capitol; or, The First and Only Negro Representative in Congress from the Old Dominion* (Hartford, Conn.: American Publishing Co., 1894), pp. 171–80.

46. Hartigan, *Sharing Traditions*, pp. 85–98; Wolfe, *Edmonia Lewis*.

47. Shirley Samuels, introduction to *The Culture of Sentiment: Race, Gender, and Sentimentality in Nineteenth-Century America*, ed. Shirley Samuels (New York: Oxford University Press, 1992), p. 4.

48. For a discussion of Lewis's work, see Kirsten P. Buick, "The Ideal Works of Edmonia Lewis: Invoking and Inverting Autobiography," in *Reading American Art*, ed. Elizabeth Milroy and Maryann Doezema (New Haven, Conn.: Yale University Press, 1998), pp. 190–207.

49. William H. Gerdts, *American Neo-Classic Sculpture: The Marble Resurrection* (New York: Viking Press, 1973), p. 136.

50. I would like to thank George Gurney of the National Museum of American Art, Washington, D.C., for helping me to solve the riddle of the Cupid. The Smithsonian Institution, National Museum of American Art, also has a version of *Cupid Caught*. At some point, the front part of the trap was broken on the Cupid in the Evans Collection.

51. George Ferguson, *Signs and Symbols in Christian Art* (New York: Oxford University Press, 1966), p. 37; and James Hall, *Dictionary of Subjects and Symbols in Art* (New York: Icon Editions, 1974), p. 268.

52. For an excellent study of the sentimental literature of Lydia Maria Child, who dealt with both Native American and African American issues in her fiction, see Carolyn L. Karcher, *The First Woman in the Republic: A Cultural Biography of Lydia Maria Child* (Durham, N.C.: Duke University Press, 1994); and "Rape, Murder, and Revenge in 'Slavery's Pleasant Homes': Lydia Maria Child's Antislavery Fiction and the Limits of Genre," in Samuels, *The Culture of Sentiment*, pp. 58–72.

53. Harriet Beecher Stowe, *Uncle Tom's Cabin; or, Life Among the Lowly*, text of the first edition, originally published in 1852 (New York: Harper & Row, 1965); and *The Key to Uncle Tom's Cabin; Presenting the Original Facts and Documents upon Which the Story Is Founded*, text of the first edition, originally published in 1853 (New York: Arno Press; New York Times, 1969). See also Arthur Riss, "Racial Essentialism and Family Values in *Uncle Tom's Cabin*," *American Quarterly* 46, no. 4 (Dec. 1994), pp. 513–44; Patricia R. Hill, "Writing Out the War: Harriet Beecher Stowe's Averted Gaze," in *Divided Houses: Gender and the Civil War*, ed. Catherine Clinton and Nina Silber (New York:

Oxford University Press, 1992); Harryette Mullen, "Runaway Tongue: Resistant Orality in *Uncle Tom's Cabin, Our Nig, Incidents in the Life of a Slave Girl*, and *Beloved*," in Samuels, *The Culture of Sentiment*, pp. 244–64.

54. Timothy Anglin Burgard, "Edmonia Lewis and Henry Wadsworth Longfellow: Images and Identities," *Harvard University Art Museum Gallery Series* (Feb. 18–March 3, 1995), p. 7.

55. Cynthia D. Nickerson, "Artistic Interpretations of Henry Wadsworth Longfellow's *The Song of Hiawatha*, 1855–1900," *The American Art Journal* 16, no. 3 (Summer 1984), p. 54.

56. Henry Wadsworth Longfellow, *The Song of Hiawatha* (New York: Bounty Books, 1968), pp. 98, 100, 103.

57. Lot 28, Sotheby's auction, March 17, 1994.

58. Laura Curtis Bullard, "Edmonia Lewis," *The Revolution* 7, no. 16 (April 20, 1871); reprinted in *The New National Era* 2, no. 17 (May 4, 1871), p. 1. Writers in the nineteenth century changed titles of works all the time and were quite free in their descriptions, and indifferent to accuracy.

59. See Hartigan, *Sharing Traditions*, p. 93; Nickerson, "Artistic Interpretations," pp. 60–61.

60. Charlotte Cushman to Moses Pond, May 1, 1867. Charlotte Cushman Papers, Library of Congress, container 3. See also Sara Foose Parrott, "Networking in Italy: Charlotte Cushman and 'The White Marmorean Flock'," *Women's Studies* 14, no. 4 (1988), pp. 330–31.

61. For a description of Lewis's working methods, see Gerdts, "Celebrities of the Grand Tour," in Stebbins, *The Lure of Italy*, pp. 69–71. For Lewis's use of assistants, see *Daily Evening Bulletin* (San Francisco), Sept. 28, 1872, courtesy of Col. Merl M. Moore, Jr., Falls Church, Virginia. In the year before the report on Lewis's nine assistants, Laura Curtis Bullard, editor of *The Revolution*, made it clear in her article "Edmonia Lewis" that the artist worked her own marble: "Miss Lewis is one of the few sculptors whom no one charges with having assistance in her work. Every one admits that whether good or bad, her marbles are all her own. So determined is she to avoid all occasion for detraction, that she even 'puts up' her clay; a work purely mechanical, and one of great drudgery, which scarcely any male sculptor does for himself."

62. "Seeking Equality Abroad: Why Miss Edmonia Lewis, The Colored Sculptor, Returns to Rome—Her Early Life and Struggles," *New York Times* (Dec. 29, 1878), p. 5; courtesy of Col. Merl M. Moore, Jr. Five years earlier, Lewis had claimed the summers in Italy were too much for her, but she expected to "live and die in sunny Italia"; "Edmonia Lewis, The Famous Colored Sculptress in San Francisco," *San Francisco Chronicle* (Aug. 26, 1875), p. 5.

Illustrating the Word

Paintings by Aaron Douglas and Jacob Lawrence

Amy M. Mooney

Imagine witnessing the Creation: shafts of light break against darkness; hills and mountains rise and fall to valleys; rivers run over the earth for the first time; birds and beasts cry shrilly; and, finally, humankind appears. Conceived by the sheer force and will of an omnipotent being, these miraculous events take place over seven days. Regardless of one's personal convictions, the beginning of the Book of Genesis provides a profound narrative that for centuries has inspired artists and poets. Many artists have created moving images that reinterpret the biblical word through prose or paint, infusing elements from their own eras.

At the peak of the Harlem Renaissance, Aaron Douglas illustrated James Weldon Johnson's *God's Trombones: Seven Negro Sermons in Verse* (1927), a book of poems based on Johnson's interpretations of popular folk sermons. In the painting *The Creation* (left, pl. 25), the artist conflated God's labors into a single scene in which his omnipotent hand reaches down from the swirling heavens to a lone figure standing near the hills and valleys of the newly formed world. Bands of light and color shift across the composition in an emotive response to the new world's state of flux. More recently, Jacob Lawrence also addressed this biblical theme by creating a series of eight gouache paintings, the *Genesis Creation Sermon* series (pls. 51–58). In each work, Lawrence ingeniously gives the viewer the feeling of being among the church brethren, witnessing the dramatic ministering of the beginning of the world. Through these works, Douglas and Lawrence captured and visualized the profound impact of a preacher's words.

Although more than sixty years separate Douglas's and Lawrence's works, both series were based on the artists' personal experiences in the black church as well as their interest in folk culture. Moreover, their academic training and exposure to Synthetic Cubism, Art Deco, and African and folk art allowed each to develop a style well suited to illustration. Characterized by flat, dynamic, and reductivist forms, their unique styles are ideal for narration because they communicate clearly and directly. Both artists utilized a serial format to tell the stories of African American history, heroes, and daily life. Throughout their careers, Douglas and Lawrence intentionally created art that was not only accessible to, but actively included, ordinary people. Both artists subscribed to the belief that effective art must be based on one's own life and experience. By establishing the historical context for the images and comparing them to the verses on which they were based, I will examine how Douglas and Lawrence documented, illustrated, and preserved the character of the preacher and his seminal role in the African American church.

During the Harlem Renaissance years of 1917 to 1935, authors, political activists, and intellectuals such as James Weldon Johnson, Alain Locke, and W. E. B. Du Bois promoted the appreciation and preservation of sermons, spirituals, and the blues, recognizing these art forms as unquestionably folk and distinctly African American. As the editor of *The Crisis*, the journal of the National Association for the Advancement of Colored People (NAACP), Locke influenced contemporary culture. Locke and Johnson also advised readers through their

contributions to *Opportunity*, the journal of the National Urban League. Currently, the term *folk art* is applied to the works of self-taught visual artists whose techniques and subject matter are frequently described as both "naive" and "visionary." During the 1920s and 1930s, however, the term had broader connotations that encompassed visual, musical, and oral traditions as well as the mind-set of everyday people.[1] Two interrelated factors motivated the developing interest in folk culture. First, many prominent blacks promoted art that was based on commonplace subjects because they believed such an art could establish a cultural tradition specific to African Americans. Locke and others subscribed to the idea that art could end social prejudice and improve race relations. They optimistically assumed whites would abandon the racist contention that African Americans and their artistic traditions were insignificant once they became aware of the important and original contributions blacks made to American art. Like Locke, Johnson reasoned, "No people that has ever produced great literature and art has been looked on by the world as distinctly inferior."[2] Thus, Locke and other black intellectuals regarded and promoted art as a vehicle for social progress. Folk art countered the perceived lack of original American artistic traditions; by promoting it, they asserted that African Americans have been integral to the formation of a national identity.

The interest in African American folk culture was also motivated by a concern for its preservation. Many intellectuals believed that modern life would destroy folk traditions as people became increasingly urban and removed from their roots. In response to this idea, anthropologists such as Franz Boas urged their students to travel to the South to record and document ordinary life in rural communities. Books on folk songs, poetry, and spirituals were heralded in *Opportunity* as "a plea for increased activity in the discovery and preservation of that folk-poetry still commonly known . . . but fast giving way before the encroachments of literacy, machine industry, commercialized music and the radio."[3]

Locke believed the impact of folk art traditions was immediate, compelling, and universal. Thus, while others preserved folk culture for posterity, Locke perceived that it was "fundamentally and everlastingly human" and should not be relegated to the past.[4] Rather, African American artists should use it as a relevant and viable model. Subscribing to similar beliefs, Johnson, Douglas, and Lawrence merged the populist appeal of the folk arts with their modernist training to create works addressing the themes of uplift and progress through a language that was particular to African Americans.

The Transformation of *God's Trombones*

A prominent cultural and political leader, Johnson contributed to the documentation and publication of folk art through his appreciation of oral tradition—especially black spirituals and sermons.[5] He believed sermons delivered in African American churches were unique because of their "imagery, idioms, peculiar turns of thought and distinctive humor and pathos."[6] He considered sermons the masterworks of skilled orators that were imbued with a distinctly African American "racial flavor."[7] Johnson's inspiration for *God's Trombones* was a Kansas City minister who transformed himself from a self-conscious, formal presenter speaking before an apathetic, dozing audience into a masterful, emotional orator capable of bringing an enrapt congregation to its feet.[8] In honor and appreciation of this and other African American ministers, Johnson attempted to capture and communicate their character:

> The old-time Negro preacher has not yet been given the niche in which he properly belongs. He has been portrayed only as a semi-comic figure. . . . It was the old-time preacher who for generations was the mainspring of hope and inspiration for the Negro in America. . . . This power of the old-time preacher, somewhat lessened and changed in his successors, is still a vital force.[9]

Shortly after Johnson witnessed the dramatic performance of the Kansas City minister, he wrote "The Creation," a poem that complements and captures the preacher's dynamic cadence and tone.

In contrast to writers such as Zora Neale Hurston, who sought to develop an authentic folk voice, Johnson did not write his poems in vernacular or colloquial language. Instead, he felt dialect should have limited use and was only appropriate in specific settings. He noted, moreover, that few preachers spoke in regional dialects, because their sermons were based on the King James version of the Bible. He claimed that ministers fused "Bible English" and "folk idioms" with the "innate grandiloquence of their old African tongues," and that they "knew the secret of oratory, that at the bottom it is a progression of rhythmic works more than it is anything else."[10]

Understanding that it was not just the preacher's dynamic intonations and dramatic rhetoric which moved the congregation to ecstasy but also his ability to create vivid visual images, Johnson asked Viking Press to commission Douglas to illustrate the volume of poetry (fig. 1). Johnson admired Douglas's illustrations for *Opportunity* and *The Crisis* and believed the modern energy of the artist's hard-edged drawings would make his verses all the more appealing to a contemporary audience. In turn, Douglas expressed admiration for the elder statesman and was familiar with his work with the NAACP.[11] The two men had established a rapport, for earlier that year Douglas designed the jacket for Johnson's novel, *Autobiography of an Ex-Colored Man*.[12]

After moving to Harlem in uptown Manhattan from Topeka, Kansas, in 1925 and studying art and graphic design with the German trained artist Winold Reiss, Douglas developed a style that was especially suited to reproduction.[13] Reiss alternated between sensitive, hyperrealistic portraits influenced by the aesthetics of New Objectivity and bold graphic designs based on Cubism; he used both artistic styles in his contributions to Locke's anthology *The New Negro* (1925).[14] Douglas's aesthetic was inspired by his teacher's interest in African art and appreciation

Fig. 1. Aaron Douglas, cover of *God's Trombones: Seven Negro Sermons in Verse* by James Weldon Johnson (Viking Press, 1927). Walter O. Evans Collection.

of folk culture, especially the sharp outlines of woodcuts and *scherenschnitt*, a paper-cutting technique used in German folk art.[15] His distinct and striking silhouetted forms were also influenced by modernist aesthetics such as Art Deco, Synthetic Cubism, and Synchronism. By contributing illustrations for *The Crisis, Opportunity*, and the anthology *The New Negro*, Douglas quickly established a reputation that led to many other prestigious commissions, including *Plays of Negro Life* edited by Locke (1927), *Black Magic* by Paul Morand (1929), *God Sends Sunday* by Arna Bontemps (1931; fig. 2), and *Banana Bottom* by Claude McKay (1933).[16]

Fig. 2. Aaron Douglas, cover of *God Sends Sunday* by Arna Bontemps (Harcourt Brace, 1931). Walter O. Evans Collection.

According to art historian Amy Helene Kirschke, Douglas wanted his illustrations for *God's Trombones* to express "the enormous power, spiritual power that's behind Negro life."[17] Referring to the 1920s and 1930s as his "Hallelujah period," Douglas "believed the Negro was destined to save the 'soul' of America" through art.[18] Although influenced by the styles of several artistic movements, Douglas's depictions of spirituality featured faces and limbs carefully drawn to "reveal African features and recognizable Black poses."[19] Douglas attended black churches and was interested in the philosophy of the mystic George Ivanovitch Gurdjieff, whose teachings combined Christianity and self-realization.[20] Like others, Douglas believed the "common man" was a source of

inspiration, stating, "something was coming out of him which the various artists . . . could get hold of and make something that was later known as the Harlem Renaissance."[21]

Douglas's illustrations for *God's Trombones* are literal and symbolic interpretations of the poet's words. Each image acts as a visual synopsis, transforming the verse into the essential elements of the sermon. By including a rainbow and a plant next to the image of man in *The Creation* (pl. 25), Douglas was in keeping with the elements literally described in the poem. With the measured cadence of the preacher he admired, Johnson wrote:

> Then the green grass sprouted,
> And the little red flowers blossomed,
>
> .
>
> And God smiled again,
> And the rainbow appeared,
> And curled itself around his shoulder.

The visualization of these words is dynamic; the repetition of distinct forms and the incremental tonal shifts convey a sense of movement and development appropriate to the delivery of the Creation sermon. Similarly, in the poem, Johnson's rhythmic use of words and repetitions gradually builds up the excitement of each miraculous event, evoking the tension and resolution essential to any credible and dramatic performance, and to creation itself.

Inventively, Douglas communicated the temporal aspect of Johnson's narrative by repeating the circular forms that increase as they move toward the viewer, imitating Johnson's text: "God gathered it up in a shining ball / And flung it against the darkness." The undulating bands representing heaven at the top of the painting shift from lighter to darker tones, furthering the sense of dramatic flux of the newly created world and the separation of light from darkness. Furthermore, these broad, wavelike bands have a "pulsating and emotional quality" that imitates the words and delivery of Johnson's Creation sermon.[22]

The painting in the Evans Collection is the second work Douglas made on the Creation theme.

The first was reproduced alongside Johnson's poem "The Creation—A Negro Sermon," published in *The New Negro* in 1925 and again in *Opportunity* in 1926 (fig. 3).[23] This earlier illustration, entitled *The Sun God*, depicts a female figure in a tropical landscape and seems generalized, not directly relating to the text, but because of its association with the poem, the image became known as *The Creation*. Although he typically reproduced the same drawing in different publications, sometimes adding or eliminating details, Douglas specifically decided not to reuse this illustration for *God's Trombones*. Instead, he invented a completely new work based directly on Johnson's words.[24] For the book to successfully communicate the emotional impact of a sermon, the text and illustrations had to deliver a unified narrative, resulting in a collaborative effort between the artist and poet.

For Johnson's fourth poem, "Go Down Death— A Funeral Sermon," Douglas evoked the solemnity and catharsis of a funeral requiem in his illustration (pl. 26). The poet relates the story of a beloved woman named Sister Caroline, describing her life-long labor and her glorious return to God. Instead of literally depicting the pain and suffering at her deathbed, Douglas envisioned Sister Caroline's salvation as a stylized winged figure symbolic of Death. Upon a pale horse Death descends, both visually and textually: "Through heaven's pearly gates, / Past suns and moons and stars," as the "foam from his horse" leaves a cometlike trail in the sky. Frequently, Douglas used a shaft of bright light to illuminate the focal point of the dramatic event. In *Go Down Death* an intense light emanating from a distant planet symbolically guides Death to the dying woman who greets him "like a welcome friend." The artist created an awe-inspiring and comforting vision of the end of life intended, like Johnson's poem, to console the bereaved and address the reality of mortality.

The words and images for *The Judgment Day* (pl. 27) are marked by a similar emotive expression. Johnson's apocalyptic vision of God raining down fire, poised in the middle of the air "to judge the quick and the dead," is signaled through his messenger, the archangel Gabriel. Douglas depicted the towering figure of Gabriel with "one foot on the mountain top" and the "other in the middle of the sea." He blows his horn to "wake the living nations" and "shake old hell's foundations." Below Gabriel, figures from the "army of the dead" kneel and gesture toward heaven. As in *Go Down Death*, Douglas relied on the visual and symbolic impact of light. Concentric rings, shafts, and dynamic zigzags of light emanating from the earth and sky visually unite the composition and complement Johnson's emotionally charged stanzas. Like the recurring phrases of the folk preacher, the angular and circular forms are purposefully repeated as a focus and an organizing principle.[25] Rhetorically, in the poem, the preacher

Fig. 3. Aaron Douglas, *The Sun God*, c. 1925, opaque watercolor with ink over graphite underdrawing on wove paper, 4 × 2½ in. Howard University Gallery of Art, Washington, D.C.

asks three times "Where will you stand?" At this moment, the poet brings readers to the dramatic climax—and the underlying purpose of the sermon—in questioning whether they are prepared for Judgment Day.

In all his illustrations for *God's Trombones*, Douglas employed shafts of light to convey divine intervention as well as to illuminate the narrative progression of the sermon. The gradual shifts in tone and scale indicate movement, adding a temporal aspect to the image, a technique common in Futurist and Synchronist paintings.[26] Douglas used the same technique in several other paintings that dealt with religious themes, including the suite of murals at the library of Fisk University in Nashville (1930). In his description of these murals, the artist explained that in one panel "the light of Christianity penetrates the encircling shadows" and causes "ribbons of light to surround the figures."[27] Thus, it was through his faith and artistic vision that Douglas successfully transformed the text of *God's Trombones* into moving and evocative images.

Inspired Visions of the Creation Sermon

Jacob Lawrence based his *Genesis Creation Sermon* series not on poetry but on biblical texts and his own memories of Sunday sermons. Each work is accompanied by wall text of paraphrased verses from the Creation passages in the Book of Genesis. According to Lawrence, the series was inspired by the sermons of Reverend Adam Clayton Powell, Sr., whom he heard at the Abyssinian Baptist Church in Harlem.[28] A pivotal figure in the church's development, Powell had raised enough funds in 1923 to move the Abyssinian Baptist Church from its cramped quarters in lower Manhattan to its resplendent building in Harlem.[29] Powell's role as pastor extended far beyond his weekly sermons; he served his congregation tirelessly, opening a community center, a home for the aged, and soup kitchens during the Depression.

In a 1968 interview, Lawrence remembered growing up in Harlem and "going to church regularly and being in Sunday school and participating in church plays. Powell, Sr., was a very big name then. I can remember some of his sermons. One of his famous ones was the dry bones sermon. I heard him do that several times and he was very dramatic with it."[30] The dry bones sermon, based on 37 Ezekiel, was among the most dramatic in the preacher's repertoire. So inspired was Lawrence by Powell's performances that he introduced aspects of the minister's uplifting style into his *Genesis Creation Sermon* series some sixty years later, remembering:

> The passion of [the sermon's] delivery had such an impact on me, that to this day it has remained a great influence in the creative process of my paintings. Such works as the *Migrations* series, the *John Brown* series, and the *Builders* themes have developed because of this awe-inspiring and beautiful mystery of life and our being. I do hope that these eight works will convey to those who view them the beauty of our existence.[31]

As Lawrence attested, the delivery of the sermon is as important as the words themselves. The oratorical skills of a preacher—his intonation, gesture, and energy—are the tools upon which he relies. Understanding the most significant aspects of the service, Lawrence emphasized the minister's emotional appeal, portraying both his gestures and the reactions of the laity. In addition, the artist's dramatic use of color, angular forms, and textual references heightens the viewer's experience of the miraculous events that unfold during the sermon.

In contrast to the paintings from the *Toussaint L'Ouverture* (1937–38), *Frederick Douglass* (1938–40), *Harriet Tubman* (1938–40), and *John Brown* (1941) series, in which he depicted the lives of extraordinary individuals and conveyed black people's quest for freedom and social equality, the *Genesis Creation Sermon* series has a more universal appeal. The narrative panels, compositions, subjects, and titles are remarkably similar. The compositional layout of each of the eight *Genesis Creation Sermon* paintings varies only slightly. Each painting is set within a church, the preacher

prominently positioned at center and elevated on a pulpit. In some instances, the laity is depicted as awestruck by his animated gestures as they listen attentively in the pews. In others, they are transfixed by the events taking place through four windows in the back of the church. Lawrence used the background windows to visualize the events from the minister's sermon, transforming the words into vivid images of the Creation.

Lawrence's narration begins with *Genesis Creation Sermon I: In the Beginning All Was Void* (pl. 51). The preacher kneels on the pulpit, raising his grasped hands in prayer—a passionate gesture that has a profound impact on the laity. Here we simultaneously experience the preacher's forceful delivery, the congregation's emotional response, and the event unfolding outside the windows of the church. The preacher encourages the congregation to look to the windows and witness the frightening blackness from which the world originated. Some are moved to tears, while others seem apprehensive and tense. Although a prominent Bible lies open on the lectern at the left, the preacher does not read the Word; rather, he convinces his congregation to see the world's former emptiness with their own eyes. The figures and their surroundings are painted in the artist's flat, abstract, and expressive style, although the contours are less angular and more curvilinear than in his earlier works. This modulation is especially evident in the figure's hands; it seems the artist exaggerated the proportions to emphasize their strength and ability. Lawrence's interest in expressing the power of ordinary people reflects his conviction that art should be based on personal experience and convey a social message. By merging the aesthetics of modernism with the realities of African American life at the end of the millennium, Lawrence has continued to achieve the goals of the Harlem Renaissance.

The absolute conviction of the worshipers is confirmed by their responses to the preacher in *Genesis Creation Sermon IV* (pl. 54). The artist's title, *And God Created the Day and the Night and God Created and Put Stars in the Skies*, describes the events depicted through the church windows. In this instance, however, no one watches the separation of day and night or the first twinkling stars; rather, all eyes are riveted on the preacher. Grasping the Bible with massive, capable hands, he leans back, mouth open and eyes squeezed shut, as if the power of his faith is the catalyst for the reoccurring miracle. His oratorical power and imposing presence are further emphasized by the contrast between his enveloping black robe and the surrounding bright hues. His belief is so compelling that people lean forward, stretch toward him, and are moved to tears.

The congregation sits next to the windows in the third work from the series, *Genesis Creation Sermon III: And God Said "Let the Earth Bring Forth the Grass, Trees, Fruits and Herbs* (pl. 53 and p. 50). Some look out, admiring the paradise before them, while others crane their necks toward the minister. With open arms he gestures toward the cathartic end of the magnificent Creation spectacle. Pointing toward the rolling hills, trees, and fallen fruit (foreshadowing the future), he urges his listeners to return the following Sunday for the sermon that will tell how the drama in the Garden of Eden unfolds. The congregation responds with tears and expressions of awe, joy, and trepidation, clearly communicating the effectiveness of the preacher's profound performance.

In this image Lawrence's continuing interest in the collage aesthetic of Synthetic Cubism is most evident. The spatial distinction between the pulpit and the floor is dramatically flattened; the pews are defined through a series of different-colored angles; and the trees, hills, and fruit in the background resemble paper cutouts.

Throughout the series, two icons are distinctly repeated: a single flower bud in a vase and a toolbox. Inspired by the detailed realism and iconography in the Northern Renaissance paintings he viewed as a young man at the Metropolitan Museum of Art in New York, Lawrence incorporated traditional Christian symbols in his *Genesis Creation Sermon* series.[32] In

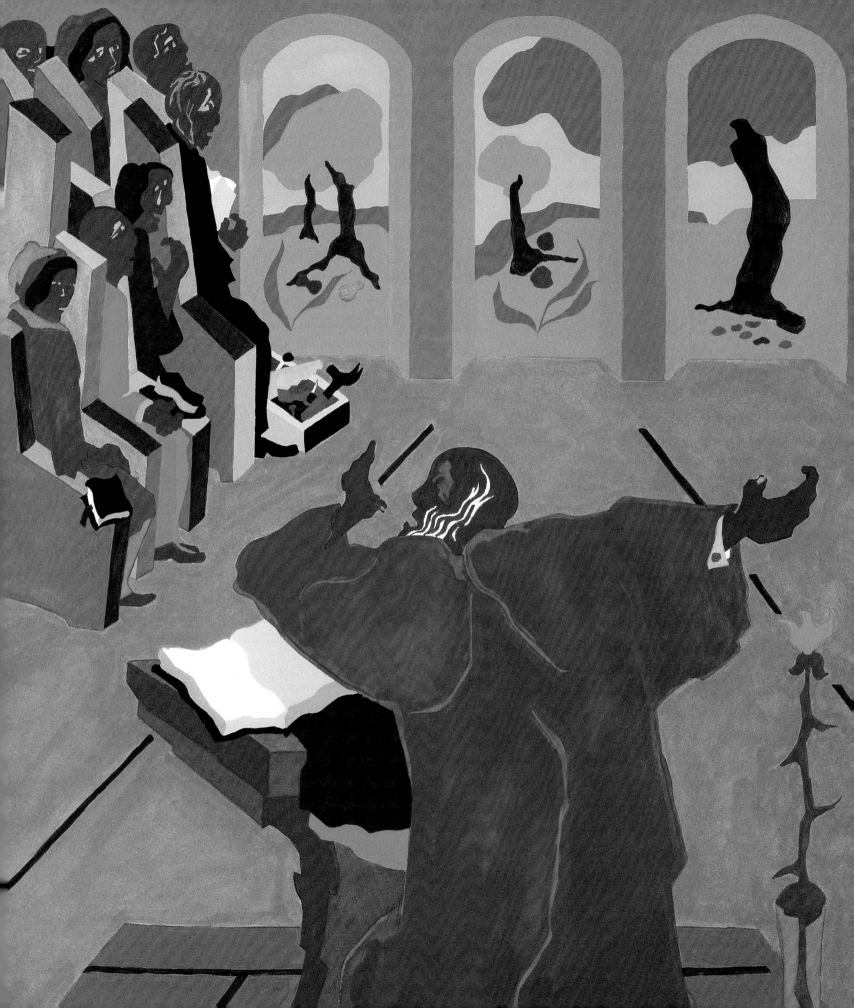

seven of the eight paintings, a single rose in a vase is placed on the pulpit next to the preacher, perhaps as a reference extolling the Christian virtue of charity.[33] Lawrence also depicted the toolbox of Joseph's carpenter shop, a symbolic device commonly used to indicate Christ's humble beginnings, emphasizing his humanity and connection to manual labor.

Lawrence incorporated the toolbox into earlier works from the 1950s that spoke to the strength and creative ability of carpenters, and he included the motif in his *Builders* series of the 1970s. The artist respected the common, everyday experiences that are integral to American identity. For Lawrence, the symbolism of tools is multilayered: They are linked to the artistry of cabinetmakers, such as the accomplished Bates brothers whom he admired in Harlem, and he considers tools themselves to be artistic objects, "aesthetically beautiful, like sculpture."[34] On a more abstract level, Lawrence believes that tools refer to the human condition, symbolizing the building of the environment, family, and aspirations.[35] In the *Genesis Creation Sermon* series, the toolbox signals Lawrence's ongoing social consciousness and awareness of the class and skills of the church members (the Abyssinian Baptist Church, for example, was known as "the church of the people," having a predominantly working-class congregation).[36] Furthermore, Lawrence stated that in these paintings the toolbox could be read as a metaphor for the role of the church, which builds a sense of community and identity for its members.[37]

The black church was born during slavery and continued to grow and thrive throughout each phase of American history. As discussed by Leroy Fitts in *A History of Black Baptists*, during the "formative period of Black Church life, the Black Baptist Preachers, more specifically, had to come to grips with the pragmatic situation of life in America. They had to relate a relevant theology to slavery in the South and White racism throughout the nation."[38] Early black churches offered the opportunity for African Americans to gather, strengthen community bonds, and be influenced by black leaders. The minister's commitment to his congregation included much more than preaching: in his leadership role, he wielded a great deal of influence on people's daily lives, advising congregants on economic, social, and political matters—even where to shop and how to vote. Through a melding of theology, education, and activism, his weekly sermons became a focal point for a community.

The role of the black minister was further elucidated by W. E. B. Du Bois in *The Souls of Black Folk*:

> The Preacher is the most unique personality developed by the Negro on American soil. A leader, a politician, an orator, a "boss," an intriguer, an idealist—all these he is. . . . The combination of a certain adroitness with deep-seated earnestness, of tact with consummate ability, gave him his preeminence, and helps him maintain it.[39]

Like Du Bois and Johnson, Douglas and Lawrence recorded and celebrated not only the seminal role of the African American preacher but also the part played by the common people who believed in him. Their expressive styles communicate the preacher's tremendous power and his ability to articulate the word. Douglas's and Lawrence's modern paintings created sermons for the eye and the ear, preserved the folk voice of the past, and satisfied the yearning for a unique American art form. Together, their efforts may be viewed as part of the continuing contributions that African Americans make to the nation's collective spiritual growth and to our rich heritage.

Jacob Lawrence, *Genesis Creation Sermon III: And God Said "Let the Earth Bring Forth the Grass, Trees, Fruits and Herbs,"* detail (pl. 53)

This essay is dedicated to the Washington Tabernacle Baptist Church in Saint Louis, Missouri, for their generous support and investment in young scholars such as myself. I am grateful to Helen M. Shannon for discussing her recent interview with Jacob Lawrence. I also thank Andrea D. Barnwell and Cherise Smith for their critical contributions to this essay. Finally, my husband, Geof Bradfield, also provided editorial expertise. His patience and support are much appreciated.

NOTES

1. Many resources discuss the inspiration and aesthetics of folk artists. See Jane Livingston and John Beardsley, *Black Folk Art in America, 1930–1980* (Jackson: University Press of Mississippi, 1982); and Lynda Roscoe Hartigan, *Made with Passion* (Washington, D.C.: Smithsonian Institution Press, 1990). For a critical perspective on the definition of this term, see Eugene W. Metcalf, "Black Art, Folk Art, and Social Control," *Winterthur Portfolio* 18, no. 4 (Winter 1983), pp. 271–89.

2. James Weldon Johnson, ed., *The Book of American Negro Poetry*, 2d ed. (1922; New York: Harcourt, Brace, 1931), p. 9.

3. Ruth R. Pearson, "Tracking Down the Negro Folk Songs—A Review," *Opportunity* 3, no. 35 (Oct. 1925), p. 335. This article favorably reviews *On the Trail of Negro Folk Songs*, by Dorothy Scarborough, assisted by Ola Lee Gulledge (Cambridge: Harvard University Press, 1925). Other books published on folk traditions during the Harlem Renaissance include James Weldon Johnson, ed., *The Book of American Negro Spirituals* (New York: Viking Press, 1925); Newbell Niles, *Folk Beliefs of the Southern Negro* (Chapel Hill: University of North Carolina Press, 1926); Howard W. Odum and Guy Johnson, *The Negro and His Songs* (Chapel Hill: University of North Carolina Press, 1925); and Nicholas G. J. Ballanta (Taylor), *Saint Helena Island Spirituals* (Philadelphia: Schirmer Press, 1925).

4. Alain Locke, ed., *The New Negro* (New York: Albert and Charles Boni, 1925; reprint, New York: Simon & Schuster, 1992), p. 199.

5. Sondra Kathryn Wilson, introduction to James Weldon Johnson, *Black Manhattan* (New York: Da Capo Press, 1991), p. ix.

6. James Weldon Johnson, *God's Trombones: Seven Negro Sermons in Verse* (New York: Viking Press, 1927), p. 8.

7. Ibid., p. 8.

8. Ibid., pp. 5–6.

9. Ibid., pp. 2–3.

10. Ibid., pp. 5, 9.

11. L. M. Collins, "Interview with Aaron Douglas," July 16, 1971, Black Oral Histories, Fisk University Special Collections. Transcript included in "The Harlem Renaissance Generation," unpublished anthology, DePaul University Library, Special Collections and Archives, p. 184.

12. The book was originally published anonymously in 1912.

13. Reiss's artistic training included the School of Applied Arts in Munich and the Düsseldorf Academy where he was exposed to the precedents for Art Deco, including Jugendstil and Art Nouveau. For a biography of Reiss, see Jeffrey Stewart, *To Color America: Portraits by Winold Reiss* (Washington, D.C.: Smithsonian Institution Press, 1989).

14. New Objectivity, or Neue Sachlichkeit, was a form of German Expressionism that stressed extremely representational detail.

15. Judith M. Friebert, *The Ardent Image: Book Illustration for Adults in America, 1920–1942* (Toledo: University of Ohio Press, 1995), p. 10.

16. Many of these original editions illustrated by Douglas are included in the extensive bibliographic collection of Dr. Walter O. Evans. The dissemination of Douglas's graphic work played an important role in securing future commissions. According to Amy Helene Kirschke, on the basis of Douglas's work for *God's Trombones*, the Chicago-based architectural firm of Holabuird and Root commissioned him to create a series of murals for the renovated Sherman Hotel; see *Aaron Douglas: Art, Race and the Harlem Renaissance* (Jackson: University Press of Mississippi, 1995), p. 114.

17. Collins, "Interview with Aaron Douglas," cited in Kirschke, *Aaron Douglas*, p. 98. She also notes that although Douglas was dissatisfied with his work and hoped to rework the images at a later date, Johnson was very enthusiastic about the images.

18. Kirschke, *Aaron Douglas*, p. 111.

19. David Driskell, "The Flowering of the Harlem Renaissance: The Art of Aaron Douglas, Meta Warrick Fuller, Palmer Hayden, and William H. Johnson," in Mary Schmidt Campbell, *Harlem Renaissance: Art of Black America* (New York: The Studio Museum in Harlem; Harry N. Abrams, 1987), p. 112.

20. Kirschke, *Aaron Douglas*, pp. 52–53. Gurdjieff's teachings were disseminated throughout Harlem by his disciple Jean Toomer, the author of *Cane* (1923).

21. L. M. Collins, "Interview with Aaron Douglas," "The Harlem Renaissance Generation," pp. 181–82.

22. Nathan Irvin Huggins used these words to describe the bands in Douglas's 1934 mural for the branch of the New York Public Library that is now the Schomburg Center for Research in Black Culture; *Harlem Renaissance* (New York: Oxford University Press, 1971), p. 171.

23. Locke, ed., *The New Negro*, p. 138; and *Opportunity* 4, no. 38 (Feb. 1926), p. 55.

24. In his interview with L. M. Collins, Douglas discussed how he was dissatisfied with his initial work for *God's Trombones* and wanted to rework the images. He did so in 1935, creating a series of larger oil paintings with greater detail and variety in color. These paintings are in various private and public

collections; *The Creation* and *Go Down Death* are reproduced in Campbell, *Harlem Renaissance*, pls. 35, 33.

25. Huggins, *Harlem Renaissance*, p. 230.

26. While studying at the Barnes Foundation near Philadelphia in 1928, Douglas became familiar with African sculpture and the modernist paintings of Cézanne, Gleizes, Matisse, and Picasso.

27. Kirschke, *Aaron Douglas*, p. 111.

28. Helen M. Shannon, telephone interview with Jacob Lawrence, Sept. 30, 1998.

29. Timothy E. Fulop, *Encylcopedia of African American Culture and History*, vol. 1 (New York: Simon and Schuster, 1996), p. 14.

30. Carroll Greene, Jr., "Interview with Jacob Lawrence," Oct. 26, 1968, Archives of American Art, Smithsonian Institution; cited in Ellen Harkins Wheat, *Jacob Lawrence: American Painter* (Seattle: Seattle Art Museum; University of Washington Press, 1986), p. 28.

31. *Jacob Lawrence: The Genesis Series* (Dearborn: University of Michigan Press, 1994).

32. Shannon, interview with Lawrence. Wheat also discusses the impact of the perspective and iconography of early Renaissance paintings on Lawrence's style; *Jacob Lawrence*, pp. 32–33.

33. Thomas Albert Stafford, *Christian Symbols in the Evangelical Churches* (New York: Abingdon-Cokesbury Press, 1942).

34. Avis Berman, taped interview with Jacob Lawrence, Feb. 6, 1983; cited in Wheat, *Jacob Lawrence*, p. 143.

35. Bonnie Hoppin, "Arts Interview: Jacob Lawrence," *Puget Soundings* (Feb. 1977), p. 6.

36. Fulop, *Encyclopedia of African American Culture and History*, vol. 1, pp. 14–15.

37. Ibid.

38. Leroy Fitts, *A History of Black Baptists* (Nashville: Broadman Press, 1985), p. 222.

39. W. E. B. Du Bois, *The Souls of Black Folk* (1903; reprint, Boston: Bedford Books, 1997), p. 149.

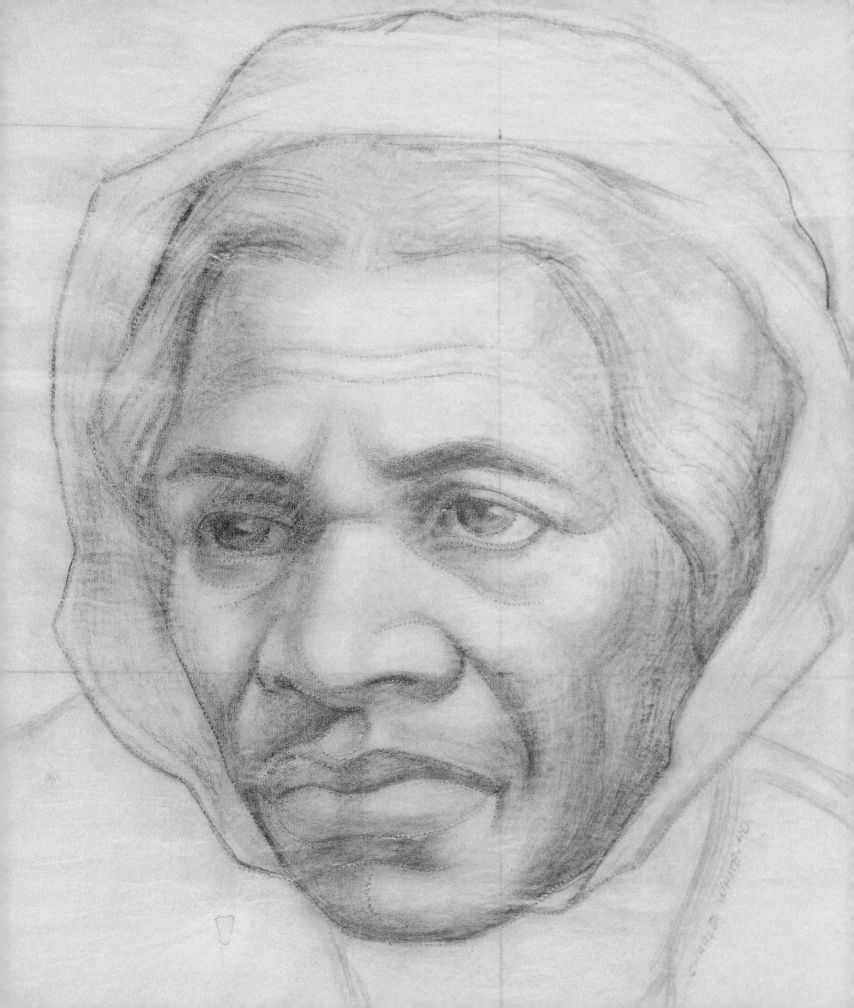

Sojourner Truth or Harriet Tubman?

Charles White's Depiction of an American Heroine

Andrea D. Barnwell

Two drawings by Charles White in the Walter O. Evans Collection of African American Art prompted protracted discussions among the contributors to this catalogue: one drawing is of Frederick Douglass (1818–1895), an escaped slave who later became one of the most influential abolitionists, identified by his distinctive hairstyle and beard (pl. 78); the other is of missionary Sojourner Truth (1797–1883), the important abolitionist and suffragist, wearing her signature bonnet (left, pl. 79). Our primary question was how do the drawings fit into White's oeuvre. Close examination revealed that both are pricked and squared for transfer, indicating they are cartoons, or preliminary drawings for a larger work. Neither has a direct correlation with White's important mural *The Contribution of the*

Negro to Democracy in America (1943) at Hampton University in Hampton, Virginia. Nor do they correspond to *Chaotic Stages of the Negro, Past and Present* (1939–40) or *Associated Negro Press* (1940), two murals reproduced in the book *Images of Dignity* whose whereabouts are currently unknown.[1] Although White executed the drawings in 1940 when he was only twenty-one, both exemplify the superior draftsmanship for which he is acclaimed. We concurred about their fine execution and great beauty, but found it difficult to determine the significance of these early works without relating them to a finished mural.

In August 1998 White's 13-foot-long *Five Great American Negroes*, also known as *Progress of the American Negro* (1939–40; fig. 1), was exhibited at

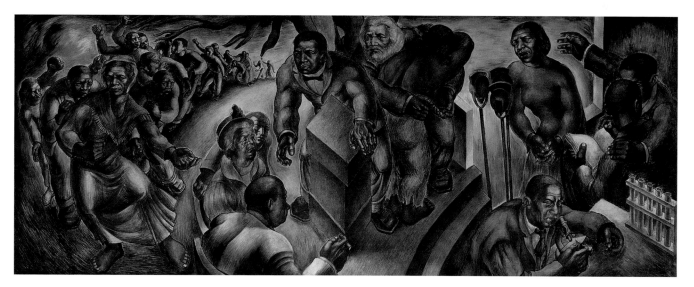

Fig. 1. Charles White, *Five Great American Negroes* (also known as *Progress of the American Negro*), 1939–40, oil on canvas, 60 × 155 in. Howard University Gallery of Art, Washington, D.C.

Charles White, *Sojourner Truth*, detail (pl. 79)

the Williamstown Art Conservation Center at the Clark Institute in Massachusetts for a group of curators and scholars affiliated with the exhibition project *To Conserve a Legacy: American Art from Historically Black Colleges and Universities.*[2] The mural immediately ignited interest among those present. For me, viewing the work was particularly significant; the mural clearly has a direct relationship with the drawings in the Evans Collection. In this essay I discuss the creation and history of *Five Great American Negroes* and consider White's depictions of heroic subjects. I conclude by proposing that in White's portrayal of Truth, whether purposely or not, he evoked the lives of both Sojourner Truth and another famous abolitionist, Harriet Tubman (1821?–1913).

Five (or Six?) Heroic Subjects

Charles White, who grew up on the south side of Chicago, began experimenting with art at the age of seven when his mother bought him an oil-paint set for his birthday. When he was in high school, it angered him that his teachers omitted the notable black people of history whom he, an avid reader, had learned about during frequent visits to the neighborhood public library. Art was a good outlet for his frustration with school. White entered the School of the Art Institute of Chicago in 1937. After graduating in 1938, he joined the easel and mural divisions of the Federal Art Project in Illinois. Art school and the federal program afforded him the time, materials, and artistic freedom to work as he chose.[3] After collaborating with American muralists Mitchell Siporin and Edward Millman on public murals, White was granted permission to create his own mural by the Works Progress Administration (WPA), which oversaw the Federal Art Project. White wanted his first public mural to be rooted in his community and, moreover, to educate and instill a sense of racial pride. Participating in the federal art program allowed him to redress oversights in the curricula that he had witnessed from the time he was a young student. Finally he had the opportunity to depict historic

figures of particular import to black Americans. In 1939, on White's behalf, the *Chicago Defender* conducted a survey among its readers, and among schoolchildren, to determine which black leaders had contributed most to the progress of black Americans. White then based his mural *Five Great American Negroes* on the results of the poll.[4]

White created figures that make symbolic gestures and evoke the lives and legacies of luminaries who had been neglected in accounts of American history. The educator Booker T. Washington (1856–1915), named the most influential black American in the survey, orates to three attentive listeners from behind a podium in the center of the mural. Directly behind him Frederick Douglass, depicted as a mature adult, embraces a slave. He looks toward Washington as if to convey that the next generation of black Americans must continue to struggle in order to secure the ideals of liberation, equality, and justice. Marian Anderson (1897?–1993), a renowned contralto whose voice earned her acclaim in America and Europe, stands with clasped hands and sings into freestanding microphones. At the lower right George Washington Carver (1864–1943), the famous scientist and director of agricultural research at Tuskegee Institute (now Tuskegee University), conducts an experiment with test tubes and a microscope. Above him two young men read a book—suggesting their access to power through study and knowledge.

The newspaper survey also concluded that Sojourner Truth, depicted at the far left, was among the five most important black people. In White's mural, Truth, wearing a shawl and bonnet, leads a procession of people. With one hand clenched and the other open, she guides the weary, downtrodden group over the rising land.

White likely relied on popular newspapers for illustrations and contemporary photographs of Anderson and Carver. The year that he started the mural, the *Chicago Defender* featured articles about Anderson singing at the Lincoln Memorial in Washington, D.C., and Carver researching plants in the laboratory.[5] Perhaps he based his depictions of Douglass and Truth

on their respective autobiographies and archival photographs.[6] By including telling objects (microphones, microscopes, podiums) near each of his heroes, he ensured they were recognizable.

Photographs of Truth show her wearing a shawl and bonnet like those in White's depiction of her. In *Five Great American Negroes*, White explained that he "picked out little symbolic things to represent each [subject]" and showed "Sojourner leading groups of her people."[7] Although Truth, among other things, led 1860s bus boycotts in Washington, D.C., and was a dedicated suffragist, she never physically led slaves to freedom. This rendition encourages discussion. Given the symbolic clarity of activities White chose for the mural's other protagonists, his decision to show Truth as a barefoot pilot rather than behind a podium or engaging an audience in some way is intriguing. One is prompted to ask why Truth is marching rather than lecturing. And because another major female leader, Harriet Tubman, actually led slaves to freedom in the North, one cannot help but wonder what encouraged White to depict Truth in this way. Tubman was not selected in the poll sponsored by the *Chicago Defender*. Since White adhered to the results of the poll in so many respects and identified the figure as Truth in an interview, we must conclude that he meant to evoke her life. However, because of the discrepancy between Truth's depiction and her historic role, I propose here a reading that allows for the presence of both Truth and Tubman. Through this alternative interpretation, I consider that White, whether purposely or not, captured the historic significance of both women.

Although White's portrayals of the five subjects clearly resemble the actual historical figures, he was more concerned with educating and conveying the extraordinary achievements of each than with capturing accurate likenesses. As Lizzetta LeFalle-Collins has noted, other African American artists such as Charles Alston, John T. Biggers, Elizabeth Catlett, Sargent Claude Johnson, Jacob Lawrence, John Wilson, and Hale Woodruff were informed by four main factors: "the aesthetic theories of Alain Locke;

the social realist movement in the United States; the rise of American socialism and communism; and finally, the work of the Mexican School artists themselves who were active in the United States."[8] White developed his rounded, muscular, stylized figures while painting murals with Siporin and Millman— artists who had worked with acclaimed Mexican muralists José Clemente Orozco and Diego Rivera. Although White had not been to Mexico at this early stage in his career, the indirect influence of Mexican muralist painting was profound. Like many Mexican and American artists, White used imagery related to the theme of progress and racial and social uplift to convey ideological concerns. LeFalle-Collins explained that as a result of this didactic purpose, many Mexican and African American muralists created "saintly portrayals of martyrs and heroes" who were rooted in their history and culture.[9] Because of his belief that works should communicate and educate, White represented his subjects as powerful, heroic, and epic (see *Woman Worker*, pl. 80).

Lost and Found

Five Great American Negroes has an extensive history. After White completed the large mural at the Federal Art Project headquarters in Chicago, it was unveiled in October 1939 at the Artists and Models Ball held at the Savoy Ballroom in Chicago.[10] Several black newspapers included articles about White's important mural.[11] In December 1940 it was included in *Exhibition of the Art of the American Negro* at the Library of Congress, a show commemorating the seventy-fifth anniversary of the Thirteenth Amendment to the Constitution, which abolished slavery.[12] Next it was installed in the Chicago Public Library.[13] In 1943 James A. Porter included the work in his book *Modern Negro Art*.[14] That same year, the WPA sent it to Arizona for inclusion in *Exhibition of the Work of 37 Negro Artists* held at the Mountain View Officers Club, Fort Huachuca—a military base where black soldiers of the 92nd and 93rd Infantry Divisions were stationed—and then at two service clubs.[15]

The exhibition also featured works by Richmond Barthé, William Carter, Archibald J. Motley, Jr., Elizabeth Olds, Dox Thrash, Vernon Winslow, and Hale Woodruff. After the exhibition completed its tour, the works were reinstalled permanently at the Mountain View Officers Club in an effort to enhance the morale of the black soldiers.[16] When the government decommissioned the base after the war, the state of Arizona presented the works of art to several universities in 1947. *Five Great American Negroes* was among the gifts made to Howard University in Washington, D.C. Because of space constraints, it has never been exhibited in the university's gallery, remaining, until recently, rolled on a drum in storage.[17]

Since the WPA had total control over the art it commissioned, White and others who participated in the government programs likely lost track of their works. (White explained that although the WPA photographed many of the art objects, he had no reproductions of *Five Great American Negroes*.)[18] Since a relatively small number of people knew of the mural's location in the permanent collection at Howard University, scholars presumed it was lost or destroyed, leading White's family and many scholars to search for the painting.[19] The rediscovery more than fifty years later of *Five Great American Negroes* and its subsequent inclusion in *To Conserve a Legacy* were welcome events.[20]

Depicting Truth and Tubman

White's depiction of Sojourner Truth is noteworthy for its apparent evocation of both Truth's and Tubman's lives. As Truth's biographer Nell Irvin Painter observed, although the two played very different roles in American history, people continually confuse them because they both lived in an era "shadowed by human bondage."[21] It is therefore useful to reflect briefly on their respective historic roles. In 1826 Truth, then a slave named Isabella, escaped from the John Dumont plantation in Ulster County, New York, with her youngest child. Isaac and Marie Van Wagenen, an abolitionist couple living in the neighboring city of Wagondale, purchased the fugitive and her daughter to rescue them from slavery. Isabella lived comfortably with them for about a year and took their last name. In 1828 she moved to New York City where she worked as a domestic servant and devoted substantial time to the Methodist church. On Pentecost, June 1, 1843, she was "called in spirit" and received the word that she was to travel and preach the word of God. As Painter recounted:

> Sojourner Truth means itinerant preacher, for a sojourner is someone not at home, and truth is what preachers impart. She saw her mission as lecturing to the people, testifying and exhorting them to "embrace Jesus, and refrain from sin."[22]

Despite her illiteracy, from the late 1840s through the 1870s, Truth traveled throughout America advocating women's suffrage and abolition. Her large physique —5 feet 11 inches—and deep voice often led people to describe her as masculine. Known for singing during her moving speeches, she always presented herself as commanding and dignified.[23]

Harriet Tubman was born into slavery a generation after Truth. When she was fifteen, an overseer struck her on the head with a weight and knocked her unconscious. The blow left a dent in her skull, and for months her recovery was uncertain. For the rest of her life, she suffered from a type of narcolepsy that caused her to fall asleep intermittently regardless of what she was doing. Despite this condition, Tubman, only 5 feet tall, worked in the field and became known for her endurance, muscular frame, and solid build. Her strength and religious faith enabled her to escape from a plantation in Dorchester County, Maryland, in 1849. With the help of abolitionists, Quakers, and free blacks, she returned to rescue other slaves. Between 1850 and 1860, Tubman led more than three hundred fugitive slaves from the South to freedom by way of the Underground Railroad—the clandestine route by which slaves escaped to the free states and Canada.

Called the Moses of her people, she arrived like an apparition, conspired to collect slaves from

plantations, and guided them on the treacherous journey north along the East Coast. Armed with a revolver, she led the fugitives on foot by night, hiding them from bounty hunters by day. Although at one time a $40,000 reward was offered for her capture, she was never apprehended and reputedly never lost a passenger. Slaves who knew that faith and the North Star were her guides equated her arrivals with spiritual visitations. Consequently, she is frequently characterized as mysterious and noted for her ability to steal her people and successfully flee in the night.[24] During the Civil War, she assisted doctors in Union hospitals and organized an intelligence and scouting corps for the Union Army.

Figuring Tubman

Beginning in the late 1930s, Tubman became an important subject for many artists. Jacob Lawrence created *Harriet Tubman* (1938–40, Hampton University Museum, Virginia), a series of thirty-one panels recounting her exhausting struggles. Lawrence portrayed Tubman as heroic in the face of seemingly insurmountable conditions, much as he treated his subjects in other historical series. Tubman was also a significant figure for the artist Elizabeth Catlett, White's former wife. In her 1946 series *The Negro Woman*, she showed the leader directing a group of escaped slaves to freedom. In the same series Catlett depicted Sojourner Truth pointing to the heavens behind a podium, her Bible open to a page marked with a cross-shaped bookmark. In 1975 Catlett revisited Tubman's life in a linocut entitled *Harriet* (fig. 2).

In 1951 the Negro History Club of Marin City and Sausalito, California, created the *Harriet Tubman Quilt* (Robert W. Woodruff Library, Atlanta University Center, Georgia). The following year, in *Harriet Tubman and Her Underground Railroad* (fig. 3), John T. Biggers depicted Tubman holding a torch while sheltering children in her garments and comforting a man made weary by his treacherous journey. She leads a line of slaves armed with pitchforks who are prepared to resist rather than be captured and forced

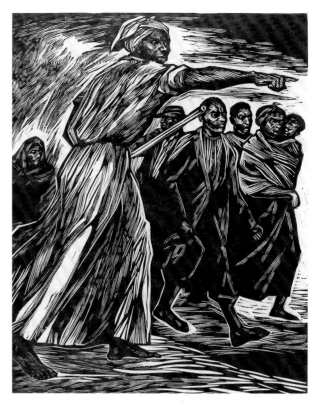

Fig. 2. Elizabeth Catlett, *Harriet*, 1975, linocut, 22 × 18 in. Hampton University Museum, Hampton, Virginia.

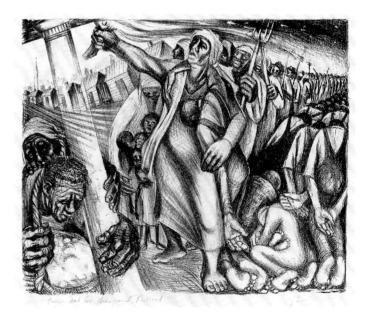

Fig. 3. John T. Biggers, *Harriet Tubman and Her Underground Railroad*, 1952, lithograph, 15½ × 19½ in. Hampton University Museum, Hampton, Virginia.

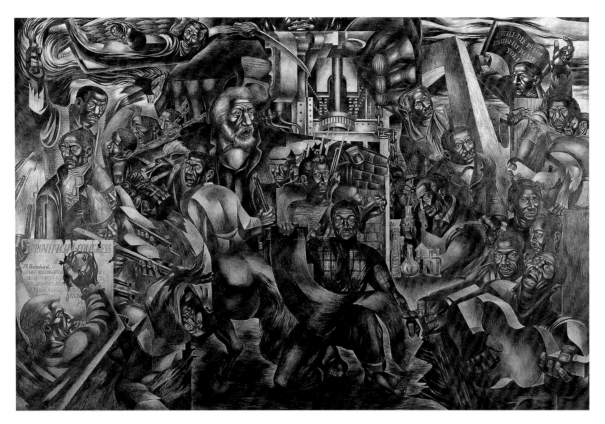

Fig. 4. Charles White, *The Contribution of the Negro to Democracy in America*, 1943, egg tempera,
11 ft. 9 in. × 17 ft. 3 in. Hampton University Museum, Hampton, Virginia.

back into slavery. Since Biggers studied under White in the early 1940s when he was a visiting faculty member at Hampton University, he might have seen White's preliminary studies of *Five Great American Negroes*. Interested in heroic black subjects, Biggers in all likelihood was informed by the compositional strategies employed by White.

Each of the aforementioned artists, who lived and worked in a period of U.S. history marked by discrimination and racism, were clearly inspired by Tubman's agency, survival tactics, and rebelliousness, and therefore commemorated her life.[25] The visual evidence in *Five Great American Negroes* suggests that White, like his contemporaries, was moved by the significance and visual impact of a female figure leading others to freedom. Wanting to evoke the magnificence of such a vital subject, he conjured images of flight and survival that would inspire later

generations. He might have felt compelled by the results of the survey to foreground a Truth acting like a Tubman.

White himself depicted Tubman several times during his career. Shortly after he completed the WPA mural, he painted *The Contribution of the Negro to Democracy in America* (fig. 4), a painting that features Truth and Tubman. Truth, wearing her bonnet, is seen at the upper right reaching behind an L-shaped beam, while Tubman is the powerful figure with a stern expression to her right. Truth's left hand almost touches Tubman's shoulder, linking the two figures. One year later a detail of Peter Still, a free black abolitionist, and Harriet Tubman from White's mural at Hampton University was featured on the cover of *New Masses*.[26] In 1965 the artist executed the ink drawing *General Moses* (fig. 5) for the permanent collection of the Golden State Mutual Life Insurance Company in

Los Angeles. Here Truth assumes a pose that suggests fatigue but not exhaustion. She sits on a rock formation. Her hands are crossed, and her bare feet firmly planted on the ground. She seems relaxed but at the same time alert and prepared to respond to any altercation. In 1967 White commemorated Tubman again in his cover illustration for a children's book, *Four Took Freedom: The Lives of Harriet Tubman, Frederick Douglass, Robert Smalls and Blanche K. Bruce*.[27] Then in 1975 he depicted her in an illustration for *The Shaping of Black America*.[28] In these works he never rendered Tubman the same way twice. Whether he showed her standing or seated, wearing a bonnet or a head wrap, or defined by softly rendered or carefully chiseled facial features, he always used her persona to embody the theme of strength.

White depicted Truth less frequently than he did Tubman. In 1942 he executed a detailed drawing of Truth wearing a bonnet.[29] In several instances, including the mural *The Contribution of the Negro to Democracy in America* and a 1954 cover illustration for *Masses and Mainstream*, he represented both women in the same composition.[30] In some drawings, the two resemble each other physically and are not differentiated by identifying symbols.[31] Without text to describe whom White portrayed, it is difficult to identify the women with absolute certainty.

Lives and Symbols

The images most frequently associated with Truth and Tubman are strikingly different. Truth is remembered through photographic portraits showing her seated in an ornate rocking chair, knitting or holding a photograph in her lap, before a relatively plain background (fig. 6). In other instances, she stands in a dignified manner, lecturing behind a podium. No matter how she was portrayed in her photographs, Truth was always seen in the expertly tailored clothing feminist and antislavery lecturers wore to "distinguish themselves from showily dressed actresses."[32] Beginning in 1863 Truth sold photographic portraits of herself rather than relying completely on others

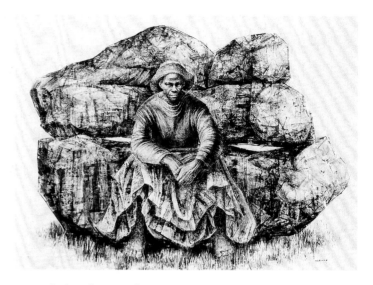

Fig. 5. Charles White, *General Moses*, 1965, inkand wash, 45½ × 66 in. Golden State Mutual Life Insurance Company, Los Angeles.

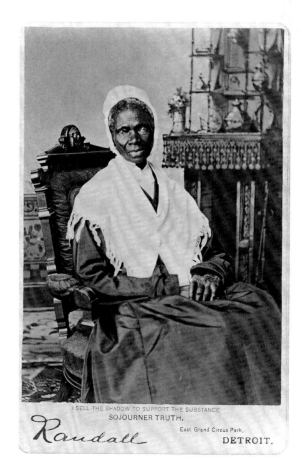

Fig. 6. Sojourner Truth, 1870. Randall Studio, National Portrait Gallery, Smithsonian Institution, Washington, D.C.

for charity while she traveled throughout the northeastern region of the United States. By the third quarter of the nineteenth century, "studio photographers could begin to profit from the reputation Truth made for herself by her sale of her own portraits."[33] The similarities between White's depiction of Truth's attire and her photographic portraits suggest that the artist had access to these photographs, which were widely disseminated during her lifetime. However, Truth's bare feet, stance with legs akimbo, and line of followers suggest that White relied on other references, coupled with his own artistic imagination, to create her image in *Five Great American Negroes*.

In the popular image of Tubman, a nineteenth-century woodcut (fig. 7), she appears as a soldier equipped for battle or service. She wears a coat and kerchief on her head—attire that resembles her blue and white federal uniform. Slung over her shoulder is a service satchel filled with first-aid supplies, and she holds a rifle at her side.[34] The woodcut does not project leisure or passivity; instead, Tubman is prepared and armed.

If we accept at face value White's 1965 statement that the figure in his 1939–40 mural is Truth, we can posit that the artist believed the lectures and speeches she gave in New England made her a symbolic, rather than an actual, leader of slaves. Such a hypothesis, however, is problematic. For although she persuaded Quakers and abolitionists to help fugitive slaves when they arrived in the North, and therefore made the conditions safer for passengers on the Underground Railroad, Truth did not physically lead others from slavery. Her audiences were white women who were interested in suffrage rather than abolishing slavery.[35] In rendering Truth as a pilot, White, an artist who interpreted rather than transcribed history, made the artistic choice to depict her in a manner not strictly in accordance with her perceived role. He represented her as he saw fit.

Several explanations may account for White's depiction of Truth. Maybe White, like many others, confused the two women, or perhaps we could

interpret White's depiction as a composite of Truth and Tubman. Reflecting on White's creation of *Five Great American Negroes* more than fifty years later, Benjamin Horowitz, White's best friend and dealer, recently asserted that the two women's roles were distinct in the artist's mind: "Charles had a number of heroes and heroines. Harriet Tubman was near the top of his list. . . . There is no doubt in my mind that Harriet Tubman was ever mistaken for anyone, including Sojourner Truth, by Charles White."[36] If we believe Horowitz, it is plausible that White did not confuse them but rather conscientiously combined the two distinct personalities into one figure to convey their joint historic significance. Although there is no visual evidence that suggests he combined two

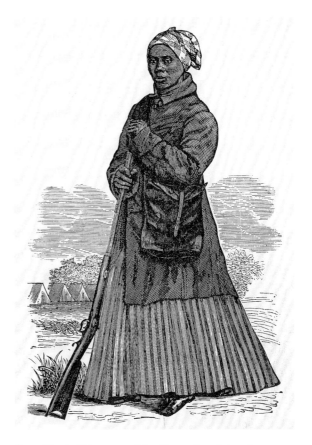

Fig. 7. Harriet Tubman, c. 1863–68 woodcut. Schomburg Center for Research in Black Culture, The New York Public Library, Astor, Lenox and Tilden Foundation.

figures in other murals he executed, the presence of elements that relate to both women's lives suggests he did so in this instance.

An impassioned supporter of black artists throughout his career, White recorded a lecture entitled *White on Black Art* (1978), an introduction to the collection of African American art in the Golden State Mutual Life Insurance Company. In this important recording, accompanied by a slide presentation, White mentions several works in the pioneering collection: murals by Charles Alston and Hale Woodruff installed in the company's lobby as well as a bronze by Richmond Barthé and an oil by Hughie Lee-Smith. Finally, he focuses on his drawing *General Moses*. His passionate and illuminating discussion is worth quoting at length (emphasis is mine):

> I always wanted to pay tribute and make some comment about all of these black heroes and heroines that had inspired me and particularly Harriet Tubman. I remember when I first read about her. Oh my God, what a woman. What a magnificent person . . . the education of life propelled her into a situation where she was able to give leadership and be a dominant part of the whole abolitionist movement. She was responsible. Responsible for thousands of slaves escaping through the underground railroad system to the north. And this woman was the key—the key person through the whole struggle against slavery. *So when I wanted to do murals, I always included her. I always found an excuse to include her.* . . . Oh, I've only captured one piece of her. I could do ten thousand pictures and never capture all the facets of this person. And this is the way that I felt about so many people. Like Paul Robeson. Like Sojourner Truth. They were way bigger than life itself. Bigger than life itself. And this is the way I feel about my people. They're bigger than life.[37]

White exaggerated for emphasis in the above statement; he did not depict Tubman in *Chaotic Stages of*

the *Negro, Past and Present* or in *Mural History of Negro Press*. Nonetheless, his recollection is significant, for it suggests that Tubman was an important figure for him throughout his lifetime.

Whether or not White purposely created a composite of Truth and Tubman in *Five Great American Negroes*, his interpretation of Truth raises significant questions. Is this simply a case of White depicting Truth's life as he saw fit, or did he perhaps intentionally blend the two women's personas and histories? In order to recognize the aspects and characteristics in White's rendering that relate to Truth's and Tubman's dynamic lives, I have proposed an interpretation that considers the presence and historic role of each woman. This reading acknowledges the evidence that White celebrated and commemorated two actual women who did extraordinary things.

Like many African Americans past and present, White felt that, due to the tumultuous history of blacks in this country, it was crucial to depict black historic figures as monumental, heroic, unfaltering, and part of a continuum. Efforts such as his (especially at that time) clearly affect black people's identities, self-esteem, coping strategies, and survival. We may consider White's mural on two interrelated levels. On one, the artist provided a generic gloss of black American history relating to leadership, commitment to national well-being, entertainment, and science. On another, by depicting particular black Americans, he deliberately evoked specific lives: We cannot look at Washington's bow tie and call him Louis Farrakhan; Douglass is not Martin Luther King, Jr., nor do we confuse Anderson with Leontyne Price or Aretha Franklin; and Carver cannot be mistaken for Charles Drew. White rendered four of his five subjects with attention to their historic roles. His specificity regarding these four figures prompts us to contextualize the figure that resembles Truth and discuss her life and legacy with the same certainty.

In proposing that the Truth figure in *Five Great American Negroes* has characteristics of Tubman, I would be remiss if I did not mention that only one

newspaper account of the period identified Truth as Tubman.[38] I would contend that because the principal goal at the time was to give people access to neglected black heroes, concerns about accuracy and identity were rarely raised. Moreover, during the prefeminist era in which White executed the mural, one would not necessarily discuss the problems associated with collapsing the two historic women. Whether or not White fused Truth's and Tubman's lives, the rediscovered mural provides the opportunity to reconsider the historical import of the drawings in the Evans Collection. The recovery of the mural at Howard University and the two cartoons highlights the difficulty of conducting critical research on African American artists and their work, as so many objects are undocumented or have vanished. Constructing a discourse about this underexamined American artist's early projects, for example, has been particularly challenging. At one time, Howard University also owned a preliminary drawing of the entire mural. However, according to Tritobia Hayes Benjamin, Director of the Howard University Gallery of Art, it has been missing for the last several years.

Until recently, then, the complete significance of the drawings of Douglass and Truth in the Evans Collection and the whereabouts of the mural were a mystery. Both drawings demonstrate White's exquisite draftsmanship and are beautiful in their own right. Like many objects in the Evans Collection, they are important works that allow us to identify and examine aspects of artists' careers not yet discussed in great detail. These drawings provide technical details about how White rendered the subjects' faces and transferred them onto the canvas. Furthermore, the drawings are invaluable because they enable us to reconsider the social and artistic implications of White's rediscovered mural.

I would like to thank Stephanie D'Alessandro, Tuliza Fleming, Jacqueline Francis, Richard J. Powell, Susan Rossen, Daniel Schulman, and Jeremy Strick for their insight and thoughtful criticism. I also thank Mary Lou Hultgren, Hampton University Art Museum; Clifton Blevins, Golden State Mutual Life Insurance Company; and Charlotte Sherman, Heritage Gallery, for their assistance.

NOTES

1. Benjamin Horowitz, *Images of Dignity: The Drawings of Charles White* (Los Angeles: Ward Ritchie Press, 1967), pp. 31–32.

2. *To Conserve a Legacy: American Art from Historically Black Colleges and Universities,* organized by Richard J. Powell and Jock Reynolds, is a two-part exhibition project. First, a team of curators selected more than one hundred works from six historically black colleges and universities (HBCUs) to be treated and restored at the Williamstown Art Conservation Center. Second, the conserved works (and many others from the HBCUs) are featured in an exhibition that will tour the nation from March 1999 through July 2001. The itinerary is the Studio Museum in Harlem (New York); Addison Gallery of American Art (Andover, Massachusetts); Corcoran Gallery of Art and the Howard University Gallery of Art (Washington, D.C.); the Art Institute of Chicago; Clark Atlanta University and High Museum of Art (Atlanta, Georgia); North Carolina Central University and Duke University Museum of Art (Durham); Fisk University Art Galleries with Tennessee State Museum (Nashville); and Hampton University Museum (Virginia).

3. Many artists who executed public murals felt that federal organizations put too many restrictions on their subject matter. See Francis V. O'Connor, ed., *Art for the Millions: Essays from the 1930s by Artists and Administrators of the WPA Federal Art Project* (Greenwich, Conn.: New York Graphic Society, 1973), pp. 46–81. In a 1965 interview with Betty Hoag, however, White said the government did not place any limitations on him and he worked as he saw fit; see Betty Hoag, "Interview with Charles White," March 9, 1965, Archives of American Art, p. 25.

4. "Washington Tops List of Race Leaders," *Chicago Defender*, Oct. 7, 1939, p. 5.

5. See "Miss Anderson Will Sing in Easter Recital," *Chicago Defender*, April 8, 1939, p. 28; "In Outdoor Concert," *Chicago Defender*, April 15, 1939, pp. 1, 6; James C. Dickerson, "Believes Dr. Carver's Discoveries Could Bring Prosperity to South," *Chicago Defender*, March 25, 1939, p. 13.

6. Frederick Douglass, *Narrative of the Life of Frederick Douglass, an American Slave, Written by Himself* (Boston: Anti-Slavery Office, 1845; reprint, Cambridge: Belknap Press, 1960); Frederick Douglass, *Life and Times of Frederick Douglass, Written by Himself* (Hartford, Conn.: Park Publishing, 1881; reprint, Secaucus, N.J.: Citadel Press, 1983); Olive Gilbert, *Narrative of Sojourner Truth* (Battle Creek, Mich.: Review and Harold Office, 1884; reprint, New York: Oxford University Press, 1991).

7. Hoag, "Interview with Charles White," p. 19.

8. Lizzetta LeFalle-Collins, "African American Modernists and the Mexican Muralist School," in *In the Spirit of Resistance: African-American Modernists and the Mexican Muralist School* (New York: The American Federation of the Arts, 1996), p. 28.

9. Ibid., p. 44.

10. "Artists and Models Ball Draws Capacity Crowd," *Chicago Defender*, Oct. 28, 1939, p. 22; "'Great Negroes' Mural Nearing Completion," clipping, Archives of American Art, Smithsonian Institution, Washington, D.C.

11. Robert A. Davis, "The Art Notebook," *Chicago Sunday Bee*, Oct. 6, 1940; "Chicago Negro Artist Immortalizes Own Folk," Charles White Papers, Archives of American Art.

12. Alonzo J. Aden, *Exhibition of the Art of the American Negro* (Washington, D.C.: Howard University, 1940).

13. Hoag, "Interview with Charles White," p. 19. White stated that *Five Great American Negroes* was installed in the Chicago Public Library, but according to Michael Flugg, the archivist at the library's Vivian G. Harsh Research Collection for Afro-American History and Literature, many individuals say they saw it at the George Cleveland Hall branch. As of publication date, the library has not been able to locate records indicating the mural was ever installed there. Sources such as *Images of Dignity* by Horowitz (p. 18) state the mural was installed at the branch. Because of the success of White's first public mural, he was commissioned to create at least four others: *Chaotic Stages of the Negro, Past and Present, Associated Negro Press, The Contribution of the Negro to Democracy in America*, and *Mary McLeod Bethune* (1978, Exposition Park Mary McLeod Bethune Branch, Los Angeles Public Library).

14. James A. Porter, *Modern Negro Art* (New York: Dryden Press, 1943), p. 242. In the 1969 edition published by Arno Press, a reproduction of the mural is featured in the plate section on page 242; the 1992 edition, published by Howard University Press, features a reproduction of a preliminary drawing.

15. *Exhibition of the Work of 37 Negro Artists* (Fort Huachuca, Ariz.: Mountain View Officers Club, 1943).

16. I am grateful to Jim Finley, Director of the Fort Huachuca Museum, for sharing this information with me.

17. In 1995 *Five Great American Negroes* was on view for a short time at the Maryland Institute, College of Art, Baltimore.

18. Hoag, "Interview with Charles White," p. 20.

19. Elsa Honig Fine stated that the whereabouts of the mural and its cartoons were unknown; *The Afro-American Artist: A Search for Identity* (New York: Holt, Rinehart and Winston, 1971), p. 171; see also George J. Mavigliano and Richard A. Lawson, *The Federal Art Project in Illinois 1935–1943* (Carbondale: Southern Illinois University Press, 1990), p. 162.

20. *Five Great American Negroes* has been written of at least two times since it was unveiled in conjunction with *To Conserve a Legacy*; see Arnold Berke, "A Terrible Thing to Waste," in *Preservation* (March/April 1999), pp. 60–70; and a 1998 gallery brochure published by the Clark Institute upon the completion of the restoration.

21. Nell Irvin Painter, *Sojourner Truth: A Life, A Symbol* (New York: W. W. Norton, 1996), p. 3.

22. Ibid., pp. 74–76. See also Harriet Beecher Stowe, "Sojourner Truth, the Libyan Sibyl," *Atlantic Monthly* (April 1863), pp. 473–81.

23. For a detailed account of Sojourner Truth's life, see Painter, *Sojourner Truth*.

24. For a detailed account of Harriet Tubman's life, see Sarah Bradford, *Harriet Tubman: The Moses of Her People* (New York: Carol Publishing Group, 1961). See also Benjamin Quarles, "Harriet Tubman's Unlikely Leadership," in *Black Leaders of the Nineteenth Century*, ed. Leon Litwack and August Meier (Urbana: University of Illinois Press, 1988). For information on plantation slavery and black women abolitionists, see John Hope Franklin and Loren Schweninger, *Runaway Slaves: Rebels on the Plantation* (New York: Oxford University Press, 1999); and Shirley J. Yee, *Black Women Abolitionists: A Study in Activism, 1828–1860* (Knoxville: University of Tennessee Press, 1992). I am thankful to Kirsten P. Buick for these sources.

25. In the following five years, the emphasis on Tubman's life and image continued. This was perhaps due in part to the publication of her biography by Earl Conrad, *Harriet Tubman: Negro Soldier and Abolitionist* (New York: International Publishers, 1942).

26. "Peter Still and Harriet Tubman," *New Masses* (March 7, 1944).

27. Philip Sterling and Rayford Logan, *Four Took Freedom: The Lives of Harriet Tubman, Frederick Douglass, Robert Smalls and Blanche K. Bruce* (New York: Zenith Books, 1967), cover ill.

28. Lerone Bennett, Jr., *The Shaping of Black America* (Chicago: Johnson Publishing Company, 1975), p. 143.

29. Michael Rosenfeld Gallery, *African American Art: 20th-Century Masterworks, IV* (New York: Michael Rosenfeld Gallery, 1997), p. 44.

30. *Masses and Mainstream* 7, no. 2 (Feb. 1954), cover ill.

31. For example, White's 1946 depiction of Truth holding a torch in *Images of Dignity* (p. 49) looks remarkably similar to that of Tubman in his cover illustration for *Four Took Freedom*.

32. Painter, *Sojourner Truth*, p. 187.

33. Kathleen Collins, "Shadow and Substance: Sojourner Truth," *History of Photography* (July 1983), p. 189. I am thankful to Richard J. Powell for calling this article to my attention.

34. I am not asserting the veracity or authenticity of the photograph of Truth or woodcut of Tubman. I compare them and proceed with this line of investigation because these are the images for which Truth and Tubman are most known.

35. We should note that Truth's audiences were frequently preoccupied with her appearance and more concerned with "her seeming utter differentness," which proved "irresistibly entertaining." They dwelled at length on her "Negro dialect" and descriptions of her body. Painter, *Sojourner Truth*, p. 98.

36. Benjamin Horowitz, letter to the author, Feb. 24, 1999.

37. Charles White, *White on Black Art* (Los Angeles: Golden State Mutual Life Insurance Company, 1978), slides with audio.

38. Davis, "The Art Notebook."

Norman Lewis, *Untitled*, detail (pl. 64)

Plates

1 Charles Alston

Seated Figure, 1970

2 Edward Mitchell Bannister

Streamside, 1870

3 Edward Mitchell Bannister

Ledge off Bailey's Beach, c. 1890

4 Edward Mitchell Bannister

The Old Homestead, 1895

5 Edward Mitchell Bannister

Landscape, 1897

6 Edward Mitchell Bannister

Summer Twilight, 1899

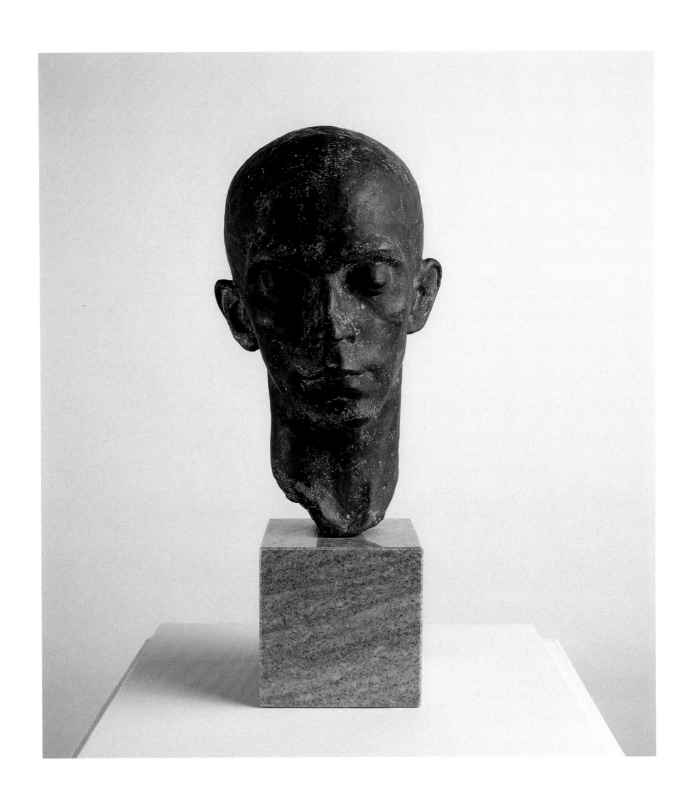

7 Richmond Barthé

Head of a Dancer, 1937

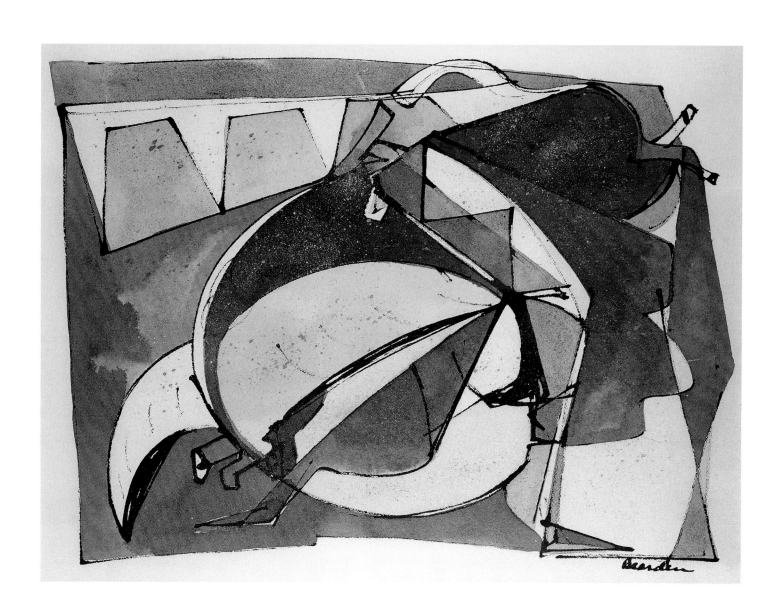

8 Romare Bearden

Lament for a Bullfighter (Inspired by Garcia Lorca), 1944

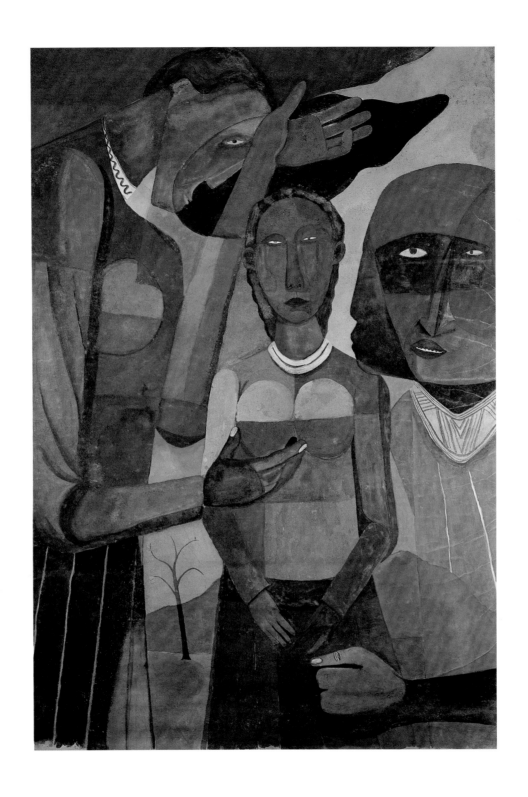

9 Romare Bearden

Presage, 1944

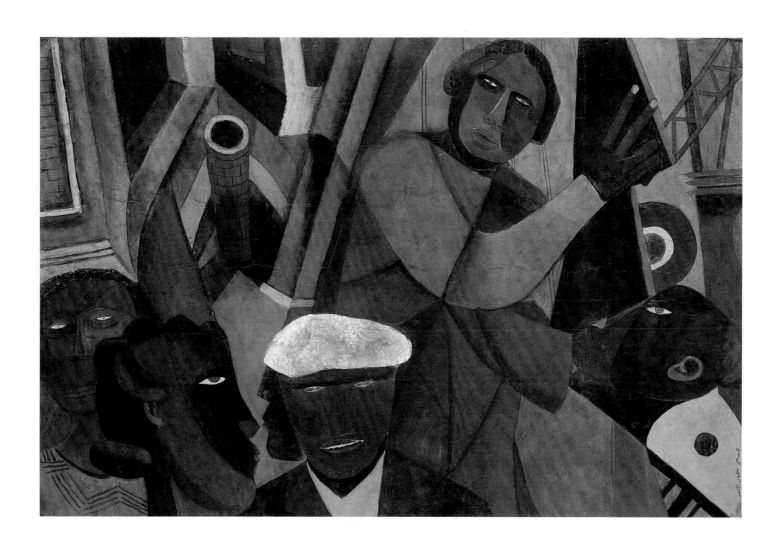

10 Romare Bearden

The Black Man in the Making of America, 1960

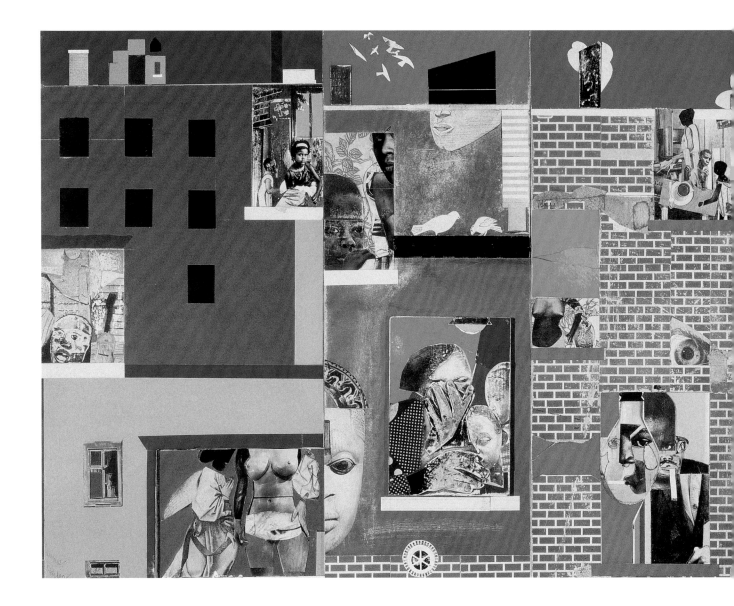

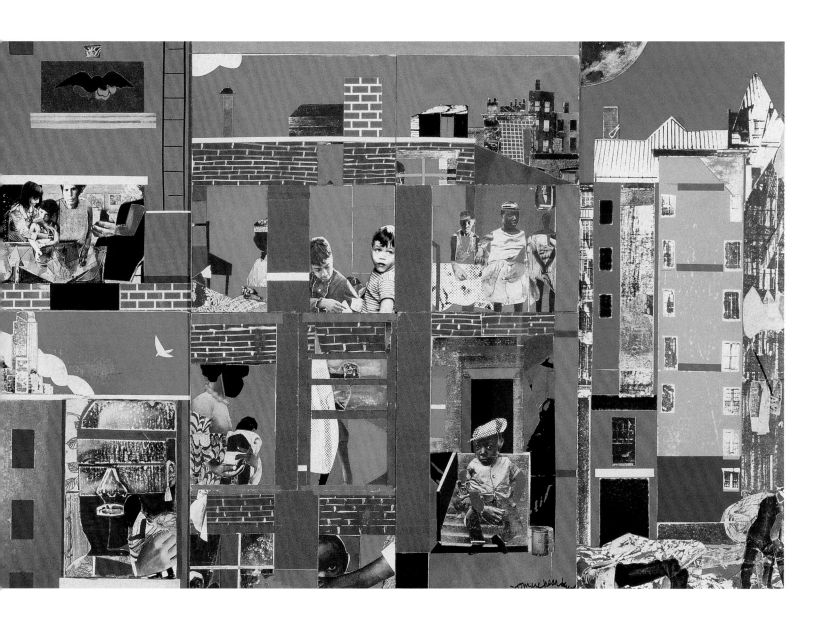

11 Romare Bearden

The Block II, 1972

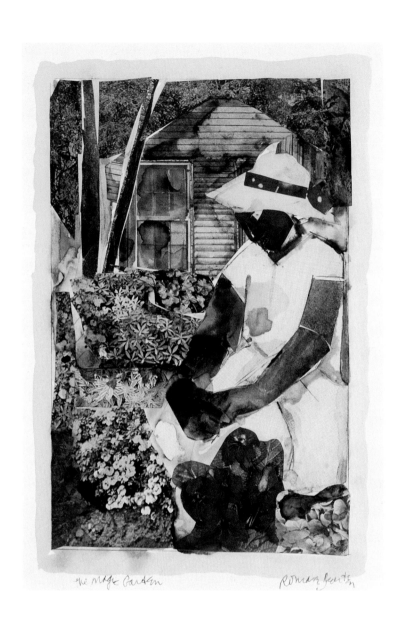

the Magic Garden Romare Bearden

12 Romare Bearden

The Magic Garden, 1978

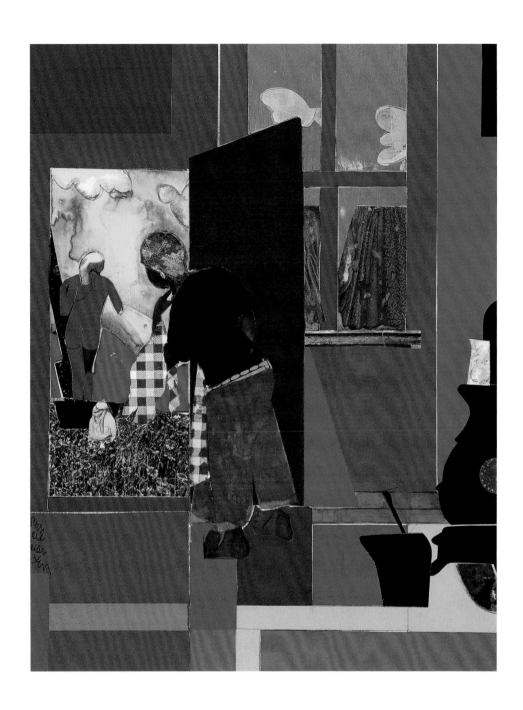

13 Romare Bearden

Sunrise, 1978

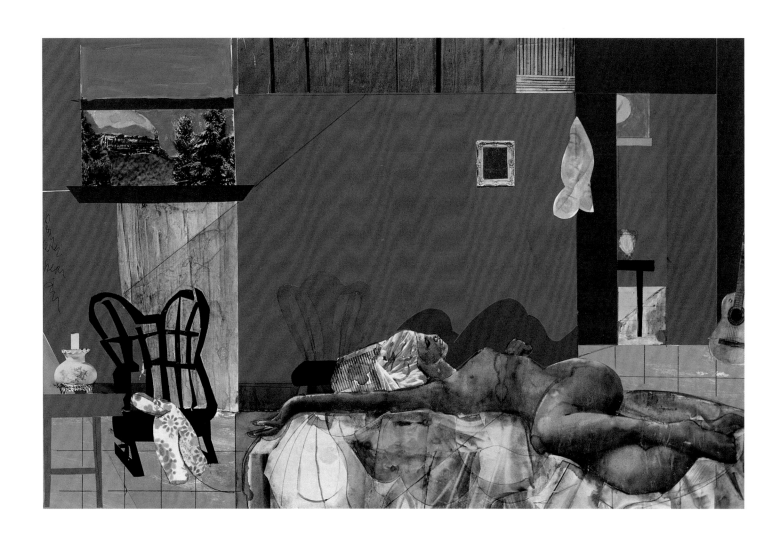

14 Romare Bearden

Reclining Nude, 1979

15 Romare Bearden

Jazz Rhapsody, 1982

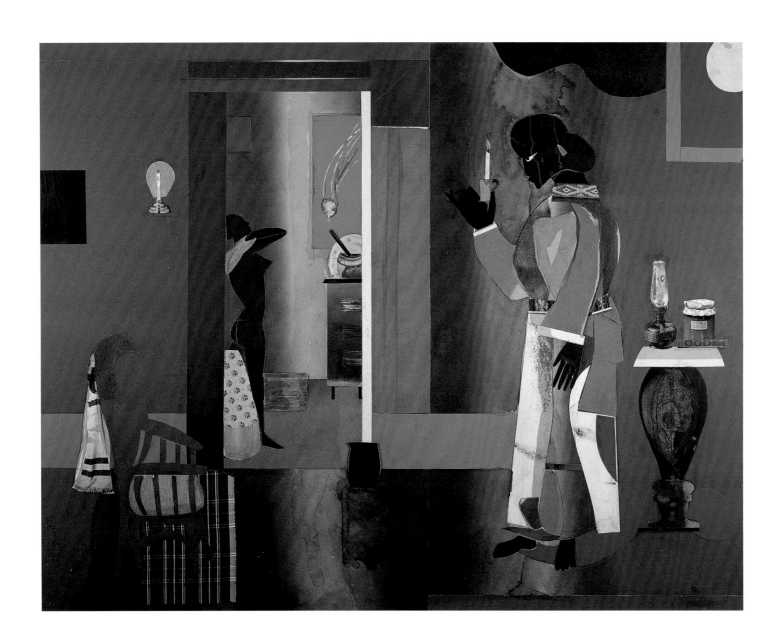

16 Romare Bearden

A Summer Star, 1982

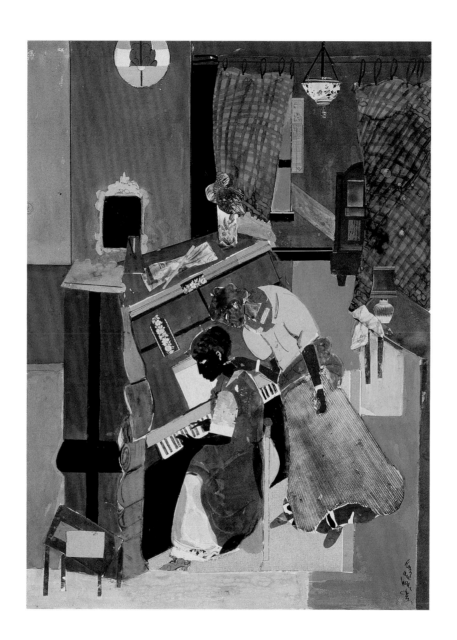

17 Romare Bearden

The Piano Lesson, 1983

18 Robert Blackburn

The Mirror, C. 1940

19 Margaret Burroughs

Girl Seated, 1959

20 Elizabeth Catlett

Pensive, 1946

21 Elizabeth Catlett

Homage to Black Women Poets, 1984

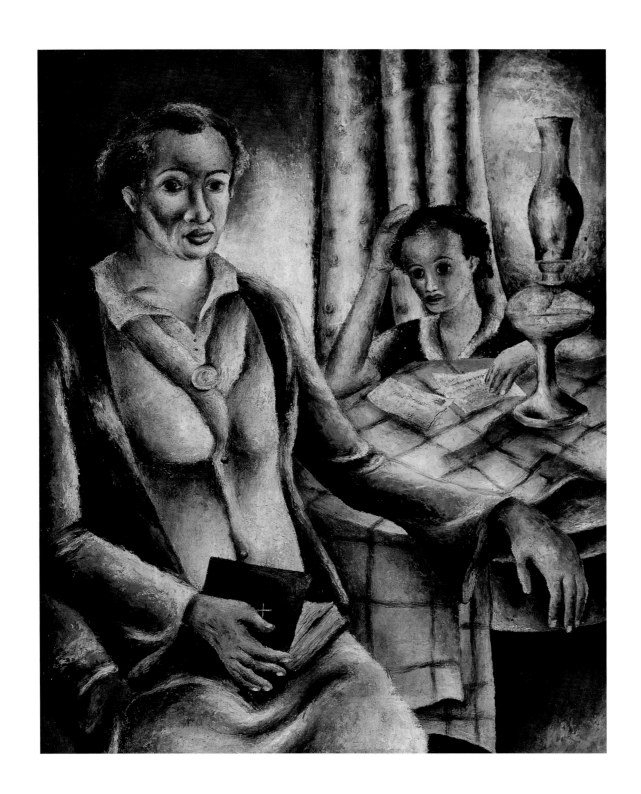

22 Eldzier Cortor

The Night Letter, 1938

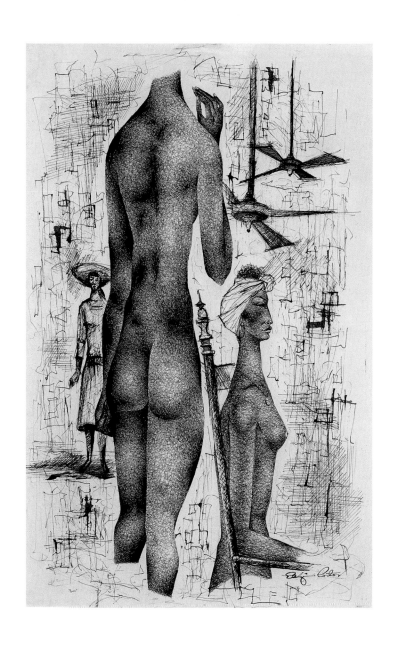

23 Eldzier Cortor

Composition with Three Women, c. 1950

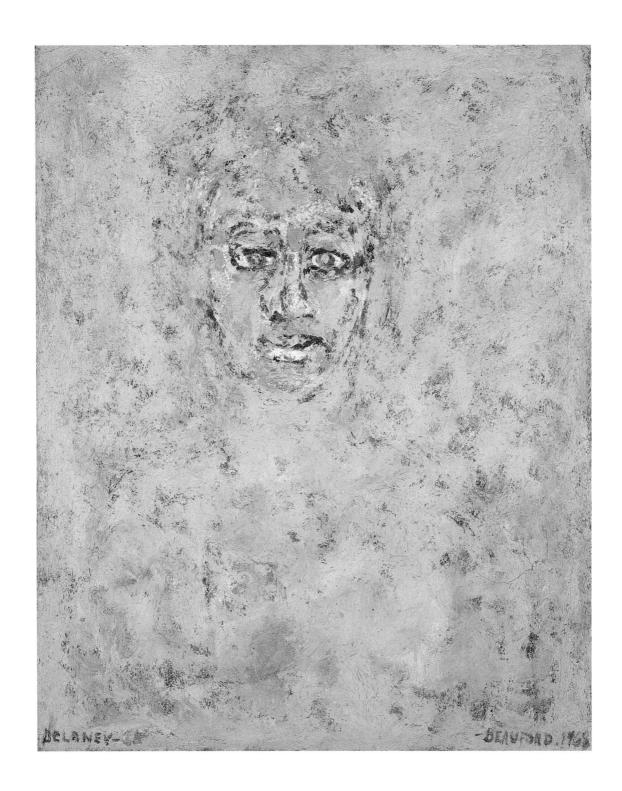

24 Beauford Delaney

Portrait of Ella Fitzgerald, 1968

25 Aaron Douglas

The Creation, 1927

26 Aaron Douglas

Go Down Death—A Funeral Sermon, 1927

27 Aaron Douglas

The Judgment Day, 1927

28 Aaron Douglas

Boy with Toy Plane, 1938

29 Aaron Douglas

The Negro Speaks of Rivers (For Langston Hughes), 1941

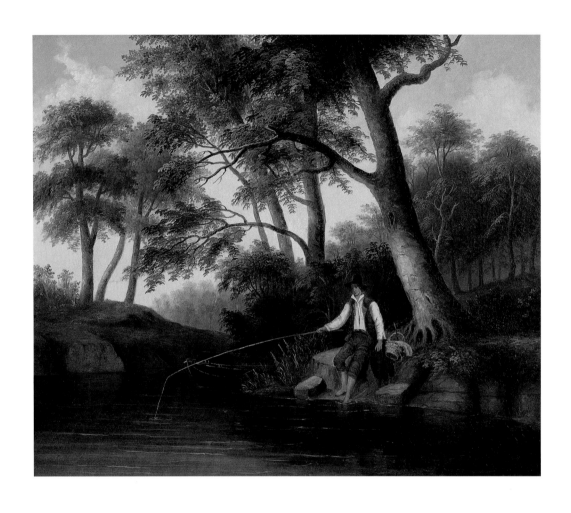

30 Robert Scott Duncanson

Man Fishing, 1848

31 Robert Scott Duncanson

Flight of the Eagle, 1856

32 Robert Scott Duncanson

Chapultepec Castle, c. 1860

33 Robert Scott Duncanson

American Landscape, 1862

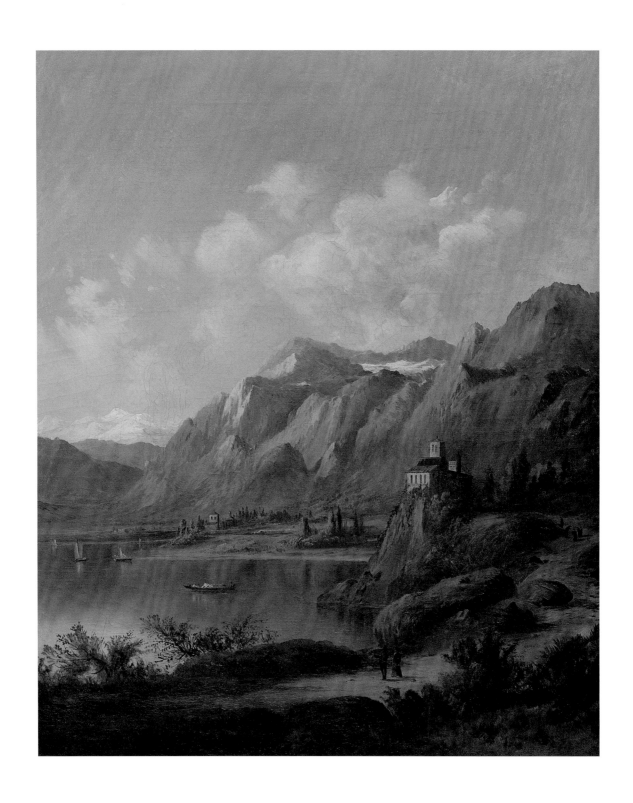

34 Robert Scott Duncanson

Lake Maggiori, 1871

35 Edwin A. Harleston

Portrait of a Woman, c. 1920

36 William A. Harper

Staircase, c. 1908

37 Richard Hunt

Wall Piece with Hanging Form, 1963

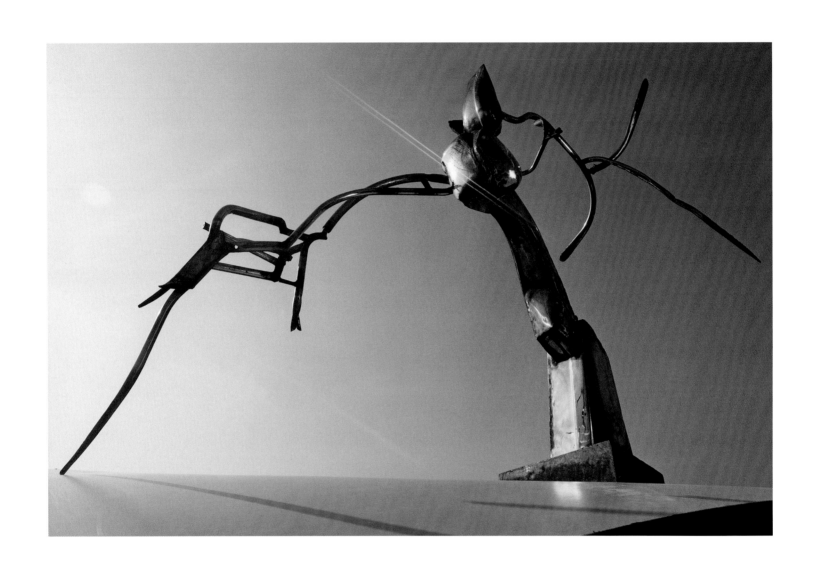

38 Richard Hunt

Bigger Bridge, 1983

39 Richard Hunt

Model for Middle Passage Monument, 1987

40 Richard Hunt

Instrument of Change (The Diaspora), 1997

41 Clementine Hunter

Funeral Procession, c. 1950

42 Clementine Hunter

Zinnias in a Pot, 1965

43 Sargent Claude Johnson

#2 Mask, c. 1940

44 Sargent Claude Johnson

The Politician, 1965

45 Sargent Claude Johnson

Cubist Bird, c. 1966

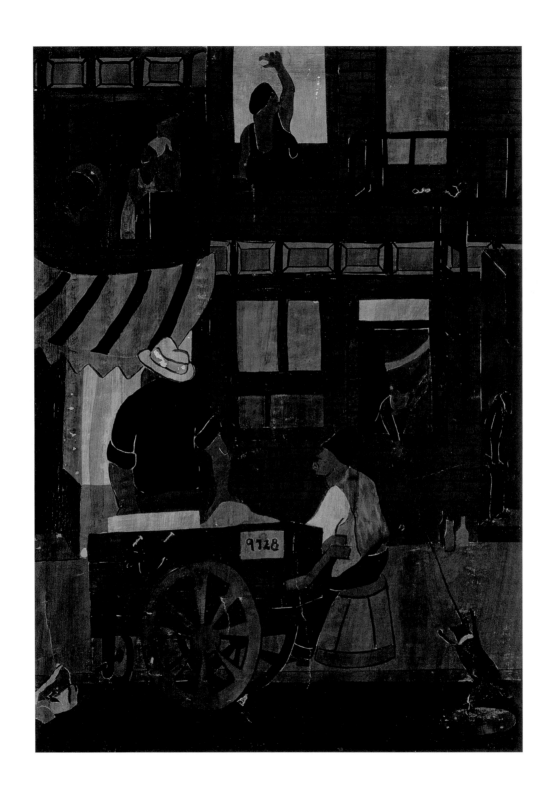

46 Jacob Lawrence

Iceman, 1936

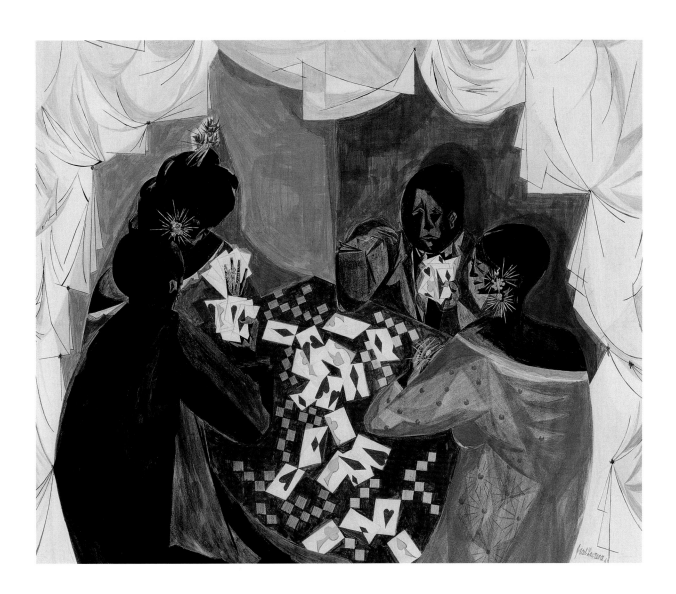

47 **Jacob Lawrence**

The Card Game, 1953

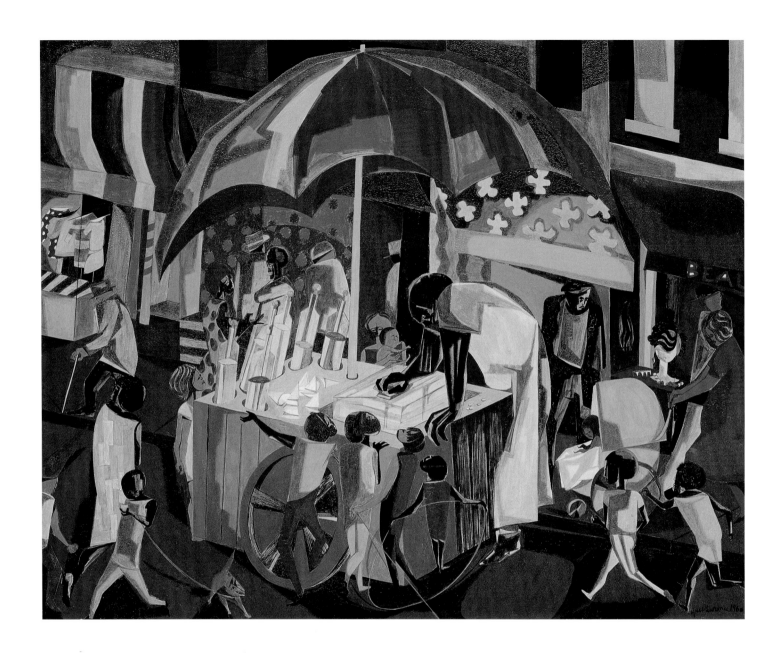

48 Jacob Lawrence

Ices II, 1960

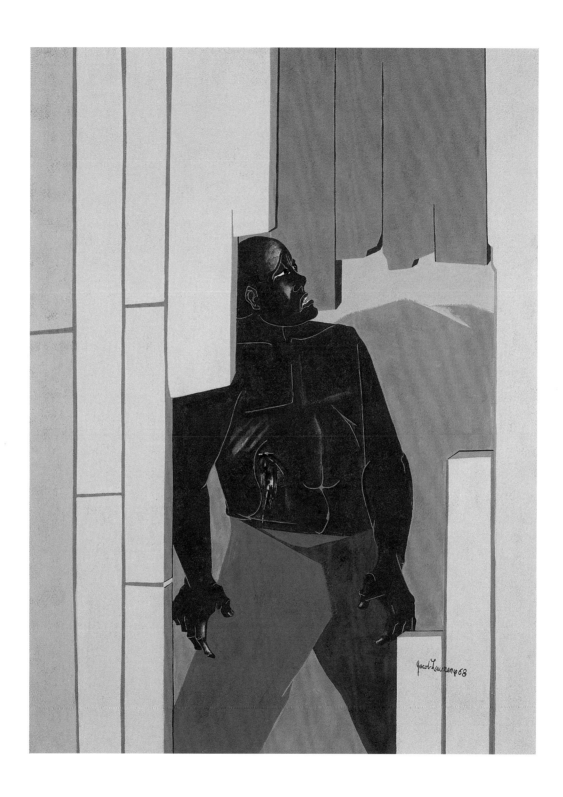

49 Jacob Lawrence

Wounded Man, 1968

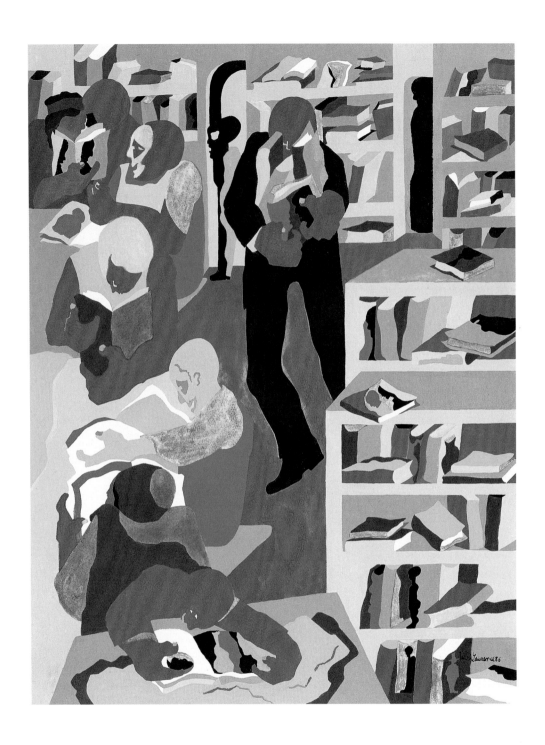

50 Jacob Lawrence

Library Series: The Schomburg, 1986

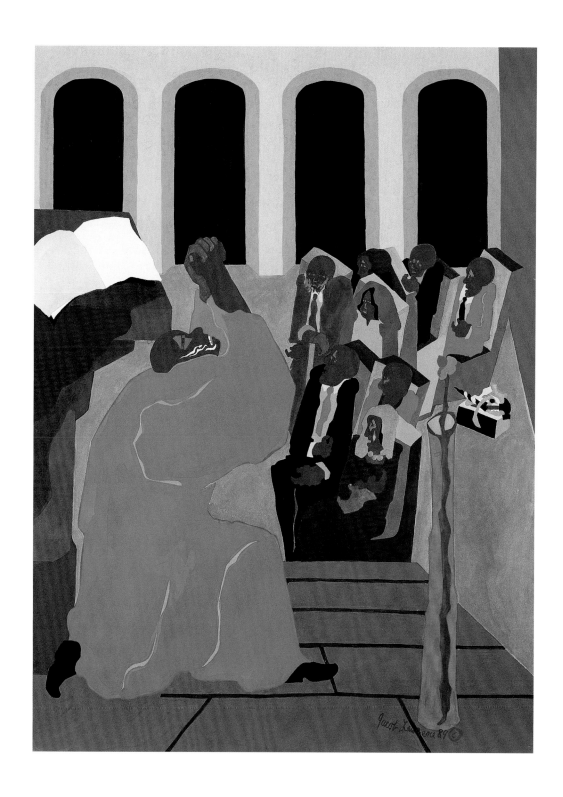

51 Jacob Lawrence

Genesis Creation Sermon I: In the Beginning All Was Void, 1989

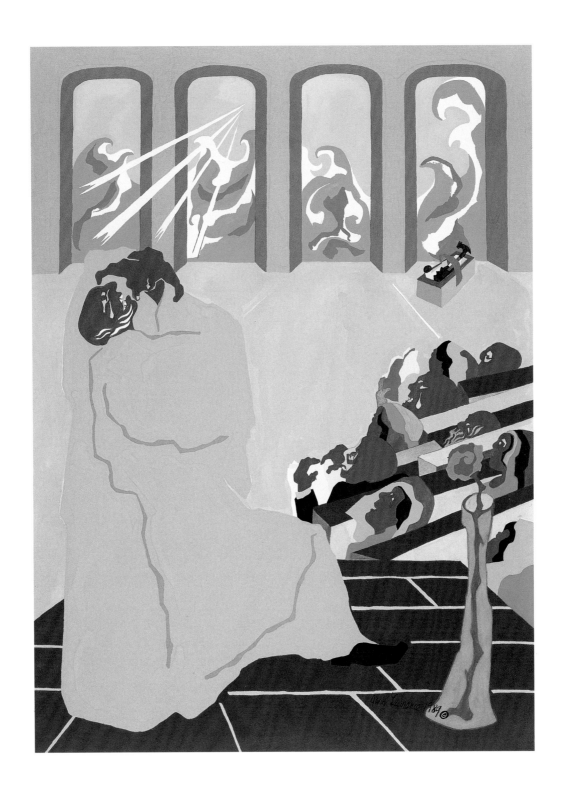

52 **Jacob Lawrence**

*Genesis Creation Sermon II: And God Brought Forth the Firmament
and the Waters*, 1989

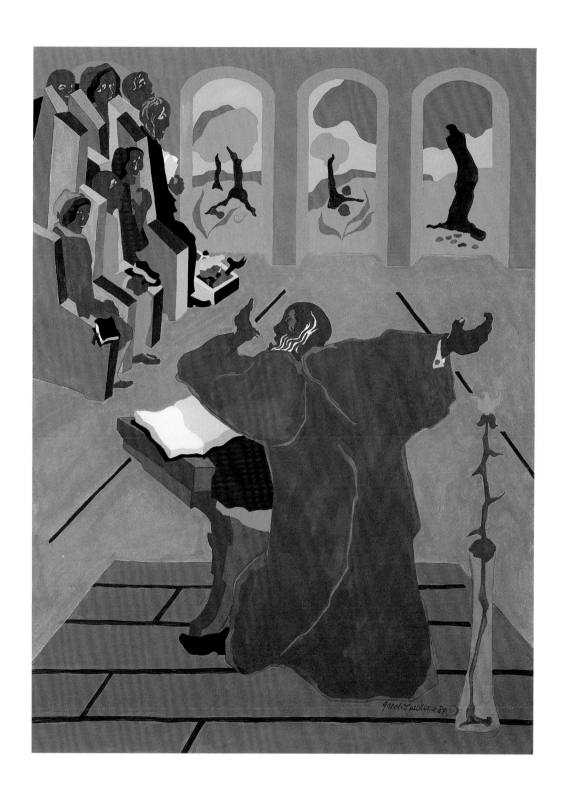

53 Jacob Lawrence

Genesis Creation Sermon III: And God Said "Let the Earth Bring Forth the Grass, Trees, Fruits, and Herbs," 1989

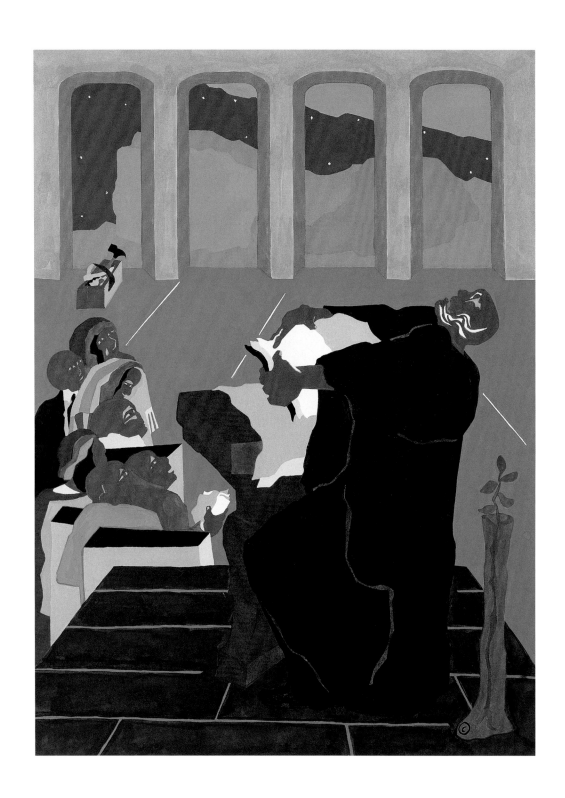

54 **Jacob Lawrence**

Genesis Creation Sermon IV: And God Created the Day and the Night
and God Created and Put Stars in the Skies, 1989

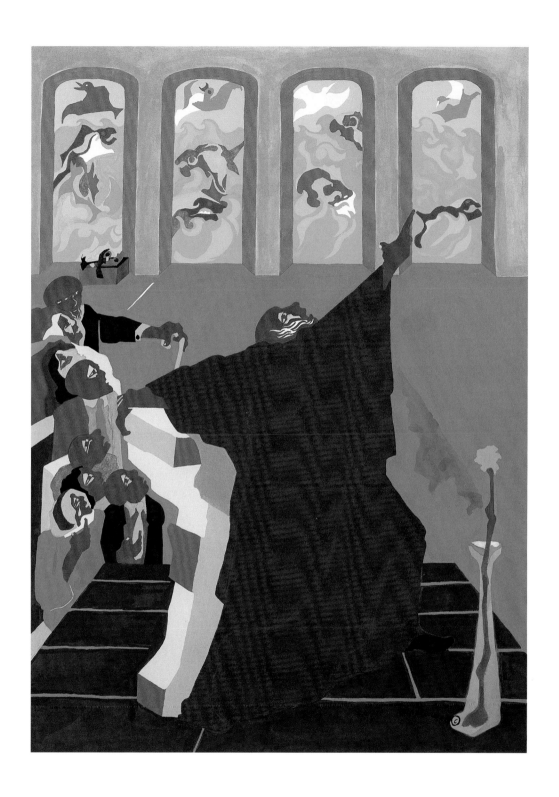

55 Jacob Lawrence

*Genesis Creation Sermon V: And God Created All the Fowls of the Air and
Fishes of the Seas,* 1989

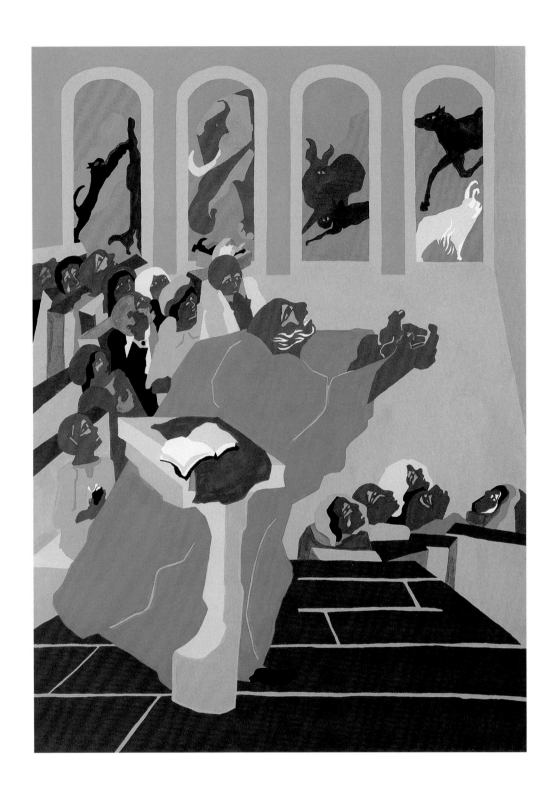

56 **Jacob Lawrence**

Genesis Creation Sermon VI: And God Created All the Beasts of the Earth, 1989

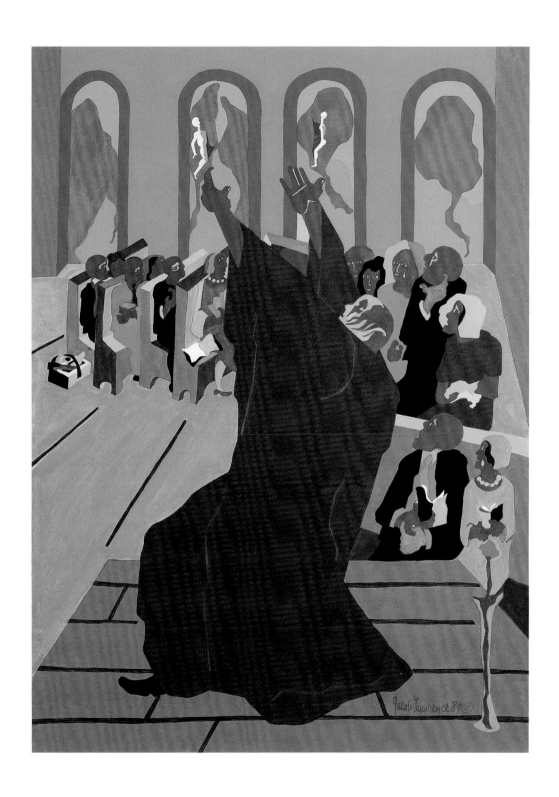

57 Jacob Lawrence

Genesis Creation Sermon VII: And God Created Man and Woman, 1989

58 **Jacob Lawrence**

Genesis Creation Sermon VIII: And Creation Was Done and All Was Well, 1989

59 **Hughie Lee-Smith**

Landscape, 1947

60 **Hughie Lee-Smith**

Landscape, 1958

61 Mary Edmonia Lewis

The Wooing of Hiawatha, 1866

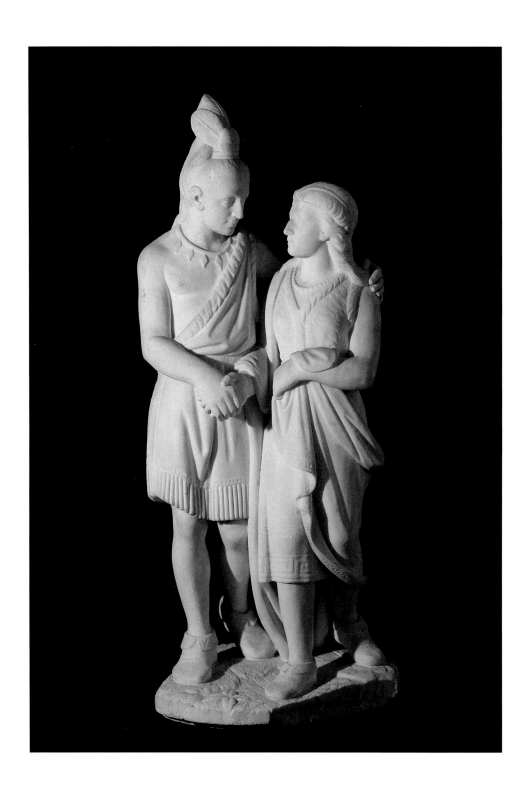

62 Mary Edmonia Lewis

The Marriage of Hiawatha, c. 1868

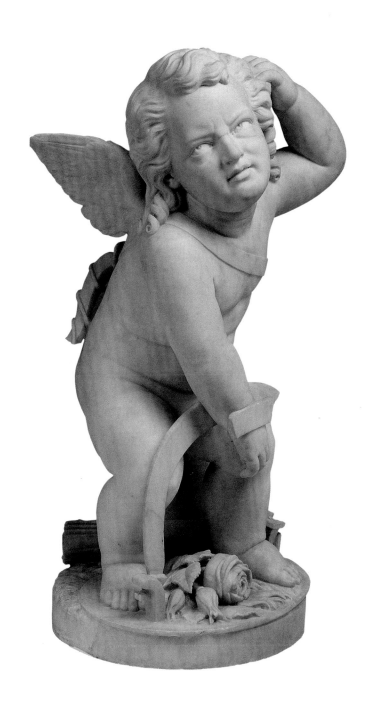

63 Mary Edmonia Lewis

Cupid Caught, 1875

64 Norman Lewis

Untitled, 1961

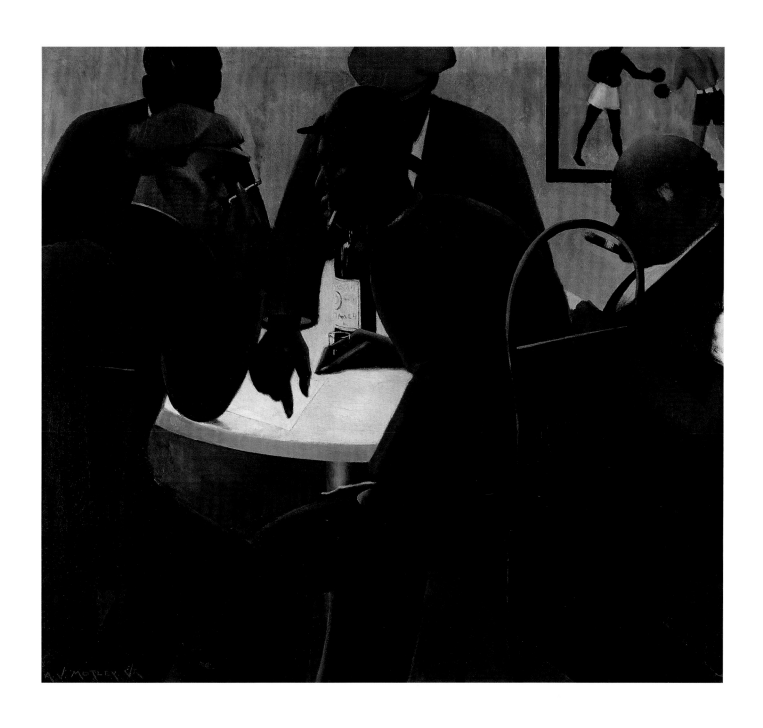

65 **Archibald J. Motley, Jr.**

The Plotters, 1939

66 Marion Perkins

Figure Sitting, c. 1939

67 **Horace Pippin**

Duck Shooting, 1941

68 Charles Ethan Porter

Autumn Landscape, c. 1887

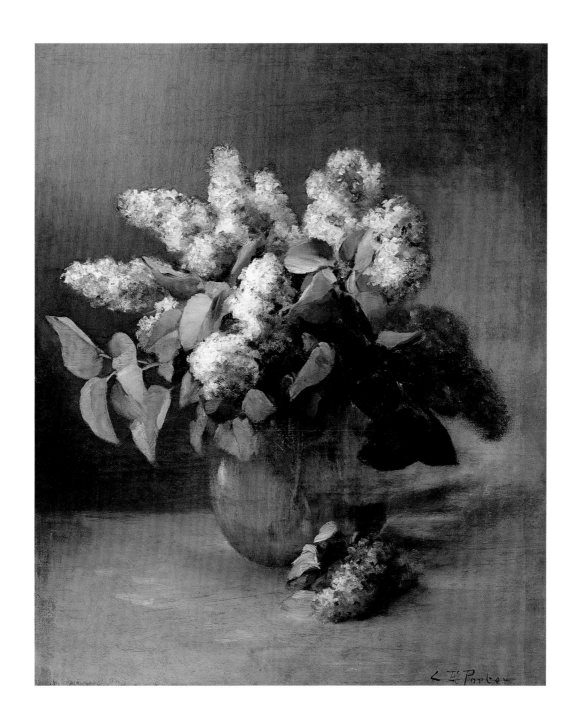

69 Charles Ethan Porter

Lilacs, c. 1890

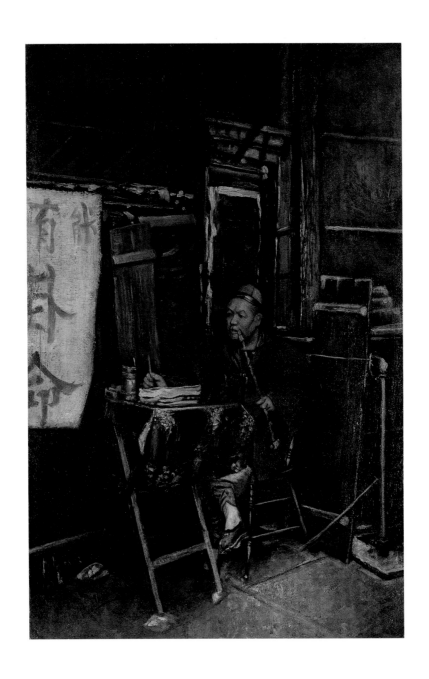

70 Nelson A. Primus

Fortune Teller, 1898

71 Charles Sebree

Head of a Woman, 1938

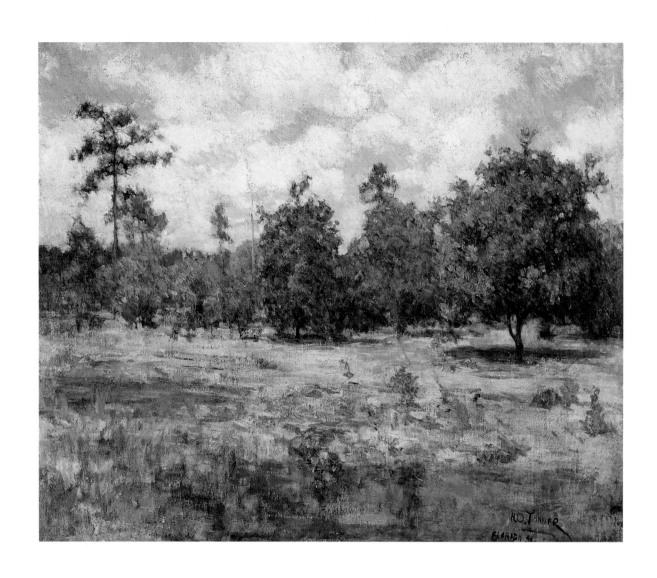

72 Henry Ossawa Tanner

Florida, 1894

73 Alma Thomas

Etude in Blue, 1966

74 Robert Thompson

Reflections, 1962

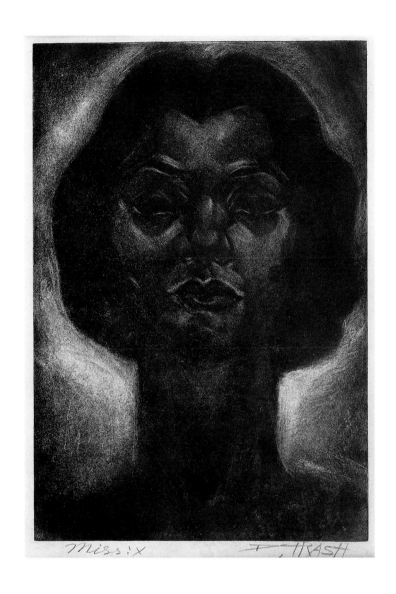

75 Dox Thrash

Miss X, 1930

76 James Lesesne Wells

Rural Landscape, 1940

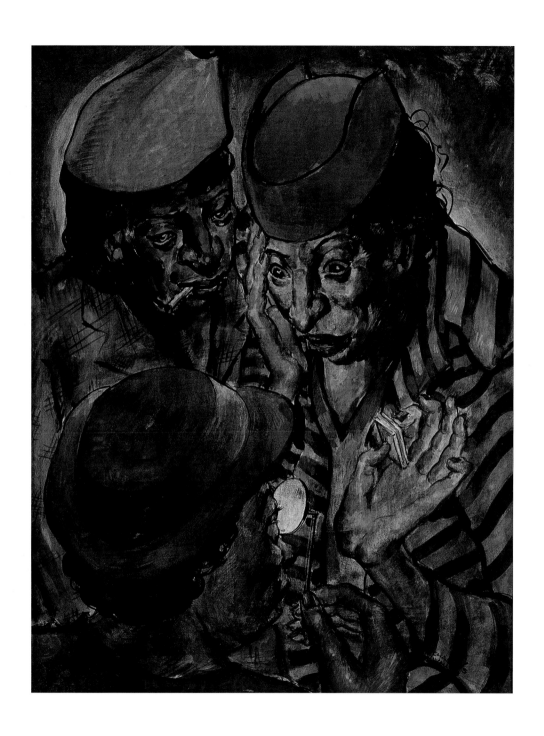

77 Charles White

The Bridge Party, 1938

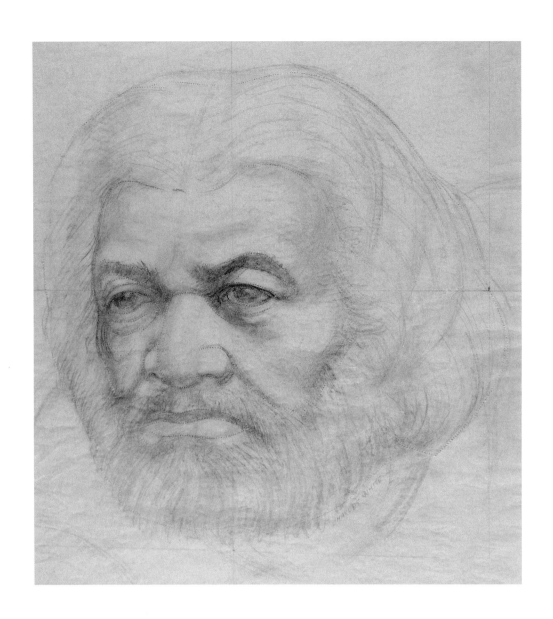

78 Charles White

Frederick Douglass, 1940

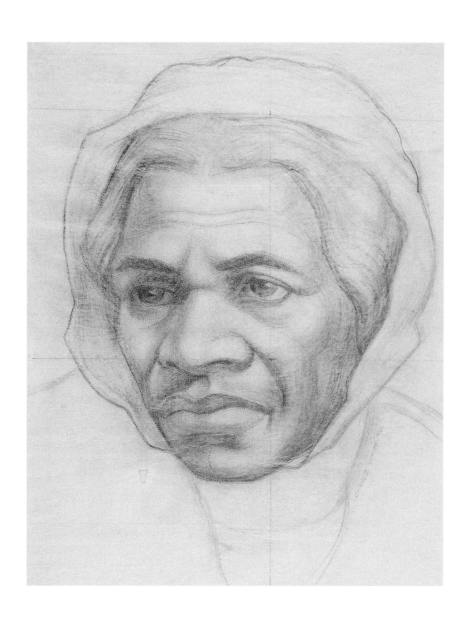

79 **Charles White**

Sojourner Truth, 1940

80 Charles White

Woman Worker, 1951

Checklist

Dimensions are given in inches; height precedes width precedes depth.

Charles Alston

Pl. 1
Seated Figure, 1970
Pastel on paper
26½ × 19½

Edward Mitchell Bannister

Pl. 2
Streamside, 1870
Oil on canvas
14 × 21

Pl. 3
Ledge off Bailey's Beach, c. 1890
Watercolor
7½ × 10

Pl. 4
The Old Homestead, 1895
Oil on canvas
36½ × 56½

Pl. 5
Landscape, 1897
Oil on canvas
21 × 25

Pl. 6
Summer Twilight, 1899
Oil on canvas
14 × 19½

Richmond Barthé

Pl. 7
Head of a Dancer, 1937
Bronze
18 × 7 × 7

Romare Bearden

Pl. 8
Lament for a Bullfighter (Inspired by Garcia Lorca), 1944
Watercolor
19¼ × 26¼

Pl. 9
Presage, 1944
Gouache on brown paper
48 × 32

Pl. 10
The Black Man in the Making of America, 1960
Mixed media on Masonite
31 × 47

Pl. 11
The Block II, 1972
Collage on board
25½ × 74

Pl. 12
The Magic Garden, 1978
Collage on board
9 × 6

Pl. 13
Sunrise, 1978
Collage on board
18 × 14

Pl. 14
Reclining Nude, 1979
Collage on board
15½ × 23½

Pl. 15
Jazz Rhapsody, 1982
Collage on board
8½ × 11

Pl. 16
A Summer Star, 1982
Collage on board
30 × 40

Pl. 17
The Piano Lesson, 1983
Collage on board
29 × 22

Robert Blackburn

Pl. 18
The Mirror, c. 1940
Monoprint
20 × 24

Margaret Burroughs

Pl. 19
Girl Seated, 1959
Watercolor
23½ × 17

Elizabeth Catlett

Pl. 20
Pensive, 1946
Bronze
19¼ × 11 × 7

Pl. 21
Homage to Black Women Poets, 1984
Mahogany
69 × 15 × 13

Eldzier Cortor

Pl. 22
The Night Letter, 1938
Oil on canvas
36 × 30

Pl. 23
Composition with Three Women, c. 1950
Pen and ink on paper
22½ × 15

Beauford Delaney

Pl. 24
Portrait of Ella Fitzgerald, 1968
Oil on canvas
24 × 19¾

Aaron Douglas

Pl. 25
The Creation, 1927
Gouache on paper
12¾ × 9

Pl. 26
Go Down Death—A Funeral Sermon, 1927
Gouache on paper
13½ × 9¾

Pl. 27
The Judgment Day, 1927
Gouache on paper
11¾ × 9

Pl. 28
Boy with Toy Plane, 1938
Oil on canvas
22½ × 17

Pl. 29
The Negro Speaks of Rivers (For Langston Hughes), 1941
Pen and ink on paper
5½ × 11

Robert Scott Duncanson

Pl. 30
Man Fishing, 1848
Oil on canvas
25 × 30

Pl. 31
Flight of the Eagle, 1856
Oil on canvas
28 × 44

Pl. 32
Chapultepec Castle, c. 1860
Oil on canvas
24 × 31

Pl. 33
American Landscape, 1862
Oil on canvas
24 × 36

Pl. 34
Lake Maggiori, 1871
Oil on canvas
34 × 29

Edwin A. Harleston

Pl. 35
Portrait of a Woman, c. 1920
Oil on canvas
20 × 16

William A. Harper

Pl. 36
Staircase, c. 1908
Oil on board
17 × 21

Richard Hunt

Pl. 37
Wall Piece with Hanging Form, 1963
Welded steel
36 × 21 × 13

Pl. 38
Bigger Bridge, 1983
Welded steel
57 × 79 × 32

Pl. 39
Model for Middle Passage Monument, 1987
Bronze
12 × 33 × 33

Pl. 40
Instrument of Change (The Diaspora), 1997
Bronze
31 × 30 × 17

Clementine Hunter

Pl. 41
Funeral Procession, c. 1950
Oil on board
13 × 18

Pl. 42
Zinnias in a Pot, 1965
Oil on board
32 × 28

Sargent Claude Johnson

Pl. 43
#2 Mask, c. 1940
Copper
8 × 6½ × 1½

Pl. 44
The Politician, 1965
Black Oaxacan clay
9¾ × 3 × 2¾

Pl. 45
Cubist Bird, c. 1966
Enamel on steel
12 × 15½

Jacob Lawrence

Pl. 46
Iceman, 1936
Gouache on paper
24 × 19

Pl. 47
The Card Game, 1953
Tempera on board
19 × 23½

Pl. 48
Ices II, 1960
Tempera on board
24 × 30

Pl. 49
Wounded Man, 1968
Gouache on paper
29½ × 22

Pl. 50
Library Series: The Schomburg, 1986
Gouache on paper
26 × 20

Pl. 51
Genesis Creation Sermon I: In the Beginning All Was Void, 1989
Gouache on paper
29¾ × 22

Pl. 52
Genesis Creation Sermon II: And God Brought Forth the Firmament and the Waters, 1989
Gouache on paper
29¾ × 22

Pl. 53
Genesis Creation Sermon III: And God Said "Let the Earth Bring Forth the Grass, Trees, Fruits, and Herbs," 1989
Gouache on paper
29¾ × 22

Pl. 54
Genesis Creation Sermon IV: And God Created the Day and the Night and God Created and Put Stars in the Skies, 1989
Gouache on paper
29¾ × 22

Pl. 55
Genesis Creation Sermon V: And God Created All the Fowls of the Air and Fishes of the Seas, 1989
Gouache on paper
29¾ × 22

Pl. 56
Genesis Creation Sermon VI: And God Created All the Beasts of the Earth, 1989
Gouache on paper
29¾ × 22

Pl. 57
Genesis Creation Sermon VII: And God Created Man and Woman, 1989
Gouache on paper
29¾ × 22

Pl. 58
Genesis Creation Sermon VIII: And Creation Was Done and All Was Well, 1989
Gouache on paper
29¾ × 22

Hughie Lee-Smith

Pl. 59
Landscape, 1947
Oil on board
19½ × 26½

Pl. 60
Landscape, 1958
Watercolor
12 × 16¾

Mary Edmonia Lewis

Pl. 61
The Wooing of Hiawatha, 1866
White marble
24 × 15 × 15

Pl. 62
The Marriage of Hiawatha, c. 1868
White marble
29 × 11½ × 12

Pl. 63
Cupid Caught, 1875
White marble
27½ × 14 × 12

Norman Lewis

Pl. 64
Untitled, 1961
Oil on paper
40 × 26½

Archibald J. Motley, Jr.

Pl. 65
The Plotters, 1939
Oil on canvas
36 × 40

Marion Perkins

Pl. 66
Figure Sitting, c. 1939
Stone
11 × 6 × 10

Horace Pippin

Pl. 67
Duck Shooting, 1941
Oil on burnt wood panel
9½ × 14½

Charles Ethan Porter

Pl. 68
Autumn Landscape, c. 1887
Oil on canvas
18 × 24

Pl. 69
Lilacs, c. 1890
Oil on canvas
22 × 18

Nelson A. Primus

Pl. 70
Fortune Teller, 1898
Oil on board
12½ × 8½

Charles Sebree

Pl. 71
Head of a Woman, 1938
Tempera on board
11½ × 8½

Henry Ossawa Tanner

Pl. 72
Florida, 1894
Oil on canvas
18½ × 22½

Alma Thomas

Pl. 73
Etude in Blue, 1966
Oil on canvas
48 × 32

Robert Thompson

Pl. 74
Reflections, 1962
Gouache on paper
21½ × 17½

Dox Thrash

Pl. 75
Miss X, 1930
Carborundum print
10½ × 7½

James Lesesne Wells

Pl. 76
Rural Landscape, 1940
Oil on canvas
20 × 24

Charles White

Pl. 77
The Bridge Party, 1938
Oil on canvas
22 × 17

Pl. 78
Frederick Douglass, 1940
Pencil on paper
14 × 11½

Pl. 79
Sojourner Truth, 1940
Pencil on paper
14 × 11½

Pl. 80
Woman Worker, 1951
Oil on canvas
30 × 24

Artists' Biographies

Compiled by Andrea D. Barnwell, Kirsten P. Buick, and Amy M. Mooney

The following brief biographies of the artists represented in this book note highlights of their lives and careers. For more complete information, see the selected references.

Charles Alston

1907–1977

Charles Alston was born in Charlotte, North Carolina, and moved to New York with his family in 1915. He studied at Columbia College, the Teacher's College at Columbia University, the National Academy of Art, and the Pratt Institute. In the late 1920s, he assisted Alain Locke with an exhibition of African art held at the 135th Street branch of the New York Public Library (now the Schomburg Center for Research in Black Culture). This early contact with African art inspired him to incorporate African themes into his work. A skilled painter, sculptor, and teacher, Alston had a profound impact on many New York artists, including Romare Bearden, Jacob Lawrence, and Norman Lewis. Alston taught at the Art Students League and founded an intellectual center in Harlem at 306 West 141st Street that attracted artists, musicians, writers, and actors. Represented in major New York museums such as the Metropolitan Museum of Art and the Whitney Museum of American Art, Alston is also known for his commercial art and the seven important murals he executed in the Harlem Hospital and the Golden State Mutual Life Insurance Company in Los Angeles. He received the Distinguished Alumni Award from Columbia University in 1975.

Bearden, Romare, and Harry Henderson. *A History of African-American Artists: From 1792 to the Present.* New York: Pantheon Books, 1993, pp. 260–70.

Coker, Gylbert Garvin. *Charles Alston, Artist and Teacher.* New York: Kenkeleba Gallery, 1990.

—ADB

Edward Mitchell Bannister

1828–1901

Born in New Brunswick, Canada, Edward Mitchell Bannister was listed in the 1850 Boston census as a resident. He received his first commission for a seascape in 1854, from John V. DeGrasse, an African American physician. From 1863 to 1865, Bannister studied with William Rimmer, a physician and sculptor, at the Lowell Institute, Massachusetts. In newspaper advertisements Bannister described himself as a "photographist" until 1865, when he changed his title to "artist." Although Bannister also painted portraits, he made his reputation as a landscape painter. In 1869 he moved to Providence, Rhode Island. The artist won one of four first-prize medals for *Under the Oaks* (whereabouts unknown) in 1876 at the Philadelphia Centennial Exposition. Bannister served on the original board of directors of the Rhode Island School of Design. A founding member of the Providence Art Club, he exhibited regularly there and at the Boston Art Club. Bannister continued to exhibit landscapes until 1899, two years before his death.

Holland, Juanita Marie. *Edward Mitchell Bannister, 1828–1901.* New York: Harry N. Abrams, 1992.
———. "To Be Free, Gifted, and Black: African American Artist Edward Mitchell Bannister." *The International Review of African American Art* 12, no. 1 (1995), pp. 4–25.

—KPB

Richmond Barthé

1901–1989

Richmond Barthé was born in Bay Saint Louis, Mississippi. He demonstrated artistic talent at a very young age and began formal artistic training in 1924 at the School of the Art Institute of Chicago where he pursued painting. During his senior year, he began modeling in clay to enhance his skill at depicting three-dimensional forms on canvas. Following his graduation from art school in 1929, Barthé moved to New York, where he earned praise from art critics including the leading black theorist Alain Locke. Almost immediately, Barthé began to establish himself as a sculptor. In the 1930s he was the most widely exhibited artist affiliated with the Harmon Foundation, noted for promoting the achievements of African American writers and visual artists. He also received notable honors, such as a Julius Rosenwald Fellowship in 1931–32 and a Guggenheim Fellowship in 1940–41. While recognized for his portrait busts of African American luminaries, Barthé is perhaps best known for his sinuous depictions of athletes and African dancers with lithe physiques and attenuated limbs that convey agility, elegance, and sensuality.

Bearden, Romare, and Harry Henderson. *A History of African-American Artists: From 1792 to the Present.* New York: Pantheon Books, 1993, pp. 136–46.

Vendryes, Margaret. "Expression and Repression of Identity: Race, Religion, and Sexuality in the Art of American Sculptor Richmond Barthé." Ph.D. dissertation, Princeton University, 1998.

—ADB

Romare Bearden

1912–1988

Born in Charlotte, North Carolina, Romare Bearden moved to Harlem with his parents when he was a young child. After earning a degree in mathematics from New York University, he enrolled in the Art Students League and studied with German artist George Grosz. From 1942 to 1945, Bearden served in the army and traveled to Paris; Bearden studied art history and philosophy at the Sorbonne in 1950. Throughout his career he explored mythological and religious themes. He is known for his revolutionary use of collage and photomontage. A founding member of Spiral, a group promoting civil rights in the visual arts, Bearden sought to relate the work of African American artists to the struggle for racial equality and the complexity and beauty of black American life.

Bearden, Romare. *The Art of Romare Bearden: The Prevalence of Ritual.* New York: Harry N. Abrams, 1973.

Conwill, Kinshasha, Sharon Patton, and Mary Schmidt Campbell. *Memory and Metaphor.* New York: Studio Museum in Harlem, 1991.

Schwartzman, Myron. *Romare Bearden: His Life and Art.* New York: Harry N. Abrams, 1990.

—ADB

Robert Blackburn

B. 1920

Robert Blackburn, best known as the director of the nonprofit Printmaking Workshop in New York, has provided facilities and instruction for young and needy artists for more than forty years. He studied in New York at the Uptown Community Arts Center, the Harlem Community Art Center, the Art Students League, and Atelier 17. While working on a WPA-sponsored project at the Harlem Community Art Center as a teenager, he learned to make lithographs, the medium for which he is most acclaimed. He has taught at institutions such as the College of the City of New York, the New School for Social Research, and Columbia University and worked as a master printer at Universal Limited Arts Editions. Celebrated for his keen observations and attention to detail, Blackburn has selflessly dedicated his time to advancing the careers of countless artists. In 1992, at age seventy-two, he was awarded a MacArthur Fellowship for his lifetime achievements.

Williams, Dave, and Reba Williams. *Alone in a Crowd: Prints of the 1930s and 1940s by African-American Artists from the Collection of Dave and Reba Williams.* Newark, N.J.: Newark Museum and Equitable Gallery, 1992.

—ADB

Margaret Burroughs

B. 1917

A native of Saint Rose, Louisiana, Margaret Burroughs moved with her family to Chicago in 1922, along with many blacks from the South in the early decades of this century who migrated to Northern cities in search of better jobs and educational opportunities. Burroughs earned a B.A. and an M.F.A. from the School of the Art Institute of Chicago and later studied at the Teacher's College at Columbia University in New York. Throughout her distinguished career, she has often evoked the themes of family, community, and history in her paintings, sculptures, and prints. In addition to her prolific artistic life, Burroughs has been a writer and a prominent activist. She helped establish the South Side Community Art Center in Chicago, one of the few WPA projects still operating today. Burroughs, a cofounder of the DuSable Museum of African American History in Chicago, currently lives and works in Chicago and serves on the board of the Chicago Park District.

"Margaret Taylor Goss Burroughs, Interview by Anna M. Tyler, Nov. 11–Dec. 5, 1988." Archives of American Art, Smithsonian Institution, Washington, D.C.

—ADB

Elizabeth Catlett

B. 1915

Born in Washington, D.C., Elizabeth Catlett studied at Howard University with Lois Mailou Jones and James Porter. In 1940 she earned an M.F.A. from the University of Iowa, where she studied with regionalist painter Grant Wood. After earning a Julius Rosenwald Fellowship in 1946, she traveled to Mexico City and worked at the Taller de Gráfica Popular. In her sculpture, painting, and works on paper, Catlett represents the beauty of the female form and conveys the principles of Social Realism. Catlett, the recipient of numerous prestigious awards, continues to live and work in Mexico with her husband, artist Francisco Mora.

Gedeon, Lucinda. *Elizabeth Catlett Sculpture: A Fifty-Year Retrospective.* Purchase, N.Y.: Neuberger Museum of Art, 1998.

Herzog, Melanie. "Elizabeth Catlett in Mexico: Identity and Cross-Cultural Intersections in the Production of Artistic Meaning." *The International Review of African American Art* 11, no. 3 (1994), pp. 19–25, 55–60.

Lewis, Samella. *The Art of Elizabeth Catlett.* Claremont, Calif.: Hancraft Studios, 1984.

—ADB

Eldzier Cortor

B. 1916

The Cortor family moved from Richmond, Virgina, to Chicago when Eldzier Cortor was very young. At the School of the Art Institute of Chicago, he took night classes with the intention of becoming a cartoonist; he enrolled as a full-time student in 1935. Cortor was first exposed to African art on a class trip to the nearby Field Museum, a natural history institution. In 1937 he took a job as an easel painter for the WPA and also taught at the South Side Community Art Center. In 1944 and 1945, Cortor won Julius Rosenwald Fellowships, which supported his stay in the Sea Islands off the coasts of South Carolina, Georgia, and northern Florida. He learned that the black population in the region retained many African customs and beliefs, and went on to travel throughout the diaspora, visiting Cuba, Jamaica, and Haiti. After moving to New York, Cortor enrolled at Columbia University and studied woodblock-printing techniques. He is most celebrated for his paintings and drawings of elongated, sensual black female nudes.

Bearden, Romare, and Harry Henderson. *A History of African-American Artists: From 1792 to the Present.* New York: Pantheon Books, 1993, pp. 272–79.

Fax, Elton C. *Seventeen Black Artists.* New York: Dodd, Mead and Company, 1971, pp. 79–94.

Kenkeleba Gallery. *Three Masters: Eldzier Cortor, Hughie Lee-Smith, Archibald John Motley, Jr.* New York, 1988, pp. 12–16.

—KPB

Beauford Delaney

1901–1979

Beauford Delaney, born in Knoxville, Tennessee, left the South in 1923 to pursue his education in Boston, where he studied at the Massachusetts Normal School, South Boston School of Art, and the Copley Society. In 1929 he moved to New York and exhibited portraits at the Whitney Studio Galleries and at the 135th Street branch of the New York Public Library (now the Schomburg Center for Research in Black Culture). He supported himself by working as a janitor at night. Although he executed primarily portraits with expressionistic brushwork and impastoed facture, by 1941 he was painting street scenes of Greenwich Village and experimenting with non-objective abstract painting and light effects. In 1953 Delaney left the United States for Paris; he formed close friendships with James Baldwin and Henry Miller and resided in the city for the rest of his life. During this time he began working in a nonobjective mode. By 1960 museums and galleries throughout Europe were exhibiting his abstract paintings. In 1979 Delaney died in Paris while hospitalized for mental illness.

Leeming, David. *Amazing Grace: A Life of Beauford Delaney.* New York: Oxford University Press, 1998.
Studio Museum in Harlem. *Explorations in the City of Light.* New York, 1996.

—ADB

Aaron Douglas

1899–1979

Several years after earning a B.F.A. from the University of Nebraska, Aaron Douglas moved to Harlem in 1925 and was immediately hired by W. E. B. Du Bois and Charles S. Johnson to create illustrations for the magazines *The Crisis* and *Opportunity.* In developing his innovative signature style, Douglas created a modern black aesthetic that synthesized Cubism, Art Deco, folk, and African art. He was influenced by Winold Reiss, a German modernist with whom he worked in 1928–29 at the Barnes Foundation near Philadelphia.

In addition to being a talented graphic designer, Douglas was a highly skilled portrait painter who captured the sitter's personality as well as physical presence. In murals he executed at the Schomburg Center for Research in Black Culture in New York and the Erastus Milo Cravath Memorial Library at Fisk University in Nashville, Douglas depicted African American historical narratives and African themes. He is now recognized as the foremost painter, muralist, and illustrator of the Harlem Renaissance and is respected as a critical contributor to the New Negro movement. Douglas influenced and inspired several generations of artists and educators until his retirement as chairman of the art department at Fisk University in 1966.

Bearden, Romare, and Harry Henderson. *A History of African-American Artists: From 1792 to the Present.* New York: Pantheon Books, 1993, pp. 126–35.
Kirschke, Amy Helene. *Aaron Douglas: Art, Race and the Harlem Renaissance.* Jackson: University Press of Mississippi, 1995.
Patton, Sharon F. *African-American Art.* New York: Oxford University Press, 1998, pp. 116–20, passim.

—AMM

Robert Scott Duncanson

1821–1872

Growing up in Seneca County, New York, Robert Scott Duncanson learned the trades of house painting, decorating, and carpentry from his father. Duncanson at first went into the family line of business in Monroe, Michigan, but in 1841 he moved to the abolitionist town of Mount Healthy, Ohio, and became a portrait painter. Although there is no evidence that Duncanson received formal training, he contributed regularly to local exhibitions. From 1845 to 1849, he worked as an itinerant artist, traveling between Monroe, Detroit, and Cincinnati. In about 1850 he received the largest commission of his career, an ambitious mural for the home of Nicholas Longworth. In 1853–54 Duncanson went on the Grand Tour of the major capitals of Europe. Upon his return he worked in the photography studio of the African American artist James P. Ball.

Between 1856 and 1871, he created his most acclaimed works: *Flight of the Eagle* (1856), *The Rainbow* (1859), *Land of the Lotus Eaters* (1861), *Vale of Kashmir* (1867), and *Ellen's Isle, Loch Katrine* (1871). Duncanson died in Detroit at age fifty-three.

Ketner, Joseph D. *The Emergence of the African American Artist: Robert S. Duncanson, 1821–1872.* Columbia: University of Missouri Press, 1993.

Lubin, David M. "Reconstructing Duncanson," in *Picturing a Nation: Art and Social Change in Nineteenth-Century America.* New Haven, Conn.: Yale University Press, 1994, pp. 107–57.

—KPB

Edwin A. Harleston

1882–1931

Known for his sensitive, realistic portraits of African Americans, especially the working class, Edwin A. Harleston was noted as a close observer of human nature. Born in Charleston, South Carolina, Harleston studied at Atlanta University, the Boston Museum of Fine Arts School, and Harvard University. He was the recipient of many notable awards, including an Amy Spingarn Prize in 1924 for the portrait of his wife, *Oudia*, and a gold medal from the Harmon Foundation in 1931 for *The Old Servant* (1928). Among the highlights of his career was assisting Aaron Douglas with the murals installed at the Schomburg Center for Research in Black Culture in New York and the Erastus Milo Cravath Memorial Library at Fisk University in Nashville. His work is represented in the collections at Fisk University, Howard University in Washington, D.C., and Clark Atlanta University.

Allison, Madeline G. "Harleston: Who Is E. A. Harleston?" *Opportunity* (Jan. 1924), pp. 21–22.

Locke, Alain. *The Negro in Art.* Washington, D.C.: Associates in Negro Folk Education, 1940, p. 132.

Porter, James A. *Modern Negro Art.* 1943. Reprint, Washington, D.C.: Howard University Press, 1992, p. 95 passim.

Reynolds, Gary, and Beryl Wright. *Against the Odds: African American Artists and the Harmon Foundation.* Newark, N.J.: The Newark Museum, 1989, p. 14, passim.

—AMM

William A. Harper

1873–1910

When William A. Harper was ten years old, he and his family moved from Cayuga, Canada, to Petersburg, Illinois, and then to Jacksonville, Illinois, in 1891. Harper enrolled at the School of the Art Institute of Chicago in 1895. He graduated in 1901 with second honors and moved to Houston, where he became a drawing instructor. From 1903 to 1905, and again from 1907 to 1908, Harper lived in Paris. In France he studied with Henry Ossawa Tanner and painted in Provence and Brittany. Harper exhibited at the Art Institute of Chicago between 1903 and 1909. Suffering from tuberculosis, he went to Cuernevaca, Mexico, in 1908 and died there two years later. The Art Institute of Chicago mounted a posthumous solo exhibition in 1910. In writing of the thirty-some canvases exhibited, the *Bulletin of The Art Institute of Chicago* noted the variety of sketching grounds and the dignity of the point of view. The bulletin also stated that Chicago had "lost a man of fine and unusual talent." Harper won numerous distinguished awards and participated in many American exhibitions during his lifetime.

McElroy, Guy C. "The Foundations for Change, 1880–1920," in *African-American Artists, 1880–1987: Selections from the Evans-Tibbs Collection.* Seattle: University of Washington Press, 1989, p. 32.

"The Past Three Months." *Bulletin of The Art Institute of Chicago* 4, no. 1 (July 1910), p. 20.

"William A. Harper." *Bulletin of The Art Institute of Chicago* 4, no. 11 (Oct. 1910), p. 11.

—KPB

Richard Hunt

B. 1935

For four decades Richard Hunt has created enormous abstract sculptures from welded steel and bronze; his works are seen in museums, universities, private collections, and public spaces around the world. While a student at the School of the Art Institute of Chicago, Hunt worked in a zoology lab at the University of Chicago and became fascinated with the

processes of metamorphosis and physical transformation. Like many twentieth-century artists who work primarily in metal, such as Barbara Chase-Riboud, Julio Gonzales, and David Smith, Hunt constantly challenges the flexibility, strength, and beauty of abstract forms and forces the limitations of the medium. This celebrated artist had a solo exhibition at the Museum of Modern Art, New York, in 1971. He presents lectures, serves on numerous boards, and is the recipient of honorary awards and fellowships. By evoking African American literature, music, and history, and by manipulating space and form, Hunt —often described by his contemporaries as one of the most gifted working artists—creates extraordinary sculptures that are industrial yet seemingly organic.

Hunt, Richard. *Richard Hunt: Growing Forward.* Notre Dame, Ind.: University of Notre Dame, 1996.
Lewis, Samella. *Richmond Barthé and Richard Hunt: Two Sculptors, Two Eras.* Los Angeles: Landau/Travelling Exhibitions, 1992.

—ADB

Clementine Hunter

1886?–1988

In 1940 Clementine Hunter, a native of Hidden Hill Plantation, Louisiana, began painting on anything she could find: cardboard boxes, soap cartons, brown paper bags, pieces of lumber, scraps of plywood, window shades, glass bottles, plastic milk jugs, cast-iron pots, paperboard, and canvasboard. Her subjects can be divided into broad categories—work, play, and religion. She repeated many themes, but no two works are alike. A prolific artist with no formal training, Hunter sold her paintings during the early 1940s for as little as twenty-five cents. By the 1980s her work was fetching thousands of dollars. Museums and galleries have exhibited Hunter's art frequently since 1945; by 1987 her paintings had been featured in more than twenty-four solo exhibitions. In 1986 Northwestern State University in Natchitoches, Louisiana, granted her an Honorary Doctor of Fine Arts degree. Hunter continued making art until she retired in 1987. Her work is represented in the permanent collections of Northwestern State University; High Museum, Atlanta; Dallas Museum of Fine Arts; Fisk University, Nashville; and African House, Melrose Plantation.

Lewis, Samella. *Art: African American,* 2d ed. Los Angeles: Hancraft Studios, 1990, pp. 110–11.
Wilson, James L. *Clementine Hunter: American Folk Artist.* Gretna, La.: Pelican Publishing Company, 1988.

—KPB

Sargent Claude Johnson

1887–1967

After attending the California School of Fine Arts, San Francisco, and the Boston School of Fine Arts, Johnson developed a unique modernist vision in his prints, ceramics, and sculpture depicting the pride, strength, and beauty of African Americans. His self-contained, geometric forms were influenced by African art, the Mexican muralists, and the desire to promote and define a distinctly African American culture. Johnson was commissioned to create several large-scale public sculptures in San Francisco, including a panel on the theme of music for the California School of the Blind (1937), reliefs for the Maritime Museum in the Aquatic Park at Fisherman's Wharf (1939), and an impressive frieze on the subject of athletics for George Washington High School (1940). After supervising the WPA sculpture division for several years, Johnson expanded his skills to include enameled murals whose universal themes allowed the artist to investigate pre-Columbian and Japanese art forms.

Bearden, Romare, and Harry Henderson. *A History of African-American Artists: From 1792 to the Present.* New York: Pantheon Books, 1993, pp. 216–25.
LeFalle-Collins, Lizzetta, and Judith Wilson. *Sargent Johnson: African American Modernist.* San Francisco: San Francisco Museum of Modern Art, 1998.
Montgomery, Evangeline J. *Sargent Johnson.* Oakland: Oakland Museum, 1971.

—AMM

Jacob Lawrence

B. 1917

While growing up in Harlem, Jacob Lawrence was introduced to art in classes taught by Charles Alston at the Harlem Art Workshop. Lawrence continued his studies at the Harlem Community Art Center with Augusta Savage, then at the American Artists School, New York. Beginning in 1937, he created series on subjects such as Toussaint L'Ouverture, Frederick Douglass, Harriet Tubman, and the Great Migration. Combining a graphic modernist style with narrative text, Lawrence made these historical lives and events accessible to all. His impressive exhibition history includes solo shows in New York at the Harlem YMCA (1938), the Downtown Gallery (1941, 1943), the Museum of Modern Art (1944), and major retrospective exhibitions at the Whitney Museum of American Art, New York (1974), and the Seattle Art Museum (1986), which traveled throughout the United States.

Bearden, Romare, and Harry Henderson. *A History of African-American Artists: From 1792 to the Present.* New York: Pantheon Books, 1993, pp. 293–314.

Turner, Elizabeth Hutton. *Jacob Lawrence: "Migration Series."* Washington, D.C.: The Rappahannock Press; The Phillips Collection, 1993.

Wheat, Ellen Harkins. *Jacob Lawrence: American Painter.* Seattle: Seattle Art Museum; University of Washington Press, 1986.

———. *Jacob Lawrence: The "Frederick Douglass" and "Harriet Tubman" Series of 1938–40.* Hampton, Va.: Hampton University Museum; University of Washington Press, 1991.

—AMM

Hughie Lee-Smith

1915–1999

In his studies at the Cleveland Institute of Art, Wayne State University in Detroit, and Karamu House in Cleveland, Hughie Lee-Smith developed an understanding of academic painting that he infused with the tenets of Surrealism and Social Realism. He taught at Clafin College, North Carolina; the Art Students League, New York; Trenton State College, New Jersey; and Howard University, Washington, D.C. Throughout his career, Lee-Smith addressed the uncertainty of the future and the effects of urban modernity in his desolate and decaying cityscapes. He was elected to the National Academy of Design in 1967, a distinction last extended to an African American artist when Henry Ossawa Tanner was honored in 1927. This exceptional recognition reflects Lee-Smith's years of education and exhibitions.

Bearden, Romare, and Harry Henderson. *A History of African-American Artists: From 1792 to the Present.* New York: Pantheon Books, 1993, pp. 332–33.

Kenkeleba Gallery. *Three Masters: Eldzier Cortor, Hughie Lee-Smith, Archibald John Motley, Jr.* New York, 1988.

New Jersey State Museum. *Hughie Lee-Smith: Retrospective Exhibition.* Trenton, 1989.

Patton, Sharon F. *African-American Art.* New York: Oxford University Press, 1998, pp. 164–65.

—AMM

Mary Edmonia Lewis

1845?–AFTER 1911

Born in Greenbush, New York, Mary Edmonia Lewis attended Oberlin College in Ohio. In 1863 she moved to Boston and trained as a sculptor. She found patrons among black and white abolitionists who belonged to William Lloyd Garrison's network. In 1865 Lewis expatriated to Rome, joining a colony of American artists who opened their studios to visitors from the United States and Europe. The subjects of Lewis's work reflect her interests and patronage: the African American experience circumscribed by slavery in *Forever Free* and *The Freedwoman on First Hearing of Her Liberty*; the Native American heritage to which she laid claim in *The Wooing of Hiawatha* and *The Marriage of Hiawatha*; the artist's Catholic faith in her portrait of Pope Pius IX; and prominent American contemporaries in portraits of Robert Gould Shaw, Abraham Lincoln, Ulysses S. Grant, and Frederick Douglass. Among other works, she exhibited the monumental sculpture *The Death of Cleopatra* (1875) in the Philadelphia Centennial Exposition (1876). She also exhibited at the World's Columbian Exposition (1893) in Chicago. When and where she died remain a mystery.

Bearden, Romare, and Harry Henderson. *A History of African-American Artists: From 1792 to the Present.* New York: Pantheon Books, 1993, pp. 54–77.

Buick, Kirsten P. "The Ideal Works of Edmonia Lewis: Invoking and Inverting Autobiography," in *Reading American Art,* ed. Elizabeth Milroy and Maryann Doezema. New Haven, Conn.: Yale University Press, 1998, pp. 190–207.

Wolfe, Rinna Evelyn. *Edmonia Lewis: Wildfire in Marble.* Parsippany, N.J.: Dillon Press, 1998.

—KPB

Norman Lewis

1909–1979

Born in New York, Norman Lewis studied with the sculptor Augusta Savage at the Augusta Savage School (1933) and at Columbia University (1933–35). In 1935 Lewis, along with more than eighty other artists, formed the Harlem Artists Guild, which secured federal funds for the Harlem Community Art Center where he taught from 1936 to 1939. An impassioned political activist, Lewis's figurative Social Realist paintings of the 1930s and 1940s focused on the lives of black families, urban workers, and street scenes. After World War II, he abandoned realism and was among the first generation of Abstract Expressionist painters. Lewis served as the first chairman of Spiral, a group of African American artists organized in 1963 in support of civil rights.

Gibson, Ann Eden. *Abstract Expressionism: Other Politics.* New Haven, Conn.: Yale University Press, 1997.

———. *Norman Lewis: From the Harlem Renaissance to Abstraction.* New York: Kenkeleba Gallery, 1989.

Gibson, Ann Eden, and Jorge Daniel Veneciano. *Norman Lewis: Black Paintings, 1946–1977.* New York: Studio Museum in Harlem, 1998.

—ADB

Archibald J. Motley, Jr.

1891–1981

Through his sensitive portraits and lively cabaret, pool hall, and street scenes, Archibald J. Motley, Jr., sought to portray all aspects of African American life with honesty, realism, and satire. After graduating from the Art Institute of Chicago in 1918, Motley exhibited in various group shows, earning his first solo exhibition in 1928 at the New Gallery in New York. This success was followed by a gold medal from the Harmon Foundation (1928) and a Guggenheim Fellowship for study in Paris (1929–30). Returning to Chicago, the artist focused on African American genre scenes, creating upbeat and energetic images that countered the pervasive malaise of the Depression. In the 1950s Motley visited Mexico and briefly experimented with Surrealism, but he returned to scenes of Chicago for the remainder of his impressive artistic career.

Kenkeleba Gallery. *Three Masters: Eldzier Cortor, Hughie Lee-Smith, Archibald John Motley, Jr.* New York, 1988.

Mooney, Amy M. "Representing Race: Disjunctures in the Work of Archibald J. Motley, Jr." *Museum Studies: African Americans in Art* (The Art Institute of Chicago) 24, no. 2 (1999), pp. 162–79.

Robinson, Jontyle Theresa, and Wendy Greenhouse. *The Art of Archibald J. Motley, Jr.* Chicago: Chicago Historical Society, 1991.

—AMM

Marion Perkins

1908–1961

During the early 1930s, Marion Perkins, a native of Marche, Arkansas, began his art career under the auspices of the WPA. A cofounder and instructor at the South Side Community Art Center in Chicago, Perkins helped forge a rich and vital community of artists, including Eldzier Cortor, Margaret Burroughs, and Charles White. He won three significant awards, the Julius Rosenwald Fellowship, a Robert Rice Jenkins Memorial Prize, and the Pauline Palmer Purchase Prize. To supplement his income, Perkins sold newspapers and worked as a janitor, dishwasher, and dockhand. During his lifetime he never received the recognition he deserved for his highly stylized and sophisticated renderings in marble, but Perkins's legacy to Chicago and the art world is undeniable.

Perkins, Marion. *Problems of the Black Artist.* Chicago: Free Black Press, 1971.

Schulman, Daniel. "Marion Perkins: A Chicago Sculptor Rediscovered." *Museum Studies: African Americans in Art* (The Art Institute of Chicago) 24, no. 2 (1999), pp. 220–43.

—KPB

Horace Pippin

1888–1946

Raised in rural Goshen, New York, Horace Pippin began drawing at a very young age. In 1917 he enlisted in the army and served in the celebrated all-black 369th Regiment in France. After sustaining a permanent injury (shot in the right shoulder in the line of duty), Pippin was discharged and settled in his birthplace of West Chester, Pennsylvania. He returned to his childhood hobby of drawing. Undeterred by his disability, he ingeniously devised a way to draw by using his crossed legs as a raised support and guiding the canvas with his left hand. Pippin's paintings, once characterized as "outsider art," are noted for their seemingly naive style, bucolic scenes, domestic interiors, flattened spaces, simplified patterns, and vivid colors. Early in his career, influential individuals and important institutions such as Albert Barnes and the Museum of Modern Art, New York, demonstrated serious interest in his works. Pippin enjoyed substantial success as an artist in the World War II era and is heralded as one of America's most accomplished self-taught artists.

Bearden, Romare, and Harry Henderson. *A History of African-American Artists: From 1792 to the Present*. New York: Pantheon Books, 1993, pp. 356–69.

Stein, Judith E. *I Tell My Heart: The Art of Horace Pippin*. Philadelphia: Pennsylvania Academy of the Fine Arts, 1993.

—KPB

Charles Ethan Porter

1847?–1923

Charles Ethan Porter, a native of Connecticut, took his first art lessons in 1862. His family was poor and could not afford to pay for his art classes on a regular basis while he was in high school. After graduation, he enrolled in the National Academy of Design in New York. In 1871 Porter exhibited *Autumn Leaves* at the academy. In 1873 and 1875, he exhibited at the American Society of Painters in Watercolor. Porter returned to Connecticut in 1878, and then studied painting in London and Paris from 1881 to 1884. He took a studio in New York in 1885, and although financial hardship forced him to move back to Hartford and later to Rockville, he periodically maintained a New York studio (1886, 1891, 1896). In 1910 he became a charter member of the Connecticut Academy of Fine Arts. Porter earned acclaim for his landscape paintings but is most celebrated for his still lifes.

The Connecticut Gallery. *Charles Ethan Porter, 1847?–1923*. Marlborough, 1987.

—KPB

Nelson A. Primus

1843–1916

Nelson A. Primus, a native of Hartford, Connecticut, was a portraitist and painter of religious subjects. Trained as a carriage painter, in 1858 he resolved to become an artist. He was apprenticed to the portrait painter George Francis and then to Elizabeth Francis Jerome. In 1859 he won a medal for drawing at the State Agricultural Society Fair in Connecticut. Primus moved to Boston in 1864. Unable to make a living as a fine artist, he supplemented his income by painting carriages and selling books. He was never able to afford art studies in Europe. Frustrated by slow sales in Hartford and Boston, Primus left the East and traveled to San Francisco in 1895. He continued to paint but once again was forced to take side jobs, at a restaurant and as a model at the Mark Hopkins Institute of Art. Primus lost many of his works in the earthquake of 1906 and died of tuberculosis in San Francisco ten years later.

Hughes, Edan Milton, ed. *Artists in California, 1786–1940*, 2d ed. San Francisco: Hughes Publishing Company, 1989.

Lewis, Samella. *Art: African American*, 2d ed. Los Angeles: Hancraft Studios, 1990, pp. 37–38.

Porter, James A. *Modern Negro Art*. 1943. Reprint, Washington, D.C.: Howard University Press, 1992, pp. 42–43.

—KPB

Charles Sebree

1941–1985

The painter and illustrator Charles Sebree was born in Madisonville, Kentucky. After studying at the School of the Art Institute of Chicago, he worked in the easel division of the Illinois Federal Art Project, a division of the WPA. Through his paintings, which the author James Porter has described as work conceived in a mood of contemplation, Sebree conveyed the spirit of the black subjects he encountered on a regular basis in Chicago. Like his contemporaries in the city, such as Eldzier Cortor, Charles Davis, and Charles White, Sebree was an active and integral participant in the art scene that flourished in Chicago beginning in the 1930s.

Porter, James A. *Modern Negro Art*. 1943. Reprint, Washington, D.C.: Howard University Press, 1992.

Studio Museum in Harlem. *WPA and the Black Artist: Chicago and New York*. New York, 1978.

—ADB

Henry Ossawa Tanner

1859–1937

Henry Ossawa Tanner, a native of Pittsburgh, expressed an interest in art as a youngster when he saw an artist working in a park. His earliest dated work, *Harbor Scene* (1876), was painted in Atlantic City. In 1879 Tanner enrolled in the Philadelphia Academy of Fine Arts, where he studied with Thomas Eakins. He was exhibiting by 1880 and remained a student at the academy off and on until 1885. Tanner moved to Atlanta in 1889 and opened a photography studio and art gallery. When the venture failed, he served as a drawing instructor at Clark University. In 1891 Tanner moved to France, where he ultimately settled for life. He studied at the Académie Julian in Paris from 1891 to 1893. Two visits to Palestine and Egypt (1897, 1898) inspired the palette, interiors, and historic locations of his biblical paintings. In 1896 his painting *Daniel in the Lion's Den* won an honorable mention in the Paris Salon, and *Resurrection of Lazarus* (1896)

was purchased by the French government. Tanner was elected an associate member of the National Academy of Design in 1909 and was named a full academician in 1927.

Hartigan, Lynda R. *Sharing Traditions: Five Black Artists in Nineteenth-Century America*. Washington, D.C.: Smithsonian Institution Press, 1985, pp. 99–116.

Mathews, Marcia M. *Henry Ossawa Tanner: American Artist*. 1969. Reprint, Chicago: University of Chicago Press, 1994.

Mosby, Dewey F., and Darrel Sewell. *Henry Ossawa Tanner*. Philadelphia: Philadelphia Museum of Art, 1991.

—KPB

Alma Thomas

1895–1978

Alma Thomas was born in Columbus, Georgia. A graduate of Howard University, Washington, D.C., she taught art in the city's public schools until she retired in 1960. In the late 1950s, Thomas enrolled in painting classes at American University and later developed professional relationships with artists such as Morris Louis and Kenneth Noland, whose luminous color-field paintings strongly influenced her. By 1964 she had abandoned realism and, painting with acrylics, developed her signature colorist style: small bars of bright reds, oranges, blues, and yellows thickly layered on light, spacious backgrounds. Many of her paintings do not exhibit obvious pictorial references; she depended on color, form, and application of paint to suggest the themes of nature, light, and night skies. Thomas's work has been featured in numerous solo exhibitions, including a 1972 retrospective at the Corcoran Gallery of Art, Washington, D.C., and the recent nationally touring exhibition organized by the Fort Wayne Museum of Art, Indiana.

Foresta, Merry A. *A Life in Art: Alma Thomas, 1891–1978*. Washington, D.C.: Smithsonian Institution Press; National Museum of American Art, 1981.

Kainen, Jacob. Introduction, *Alma W. Thomas: Retrospective Exhibition*. Washington, D.C.: Corcoran Gallery of Art, 1972.

Yanari, Sachi. *Alma Thomas: A Retrospective of the Paintings*. Fort Wayne, Ind.: Fort Wayne Museum of Art, 1998.

—ADB

Robert Thompson

1937–1966

A native of Louisville, Kentucky, Robert (Bob) Thompson moved to Boston in 1950. He studied at Boston University (1955) as well as the University of Louisville (1956–58). Thompson settled in New York in 1959. Known for creating expressive landscapes and flattened figures in high-keyed palettes, Thompson was inspired by artists such as Matisse, Titian, Goya, and other European masters. His paintings and works on paper were the subject of a 1998 retrospective exhibition organized by the Whitney Museum of American Art, New York. In 1966, following complications from surgery and prolonged drug addiction, Thompson died in Rome shortly before his twenty-ninth birthday.

Barrell, Bill, et al. "Bob Thompson: His Life and Friendships," in Leo Hamalian and Judith Wilson, eds. *Artist and Influence 1985*. New York: Hatch-Billops Collection, 1985, pp. 107–42.

Golden, Thelma, *Bob Thompson*. New York: Whitney Museum of American Art, 1998.

—ADB

Dox Thrash

1892–1965

Dox Thrash is best known as a printmaker and coinventor of the Carborundum printing process. He studied at the School of the Art Institute of Chicago (1914–17) and the Graphic Sketch Club in Philadelphia (1918–23). Thrash served as the head of the Philadelphia graphics division of the WPA from 1934 to 1942. The artist combined the ease of the lithographic technique with a soft ground made from carbon and silicon crystals, achieving the velvety textures and rich tonal variation of a mezzotint without the tedious, time-consuming process. As a Social Realist, Thrash frequently addressed themes of industry and labor as well as rendered naturalistic portraits and rural scenes. During his life Thrash participated in many prestigious exhibitions, including the first Harmon Foundation exhibition (1928) and solo shows at Howard University (1942) and the Philadelphia Art Alliance (1944).

Bringham, David R. "Bridging Identities: Dox Thrash as African American and Artist." *Smithsonian Studies in American Art*. Washington, D.C. 4, no. 2 (1990).

Patton, Sharon F. *African-American Art*. New York: Oxford University Press, 1998, pp. 147–48.

Thrash, Dox. "History of My Life," in *Philadelphia: Three Centuries of American Art*. Philadelphia: Philadelphia Museum of Art, 1976, pp. 469, 552–53.

Williams, Dave, and Reba Williams. *Alone in a Crowd: Prints of the 1930s and 1940s by African-American Artists from the Collection of Reba and Dave Williams*. Newark, N.J.: Newark Museum and Equitable Gallery, 1992.

—AMM

James Lesesne Wells

1902–1993

Although James Lesesne Wells was recognized as an accomplished painter—winning the Harmon Foundation gold medal for *The Flight into Egypt* (1931)—he decided to study printmaking. While taking classes at Columbia University and the National Academy of Design in New York, he was influenced by African, Cubist, and German Expressionist art exhibited at the Brooklyn Museum and the Metropolitan Museum of Art. Informed by the theories of the Harlem Renaissance leader Alain Locke, the strong profiles and hard edges of Wells's work (especially the later graphic designs) demonstrate the artist's interest in African subject matter.

Bearden, Romare, and Harry Henderson. *A History of African-American Artists: From 1792 to the Present*. New York: Pantheon Books, 1993, pp. 389–395.

Evans-Tibbs Collection. *Six Washington Masters: Richard Dempsey, Lois Jones, Delilah Pierce, James Porter, Alma Thomas and James Wells*. Washington, D.C., 1983, pp. 16–17.

Powell, Richard, and Jock Reynolds. *James Lesesne Wells, Sixty Years in Art*. Washington, D.C.: Washington Project for the Arts, 1986.

—AMM

Charles White

1918–1979

Charles White is recognized for the richness of his graphic work and his realist mural paintings, which typically depict aspects of the history, culture, and life of African Americans. A native of Chicago, White attended the School of the Art Institute of Chicago (1937), the Art Students League in New York (1943), and the Taller de Gráfica Popular in Mexico City (1947). Beginning in 1939, he was employed by the Illinois Federal Art Project, administered by the WPA. Successive Julius Rosenwald Fellowships in 1942 and 1943 funded his travels throughout the South, expanding his experience of the musical, performance, and literary creativity of African Americans. Many of his works convey his deep respect for labor and evoke the power of murals in small format.

Bearden, Romare, and Harry Henderson. *A History of African-American Artists: From 1792 to the Present.* New York: Pantheon Books, 1993, pp. 404–17.

Horowitz, Benjamin. *Images of Dignity: The Drawings of Charles White.* Los Angeles: Ward Ritchie Press, 1967.

White, Frances Barrett. *Reaches of the Heart.* New York: Barricade Books, 1994.

—ADB

Contributors

Andrea D. Barnwell is a MacArthur Fellow in the Department of Twentieth-Century Painting and Sculpture at the Art Institute of Chicago. A doctoral candidate in the Department of Art and Art History at Duke University, she is writing her dissertation on contemporary African women artists. She has contributed to several publications, including *African Arts, International Review of African American Art, Museum Studies: African Americans in Art, NKA: Journal of Contemporary African Art*, and catalogues for the nationally touring exhibitions *Rhapsodies in Black: Art of the Harlem Renaissance* and *To Conserve a Legacy: American Art from Historically Black Colleges and Universities*.

Tritobia Hayes Benjamin is an associate dean at Howard University and the director of the Howard University Gallery of Art in Washington, D.C. She is the author of *The Life and Art of Lois Mailou Jones* and has contributed to catalogues on African American art, such as *Alma W. Thomas: A Retrospective of the Paintings* and *Bearing Witness: Contemporary Works by African American Women Artists*. In addition she was the cocurator of the nationally touring exhibition *Three Generations of African American Women Sculptors: A Study in Paradox*.

Kirsten P. Buick recently completed her doctoral dissertation at the University of Michigan on the nineteenth-century sculptor Mary Edmonia Lewis. She has contributed essays to the publications *Museum Studies: African Americans in Art, Reading American Art*, and *Three Generations of African American Women Sculptors: A Study in Paradox*. She is currently a lecturer in the Department of Museum Education at the Art Institute of Chicago.

Amy M. Mooney is a lecturer at the University of Illinois at Chicago and Columbia College and a research assistant in the Department of African and Amerindian Art at the Art Institute of Chicago. She has contributed to *Museum Studies: African Americans in Art, NKA: Journal of Contemporary African Art*, and the *American National Bibliography*. A Ph.D. candidate at Rutgers University, her dissertation focuses on the influences and patronage of Archibald J. Motley, Jr., and his contemporaries. She was recently awarded a predoctoral fellowship at the National Museum of American Art, Smithsonian Institution, in Washington, D.C.